IMAGES
of America

WEST SALEM

ON THE COVER: An unidentified man in a carriage drives through the newly built decorative gates of West Salem's Kingwood Park Subdivision around 1911. The brick entrance was at the corner of Kingwood Avenue and Edgewater Street. Kingwood Park offered its own passenger train stop and a small, forested park. Home lots were offered for sale, ranging in price from $200 for interior sites to $600 for the corner lots. (Polk County Historical Society.)

IMAGES
of America

WEST SALEM

Lynn Mack and Debra Meaghers
with Kimberli Fitzgerald

ARCADIA
PUBLISHING

Copyright © 2011 by Lynn Mack and Debra Meaghers with Kimberli Fitzgerald
ISBN 978-1-5316-5009-4

Published by Arcadia Publishing
Charleston, South Carolina

Library of Congress Control Number: 2011925407

For all general information, please contact Arcadia Publishing:
Telephone 843-853-2070
Fax 843-853-0044
E-mail sales@arcadiapublishing.com
For customer service and orders:
Toll-Free 1-888-313-2665

Visit us on the Internet at www.arcadiapublishing.com

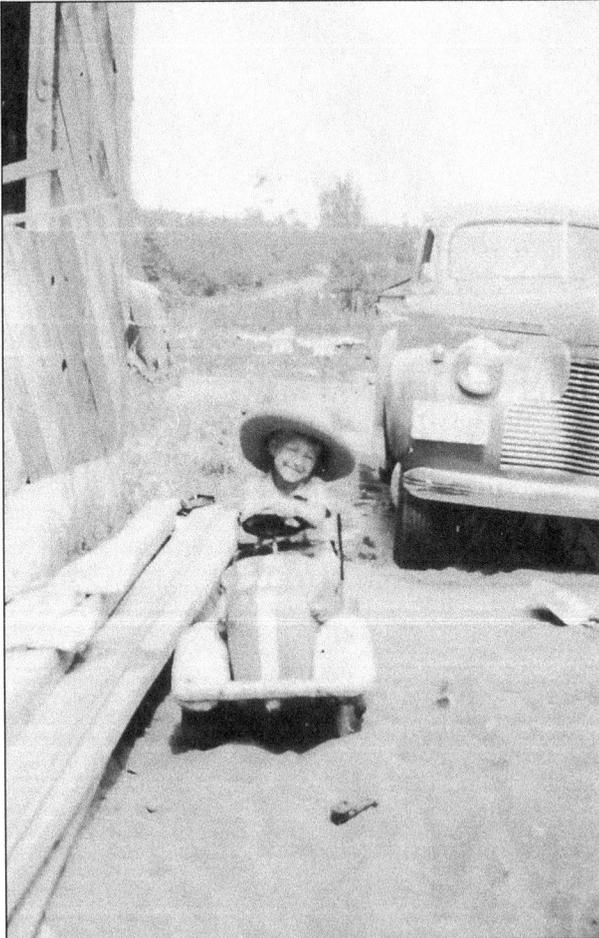

This book is dedicated to Lynn's father, Don Sellers, seen at left playing outside the Ruge Street home being built by his father in 1939. (Lynn Mack.)

CONTENTS

ACKNOWLEDGMENTS

We wish to thank the Polk County Historical Society, the Marion County Historical Society, and the Salem Public Library for allowing access to their excellent photograph archives. Without access to these photographs, this book would not have been possible. We also wish to thank all the people who answered the call for West Salem photographs and memorabilia, opened their homes and photo albums, and shared their special memories of West Salem with us. We also thank Maureen Butcher for granting access to the wonderful collection of Brush College–area photographs and research compiled by her mother, Irene Maynard. Special thanks to April (Gormsen) Swan for the donation of the massive Wallace Collection of historic photographs and documents chronicling West Salem and Salem. Very special thanks go to our cohort and friend Kimberli Fitzgerald, who brought us together and so patiently mentored us through the process. Lastly, there is no way we can fully express our appreciation for the support and patience offered us by our husbands and families as we left them to fend for themselves while we documented the story of the place that holds such fond memories for both of us. It is our hope that this book will provide a pleasant trip down memory lane as well as a connection between all of West Salem's residents, past and present.

The photographs in this book are courtesy of Lynn S. Mack unless identified individually or noted by these abbreviations:

MCHS	Marion County Historical Society
OSL	Oregon State Library
PCHS	Polk County Historical Society
PCHS-DM	Polk County Historical Society, Drew Michaels Collection
PCHS-FFF	Polk County Historical Society, Frances Friesen Finden Collection
PCHS-IM	Polk County Historical Society, Irene Maynard Collection
PCHS-JW	Polk County Historical Society, Janice Coffel Wright Collection
PCHS-SVC	Polk County Historical Society, Spring Valley Church Collection
PCHS-WC	Polk County Historical Society, Wallace Collection
SPL	Salem (Oregon) Public Library, Historic Photograph Collection
SPL-BM	Salem (Oregon) Public Library, Ben Maxwell Collection
SPL-SJ	Salem (Oregon) Public Library, *Statesman Journal* Collection

INTRODUCTION

Few people realize that West Salem was an independent town for more than 30 years, possessing its own distinct sense of place and history. Today, physical reminders of that period are still present in the community, including four properties listed in the National Register of Historic Places: the Phillips House in Spring Valley, the Spring Valley Presbyterian Church at Zena, the Harritt House on Wallace Road, and the old West Salem City Hall on Edgewater Street.

In the 19th century, settlers traveling the Oregon Trail flooded into the Willamette Valley, clearing land for farms, homes, and towns. Located on the west bank of the Willamette River in Polk County, West Salem is one such community of enterprising Oregon pioneers. The area that would become West Salem was divided into homesteads in the 1850s and, later, residential tracts. Local farmers grew wheat, which was highly valued, but hops, orchard fruits, and dairy products were also important agricultural goods. Growing steadily, the community founded Fairview School in 1868, and by 1880, the lower West Salem area boasted 11 homes with more uncounted in the hills and surrounding areas. The opening of the Center Street Bridge across the Willamette River in 1886 encouraged further development, and in 1889, the West Salem Addition was platted, with other expansions following. Still, most of West Salem remained family farms.

West Salem developed a distinct identity in the early 20th century. In 1906, West Salem attracted its first retail store, but it was the railroad that spurred growth. In 1909, the Salem, Falls City, and Western Railroad Company completed a rail line to the town, connecting it with other towns along the west side of the Willamette River. Seeing an opportunity, C.A. Richardson brought water and electrical service to West Salem in 1911 to encourage sales of lots in his subdivision. Reflecting the needs of the growing population, prominent West Salem resident Walter Gerth opened a grocery in 1912. Other businesses soon followed. Close to river and rail transportation, West Salem was also a convenient location for canneries, which provided employment for nearby residents. In 1913, a railroad bridge across the Willamette River to the east was opened, accelerating growth, which led to the construction of additional businesses and homes and a growing sense of community.

On November 26, 1913, West Salem residents voted 68 to 4 to form their own city government. With an initial private loan of $300, the City of West Salem was established with George L. Frazure as the first mayor. By 1920, exactly 208 persons lived within city limits, and Edgewater Street was recognized as the community's commercial hub. A year into the Great Depression, the 1930 census recorded 974 residents—a substantial increase. In 1940, almost 2,000 people lived in West Salem. The frequent winter flooding, which routinely caused significant property damage, as well as the populace's increasing demands on city services strained the town's resources. In 1943, a particularly devastating flood caused damage to many structures, some of which would never be rebuilt. Citing these difficulties, in a move overwhelmingly supported by local residents, West Salem's last mayor, Walter Musgrave, surrendered the West Salem city charter to Salem in November 1949.

In the years following 1949, West Salem became home to more people, many of whom worked across the river in Salem. In the 1950s and 1960s, several retirement communities were established. The old city hall continued in public ownership until the 1980s, housing the public library and branch offices of Salem government. Private ownership has preserved this building, and it remains an important structure in the life of West Salem. Though it lost its political independence, West Salem maintains a strong sense of community, visible in the former town's pride and its historic buildings. As the majority of the developable land in the Salem urban growth boundary lies in West Salem, a significant residential increase is anticipated throughout the 21st century, making it doubly important to record the history of this independent town.

One

EARLY EXPLORATION
AND SETTLEMENT

For centuries, Native Americans were the sole inhabitants of Oregon. The Yamhill band of the Kalapuya resided in the area known today as West Salem. In the early 1800s, explorers Lewis and Clark and their Corps of Discovery traveled to Oregon, documenting their adventures with journals and maps and creating an interest in the Oregon Country for people back in "the States."

Fur trappers and adventurers were the next nonnative people to come to Oregon. Early trappers worked out of Fort Astoria, which was established in 1811 by New York's John Jacob Astor. Later, the British-owned Hudson's Bay Company (HBC), under John McLoughlin, built Fort Vancouver on the north bank of the Columbia River in 1825. Many of the HBC trappers were of French Canadian descent, and when they retired from trapping in the 1830s, they settled on farms with their Indian wives and children in an area of the Willamette Valley fittingly called French Prairie. There were other trappers and adventurers, including American John Turner and Englishman George Kirby Gay, who worked somewhat independently in California and Oregon. Turner and Gay would later settle in the northern area of West Salem.

Methodist missionary Jason Lee and others came to Oregon in 1834 in hopes of bringing Christianity to the native population. The first mission station was established in French Prairie, north of Salem, but in 1840, Reverend Lee moved the mission to Chemeketa (now Salem) where a school for Kalapuya children was built. The mission to educate and convert the native population soon failed, but the Oregon Institute (now Willamette University) was eventually established as a school for children of the missionaries and white settlers. These early inhabitants had little idea of what was going to happen in Oregon during the next few years.

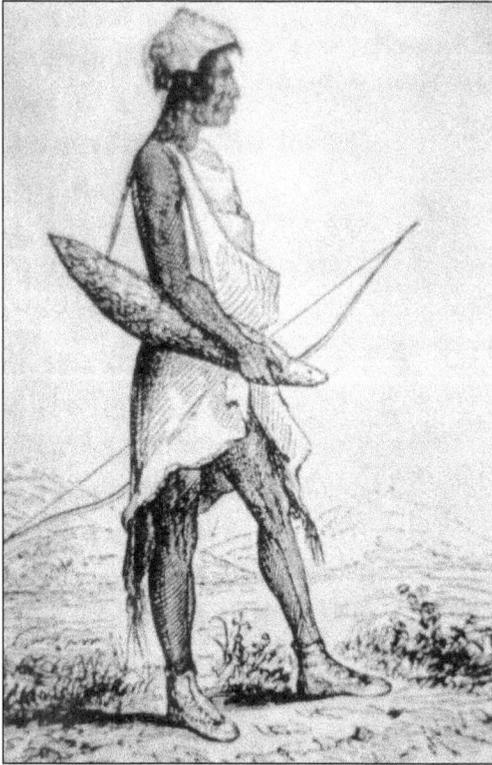

This Kalapuyan hunter was sketched by A.T. Agate during an expedition of the Pacific Northwest with Lt. Charles Wilkes in the early 1840s. As the first residents of the Willamette Valley, the Kalapuyans hunted game and gathered seasonal nuts, seeds, berries, and camas roots. They were very adept at setting controlled fires to improve the soil and clear brush, creating a better hunting and harvesting environment. (Washington County Historical Society.)

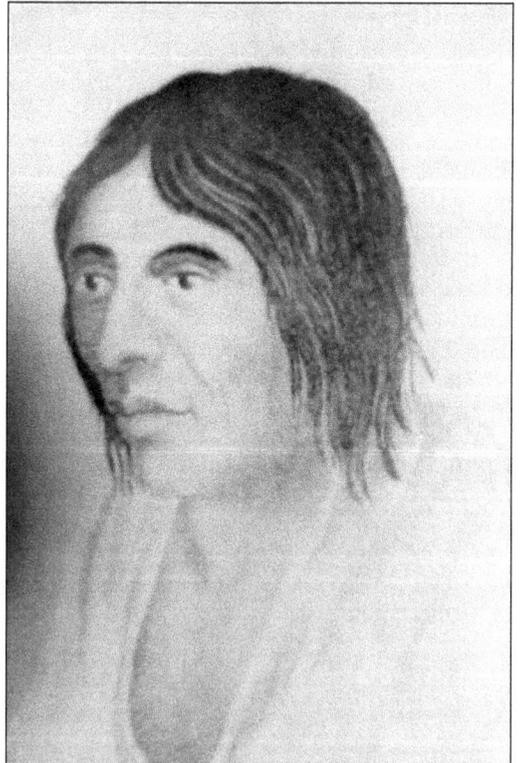

By the time the first Oregon Trail pioneers arrived in the 1840s, more than 90 percent of the native population had been decimated by epidemics of small pox and other diseases inadvertently introduced to the area by explorers, trappers, and other nonnative peoples. Under the treaties of the 1850s, most of the surviving Kalapuya were moved to the reservation at Grand Ronde. (Washington County Historical Society.)

Englishman George Kirby Gay was the first white man to settle in what is now Polk County. Gay was a sailor for many years before joining up with trapper and trader Ewing Young in California. At age 39, Gay traveled overland to the Oregon Country in 1835, settling on the west side of the Willamette River opposite the new Jason Lee Methodist Mission. (SPL.)

The first brick house west of the Rocky Mountains and north of California was built in 1842 by George Kirby Gay. When Polk County was carved out of Yamhill County in 1845, the house straddled the new Yamhill-Polk county line, with the house in Yamhill County and much of the land in Polk County. Although no longer standing, the homesite is marked by a plaque on Highway 221 (also known as Wallace Road NW). (SPL.)

The first American-born white man to settle in Polk County was "Big" John Turner from Kentucky. He made his way west very early, working as a fur trapper in both California and Oregon where his Herculean build repeatedly helped him survive the perils of frontier life. In 1835, while traveling from California to Fort Vancouver, his group was attacked by Indians. Turner grabbed an enormous branch from the campfire and swung it around with such force and anger that many of the attackers were killed and many others ran. The surviving men escaped on foot and began a 300-mile journey to Fort Vancouver, but only half of the original group—Turner, George Kirby Gay, and two others—made it to safety. Turner and his Native American wife settled in the area now known as Spring Valley. In 1843, he was involved with creating Oregon's Provisional Government at Champoeg. Turner sold his claim to John Phillips and moved to California, where in early 1847, he was part of the Second Rescue Expedition that assisted the ill-fated Donner Party by bringing in supplies and helping survivors travel down the mountain to safety. (PCHS–Sonja Ely.)

In the early 1840s, immigrants began arriving via the Oregon Trail. By 1845, several families settled in the area known today as West Salem. Among the early West Salem–area settlers were James White, the ferryman who settled the entire lower area of West Salem; the Reverend Jesse Harritt, who settled a few miles north of the ferry and was part of the Brush College community; Joshua Shaw, who settled west of the ferry and founded the village of Cincinnati (later Eola); A.J. Doak, who settled further north along the Willamette River (later named Lincoln) near today's Wallace Road; and Walter M. Walker, who settled in the western edge of the area he named Spring Valley. These men, and the communities in which they lived, were important in making West Salem what it is today. Some of these families' names can be seen on this 1852 map. (PCHS.)

James White, part of the "Great Migration," came by wagon train to Oregon in 1843 and by 1845 had settled in Polk County along the west bank of the Willamette River, opposite Jason Lee's mission village of Salem. White's claim encompassed the entire "flat" area and some of the hills of current West Salem. White began ferry service across the Willamette River in 1846 from a landing near the foot of today's Wallace Road. White was killed in April 1854 while traveling the Willamette River on the steamboat *Gazelle* when its boilers exploded. Widow Rhoda White operated the ferry for about 10 more years before selling her interest. Although the family eventually sold their land and moved away, White's Ferry provided an important transportation link for early travelers, settlers, and immigrants and deserves its special place in West Salem's history. (Both, Daniels)

Two

THE COMMUNITIES OF EOLA AND SPRING VALLEY

Today, the area of West Salem known as Eola does not give much indication of the earlier thriving community of the 1850s and 1860s. First called Cincinnati, the community was renamed Eola when it was incorporated in 1856. The town was located on LaCreole (or Rickreall) Creek near its confluence with the Willamette River. Small riverboats were able to make it to the town's docks and landings, allowing local farmers to ship crops and receive freight or catch a ride to another town along the river. In these early days, the course of the river was much different than it is today. To facilitate the trip up LaCreole Creek to the town, a canal was dug, which later proved to be a costly mistake. When the next major flood arrived, the canal allowed the river to change its course, resulting in some of what was once Polk County land ending up on the Marion County side of the river, while wiping out many buildings in the lower Eola area.

The community of Spring Valley encompasses a large area that includes the once-bustling river town of Lincoln to the east and the village of Zena to the west. Andrew J. Doak arrived in Oregon via the Oregon Trail in 1845 and settled a land claim along the Willamette River about six miles northwest of Salem. He established a ferry service around 1852, and the area soon became known as Doaks Ferry. In the early 1860s, Doak sold his ferry to Jesse D. Walling. Walling later became a business partner with Lewis Abrams, a newcomer to Lincoln. After Walling's untimely death, Abrams platted the town and purchased warehouses, docks, the ferry, and the town's store. At that time, Lincoln was the largest grain-shipping port along the Willamette River outside of Portland. But like Eola, the town of Lincoln—once thriving and important—began to decline following the construction of the railroad, which farmers found more desirable for shipping. The ferry made its last regular crossing in 1898, and all of the docks and warehouses were destroyed by fire in 1914.

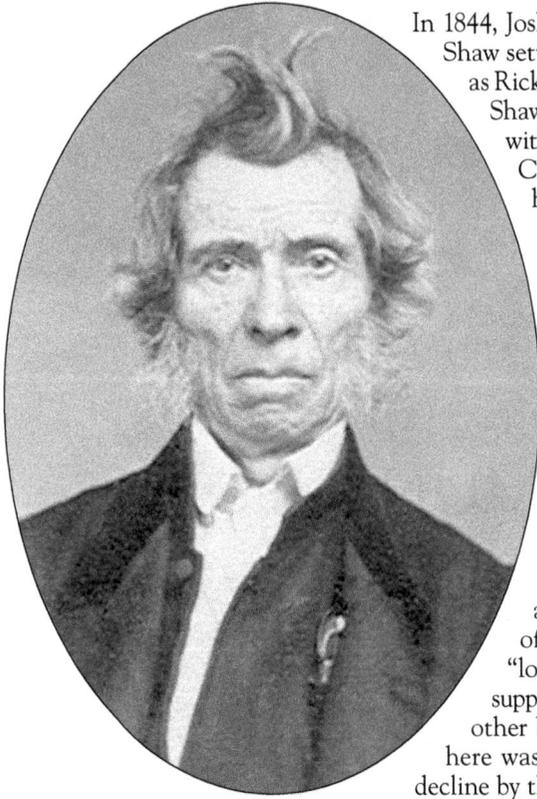

In 1844, Joshua C. "Sheep" Shaw, left, and son A.C.R. Shaw settled along the LaCreole Creek (now known as Rickreall Creek) just west of today's West Salem. Shaw came from Cincinnati, Ohio, and is credited with giving the waterfront community the name Cincinnati, as he thought the area resembled his former home. Shaw earned his nickname because he was the first to bring sheep into Oregon across the Oregon Trail. (OSL.)

A post office opened in Cincinnati in 1851. A few years later, the community was officially surveyed, platted, and incorporated as Eola, named after Aeolus, the Greek god of wind, but rumored to be for the developer's "lofty goals." This once-thriving community supported a school, two hotels, a general store, and other businesses. Most of the original plat shown here was never developed, and the town began to decline by the 1870s.

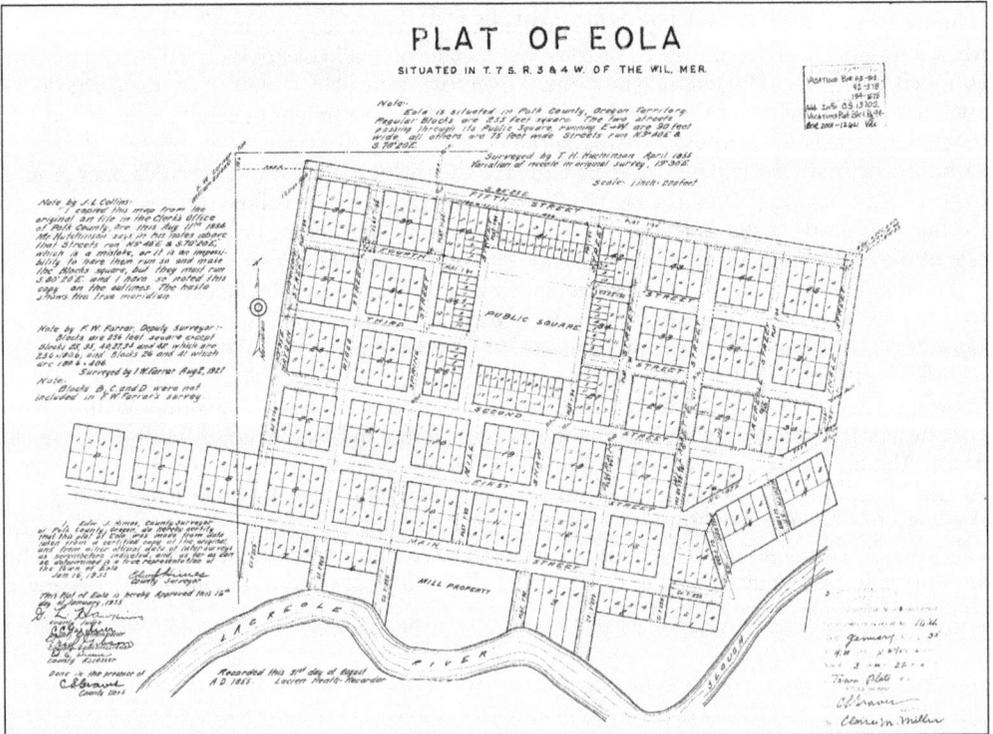

PLAT OF EOLA

SITUATED IN T. 7 S. R. 3 & 4 W. OF THE WIL. MER.

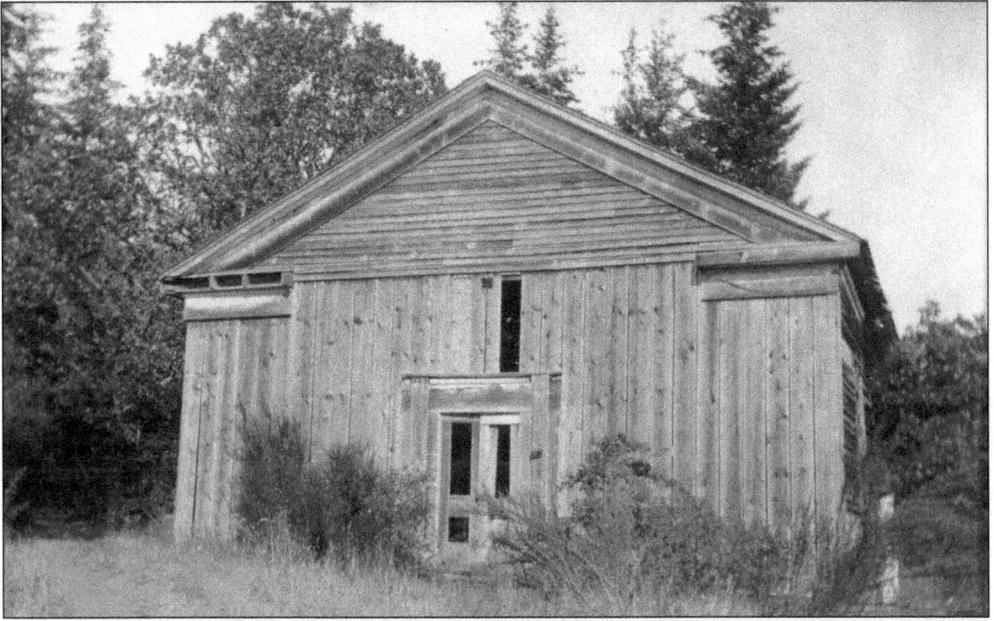

The First Christian Church was built in 1856 at a cost of $500. The building seated 200 and was made of 10-inch, square, hand-hewn sills held together by oak pegs at the corners. The first minister was Hugh McNary "Mac" Waller, and the last sermon was preached on Christmas Day in 1870. This photograph shows the building after it had been vacant for many years; it collapsed in a 1919 snowstorm. (PCHS.)

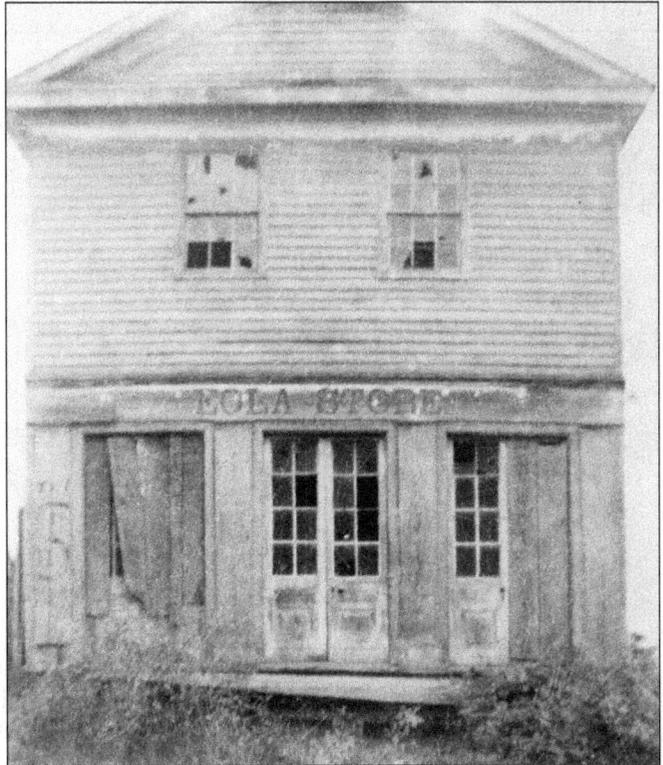

The Eola store was opened in 1852 by Townsend and Orville Waller. Housing the early post office, it was also the first stop on the route from Salem through the Rickreall valley to Ellendale, near present-day Dallas. Eola boasted two general merchandise stores in 1867. This photograph was taken in 1918, after the building had been vacant for many years. The building was torn down in 1922. (SPL.)

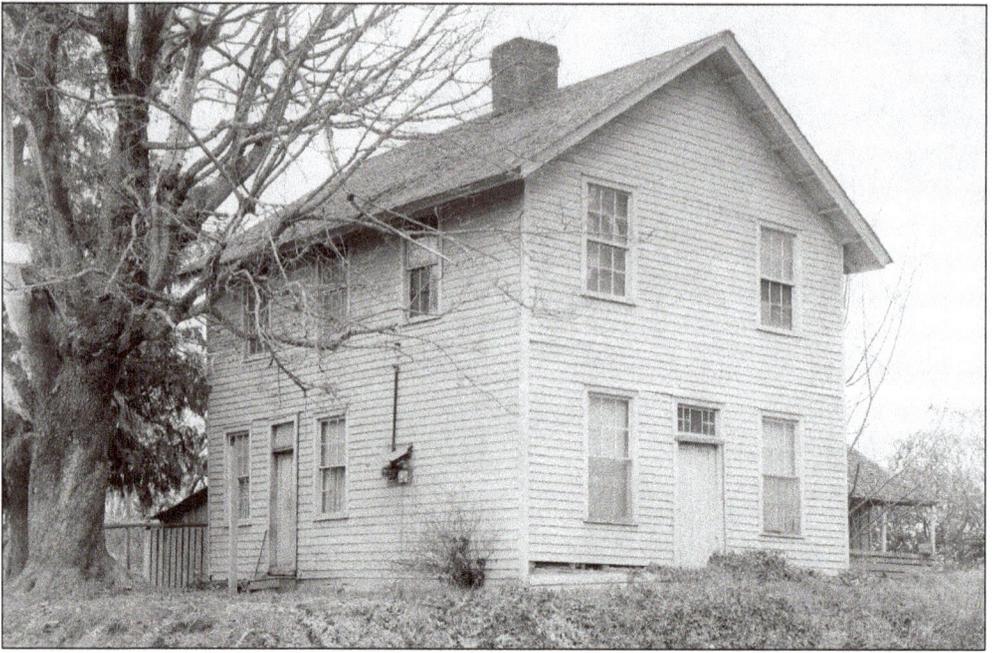

The Cincinnati House Hotel, built around 1855 by Samuel Beckett, was one of two hotels in the town. The 1867 Pacific Coast Business Directory showed the town having the hotels, an attorney, a cooper, a physician, a threshing machine, a wagon and furniture shop, a boot maker, a tanner, a blacksmith, a wagon maker, a contractor, a potter, a general merchandise store, and a post office. This photograph was taken in 1946. (SPL.)

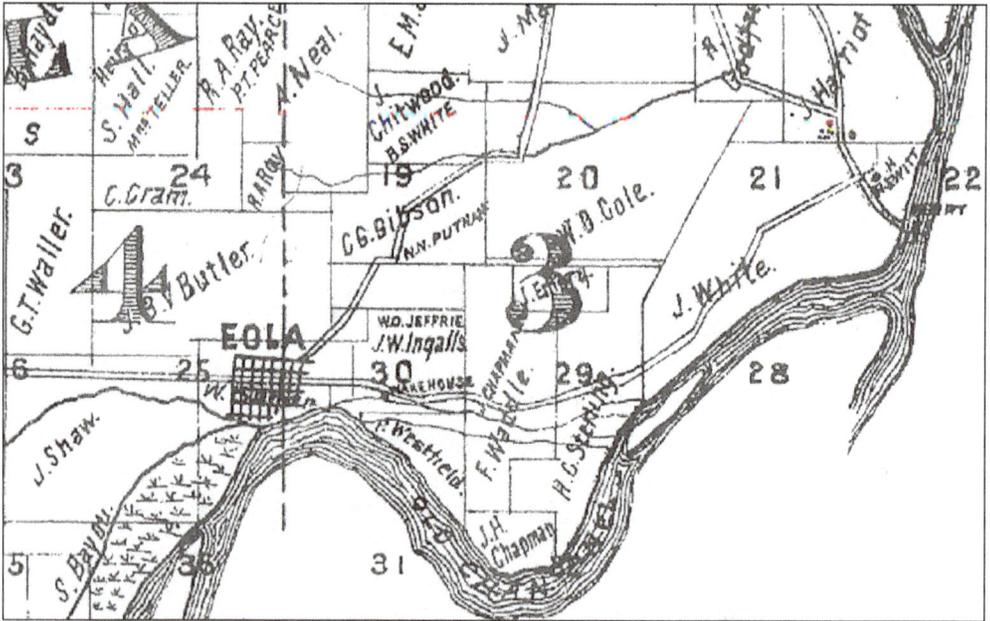

This 1882 map denotes several landowners of the Eola area. Following a major flood just a few years later, the properties marked P. Westfield, F. Waddle, J.H. Chapman, and H.C. Sterling were found to be either under the newly changed river or on the other side of the river, technically in Marion County. (PCHS.)

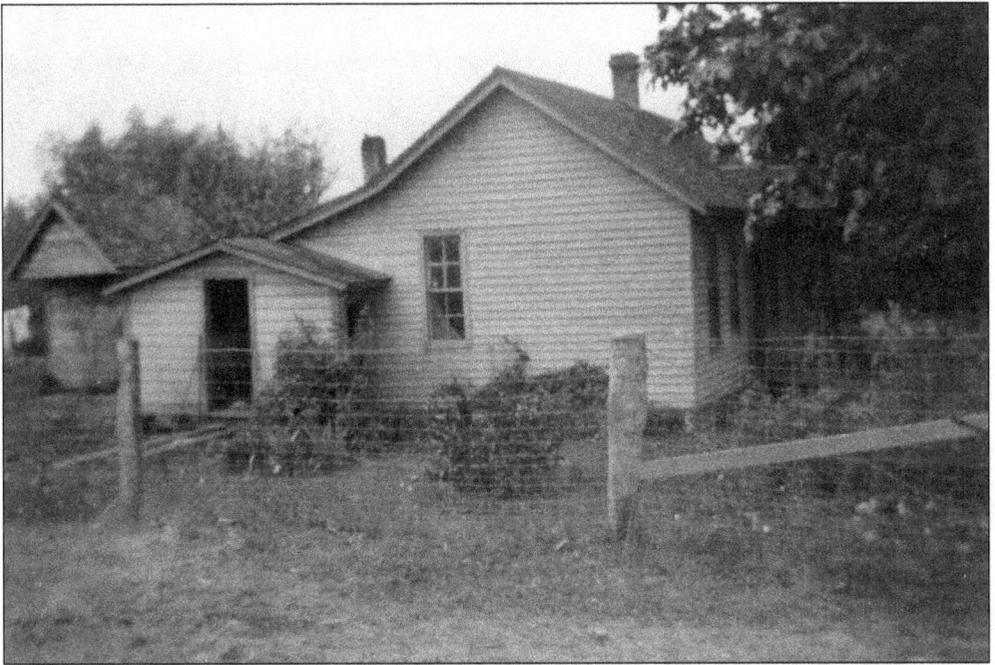

Eola School opened in 1853 in a home as a private school with a tuition of $7 per pupil per quarter; tuition was later reduced to $3. The first teacher was Abigail Scott Duniway, later known for her women's suffrage work. (PCHS.)

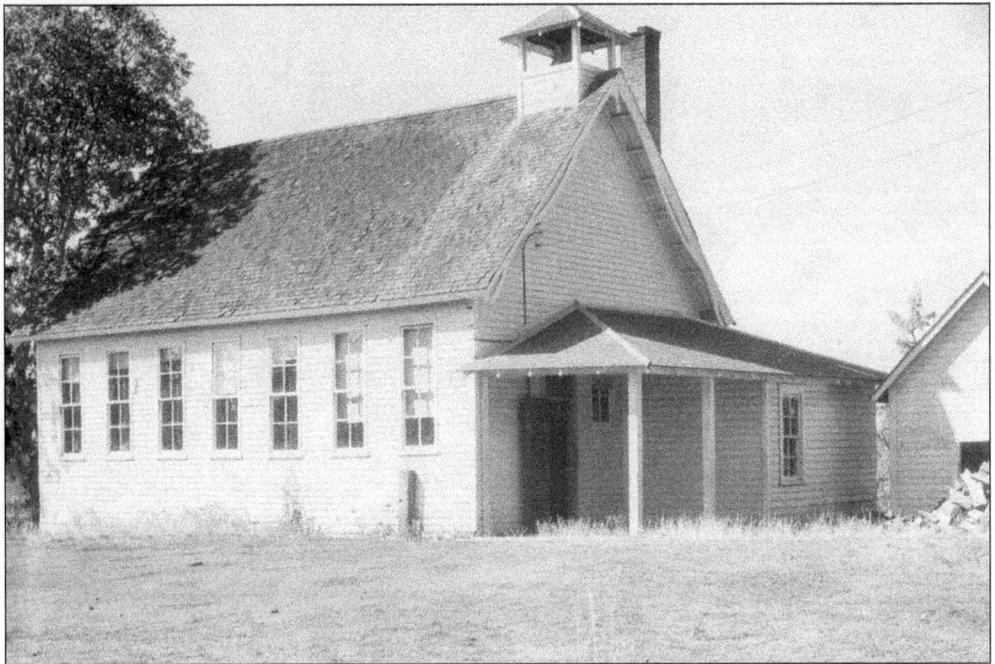

After fire destroyed the first Eola schoolhouse, this school building was erected around 1858. An 1867 business directory noted there were several thriving businesses and professional practices in Eola, along with the school, a church, and a couple of saloons. The school remained in use for 80 years before it was replaced by a larger, more modern building in 1938. (SPL.)

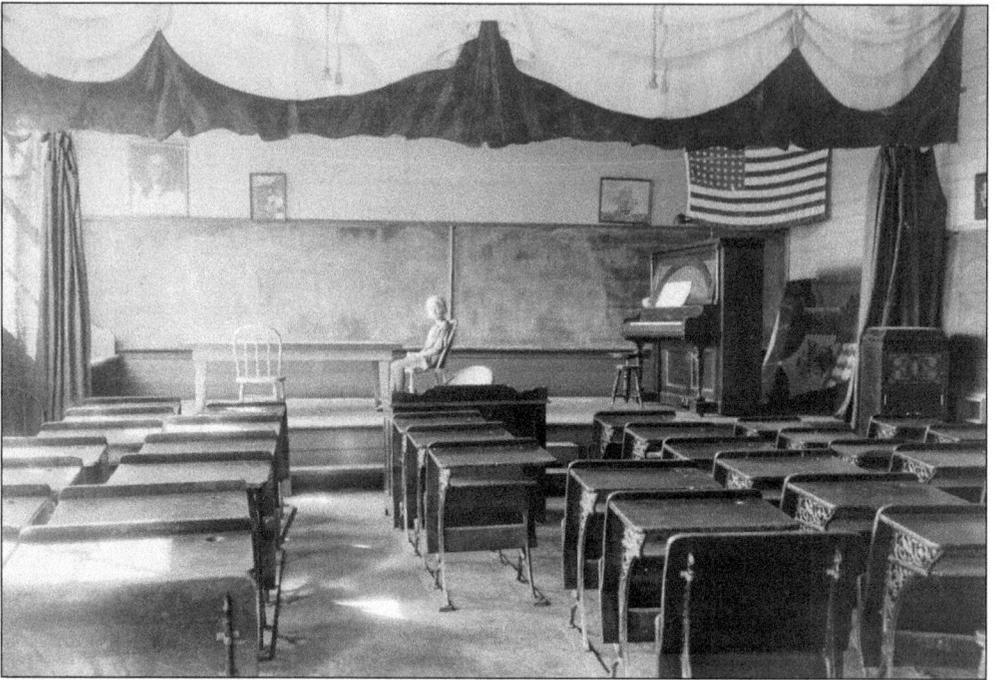

This is an interior view of the old Eola School, which was built around 1858, with an unknown girl sitting at a table on the stage. This photograph was likely taken in the 1930s. (SPL.)

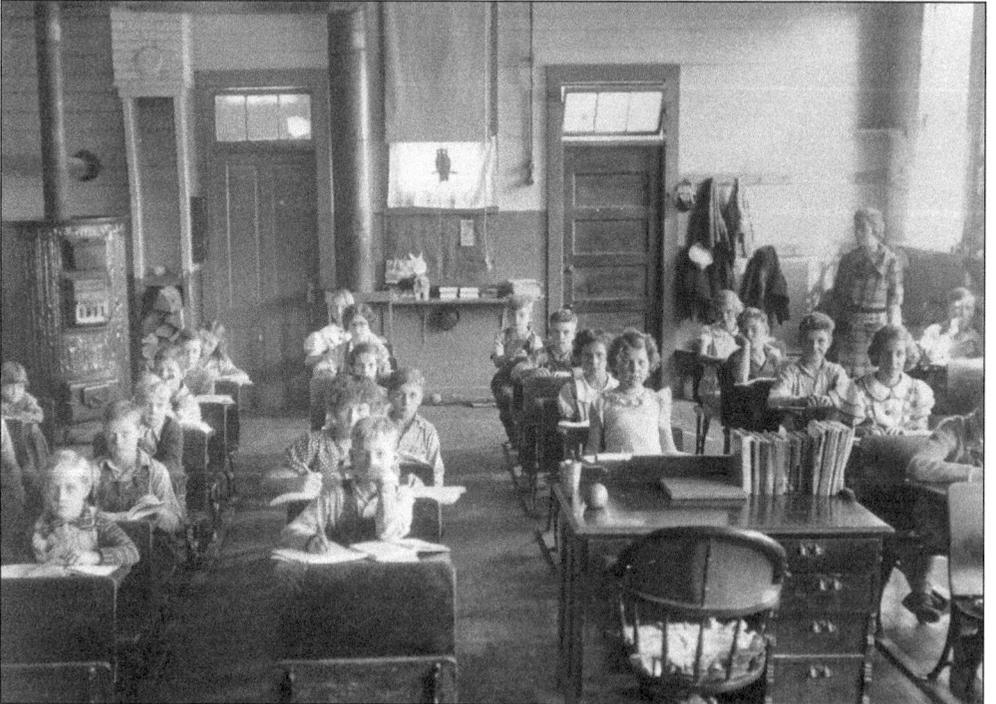

Eola School students are at their desks around 1937. Note the old wood stove at left and the token apple on the teacher's desk. The teacher stands at the right. A new school building was constructed the following year, in 1938. (SPL.)

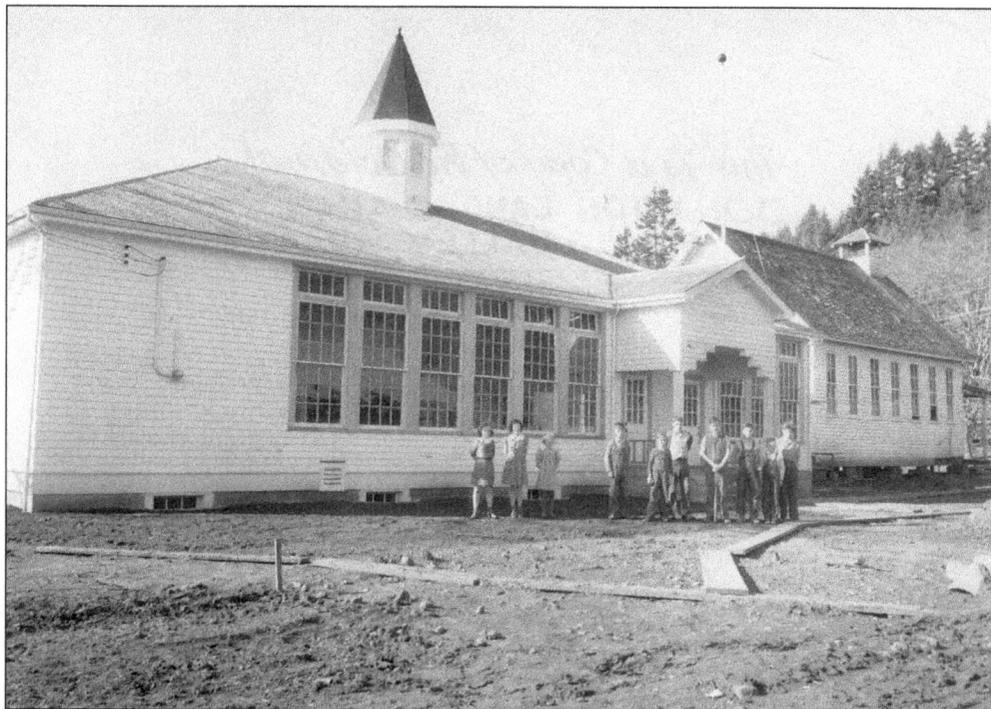

In 1938, the new Eola School was built next to the old schoolhouse. Here, several students pose for a photograph in front of their new school. The old building was later torn down. (SPL.)

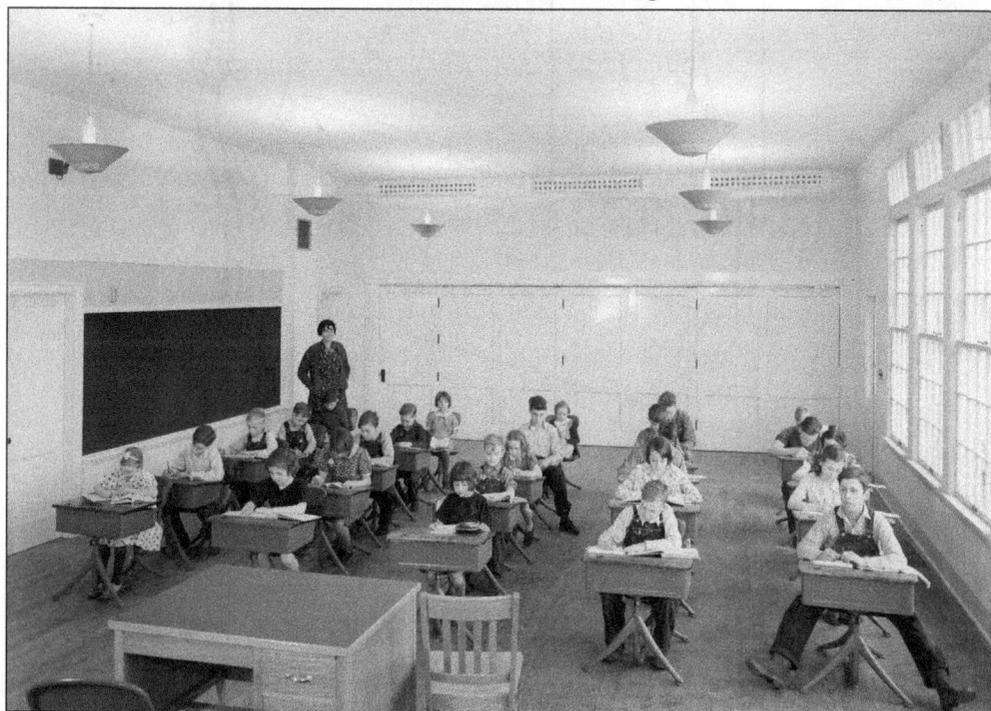

An interior view of the new Eola School, built in 1938, displays its electric lights and wall of windows, along with its new furniture. This building is used as a church today. (SPL.)

This is a Copy of the Original
DONATION LAND CLAIMS
OF THE SPRING VALLEY AREA

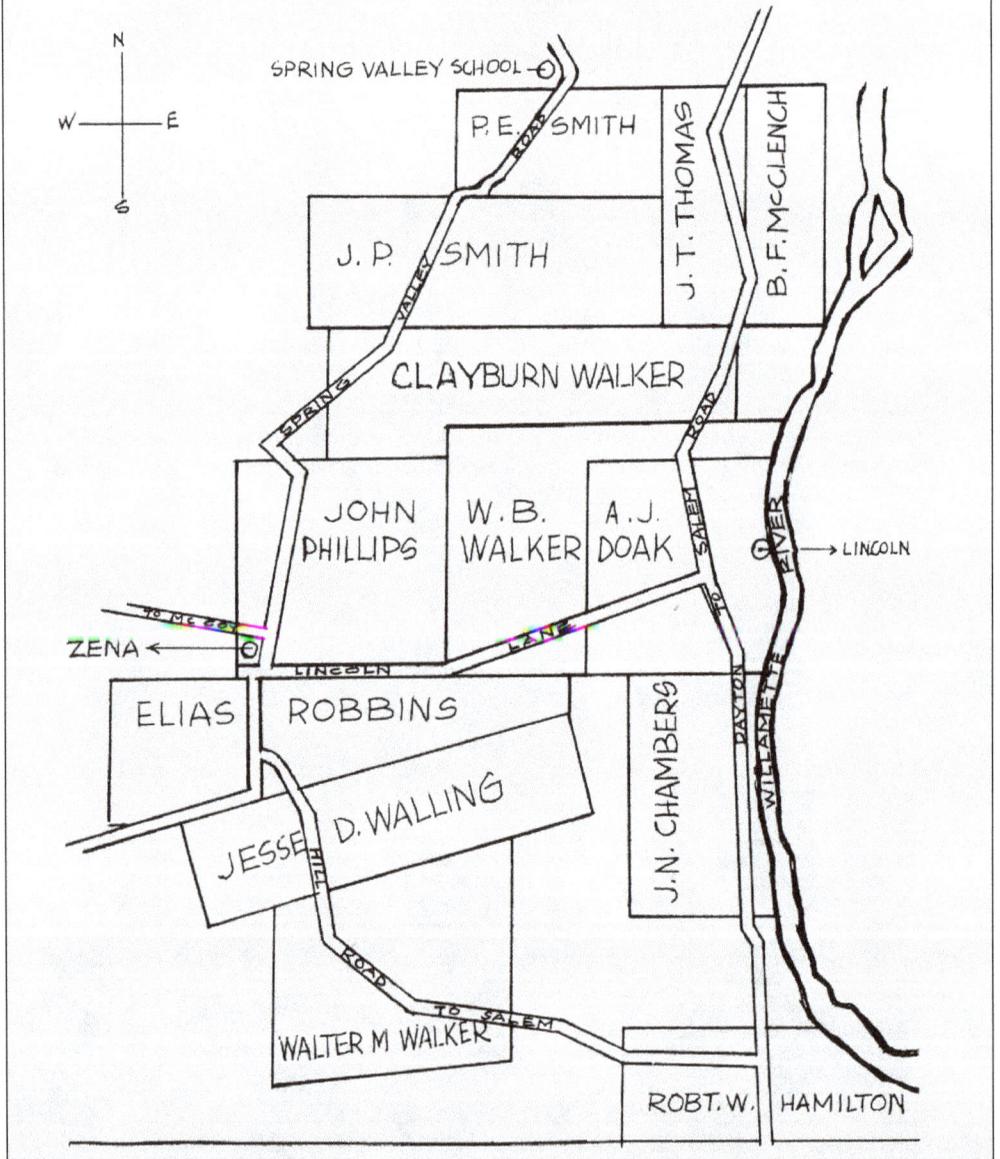

N

W———E

S

SPRING VALLEY SCHOOL

P. E. SMITH

J. P. SMITH

J. T. THOMAS

B. F. McCLENCH

CLAYBURN WALKER

JOHN PHILLIPS

W. B. WALKER

A. J. DOAK

LINCOLN

ZENA

TO McZ...

SPRING VALLEY ROAD

SALEM ROAD

WILLAMETTE RIVER

LINCOLN

ELIAS

ROBBINS

JESSE D. WALLING

HILL ROAD

J. N. CHAMBERS

DAYTON

ROAD TO SALEM

WALTER M WALKER

ROBT. W.

HAMILTON

This map shows the location of the 13 original donation land claims in the Spring Valley area of today's West Salem. Spring Valley contains the communities of Zena and Lincoln. Several of the named families remained in the area for many generations. (PCHS-SVC.)

Elizabeth and John Phillips were among the early settlers in the Spring Valley community. In July 1847, they purchased land claim rights consisting of 640 acres and a small log cabin from fur trapper John Turner for the sum of $100. Although only four feet, eight inches tall, Elizabeth was an expert horsewoman, and it was a familiar sight to see her galloping down the road seated in her prized sidesaddle. (MCHS 2007.001.1469.)

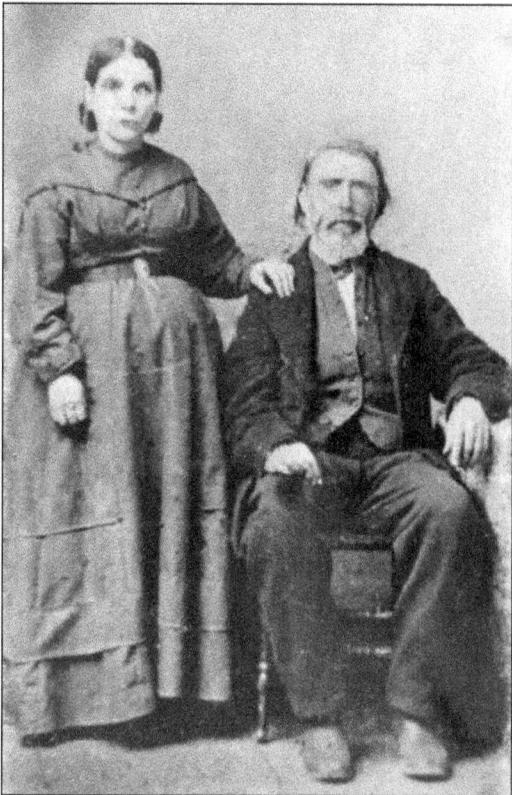

John and Elizabeth Phillips are on the porch of their house, which John built in 1853. The Colonial-style house had three fireplaces and two-inch-thick oak floors and was furnished with beautiful furniture made by Mr. Phillips. Although the house is no longer used as a residence, it still stands not far from the Zena Church, where it has stood for more than 150 years. (PCHS-SVC.)

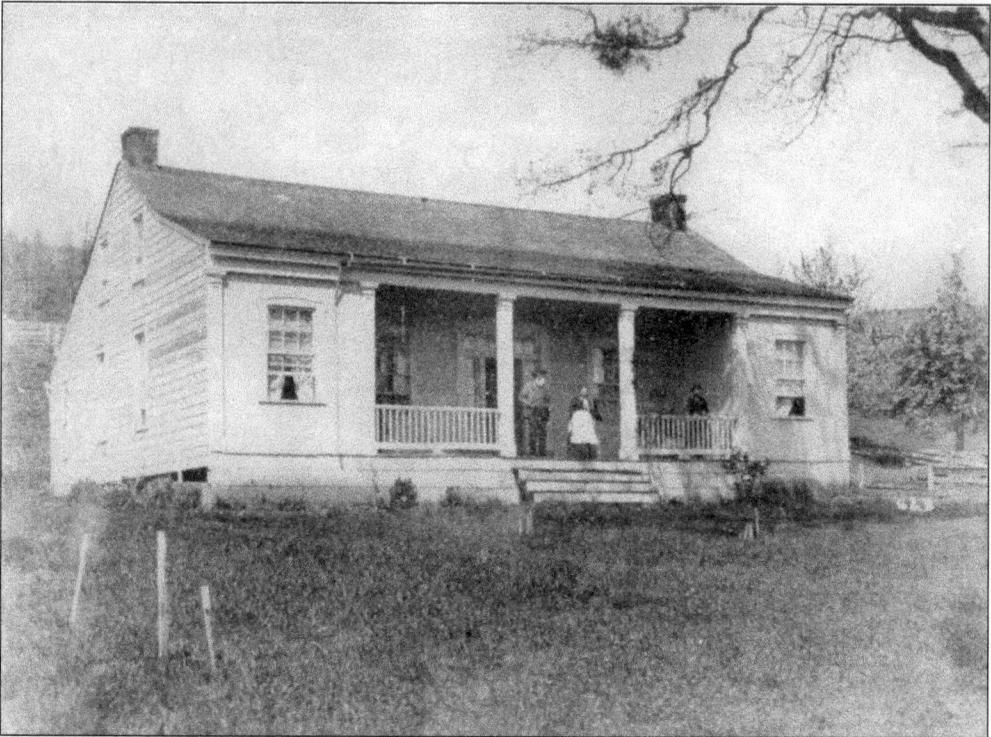

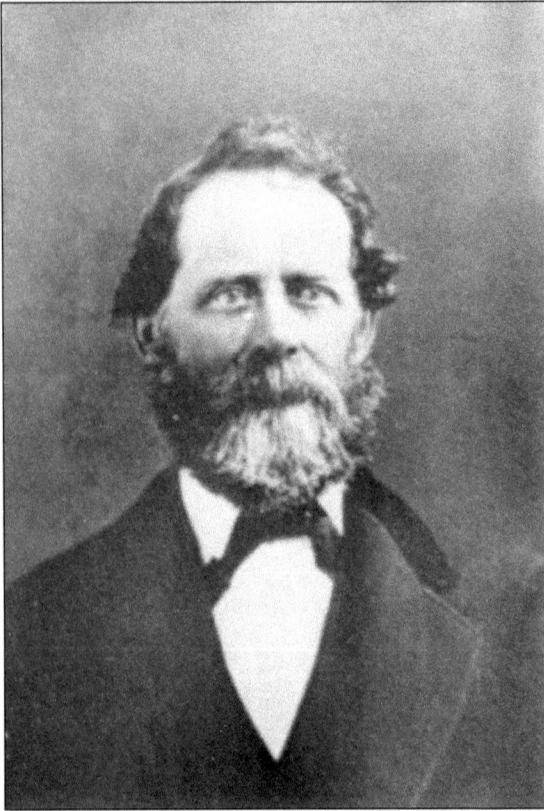

Walter M. Walker arrived in Polk County in 1848, settling near his brothers Bolivar and Claiborne and his cousin Andrew J. Doak, who had arrived in 1845. Walker brought a large supply of nursery stock with him from Missouri to establish his own orchards, as well as others in the area. A leader in the community, Walker served as a county commissioner and as a member of the territorial legislature. (MCHS 2007.001.1470.)

Walter M. Walker, with wife, Jane, and their five daughters lived in a small log cabin on their land claim for many years before building this Virginia-style home in 1862. This spacious house with multiple fireplaces, hardwood floors, and plastered walls burned down in 1920. Walker is credited with naming the area Spring Valley for its many water springs. A middle school in West Salem is named for him. (PCHS-SVC.)

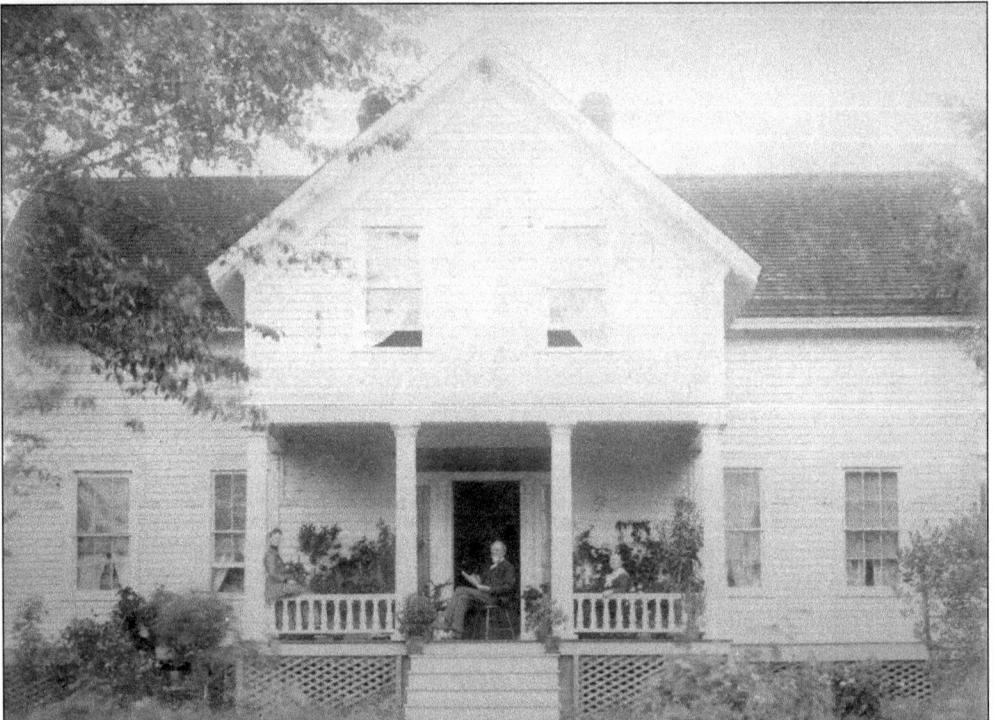

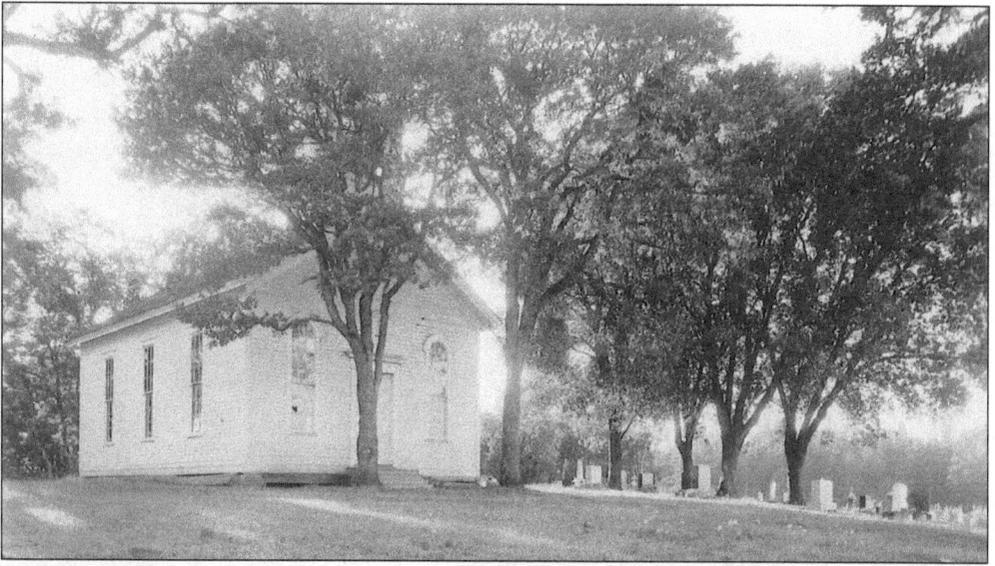

The Spring Valley Church was built in 1858–1859 by local residents and members of the Presbyterian congregation who donated the land, money, and labor. The bell in the steeple was shipped "around the Horn" in the mid-1880s. It was customary for the bell to be rung on the Sabbath and whenever there was an emergency or death in the neighborhood. (PCHS.)

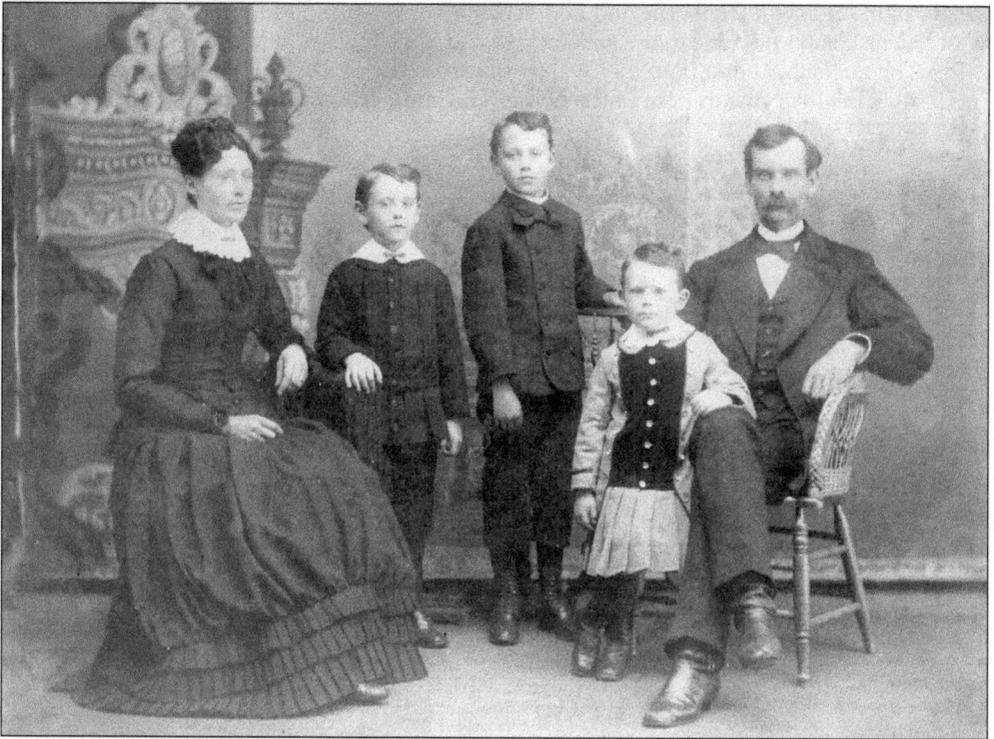

Nancy Walker, daughter of Walter M. Walker, married Dudley G. Henry in 1870. Henry was a native of Missouri who had come West (traveling around the Horn) after serving in the Civil War. The Dudley G. Henry family is shown in 1885. From left to right are Nancy, Wayne, Clyde, Worth, and Dudley. Dudley was the first resident of Spring Valley to own an automobile. (PCHS.)

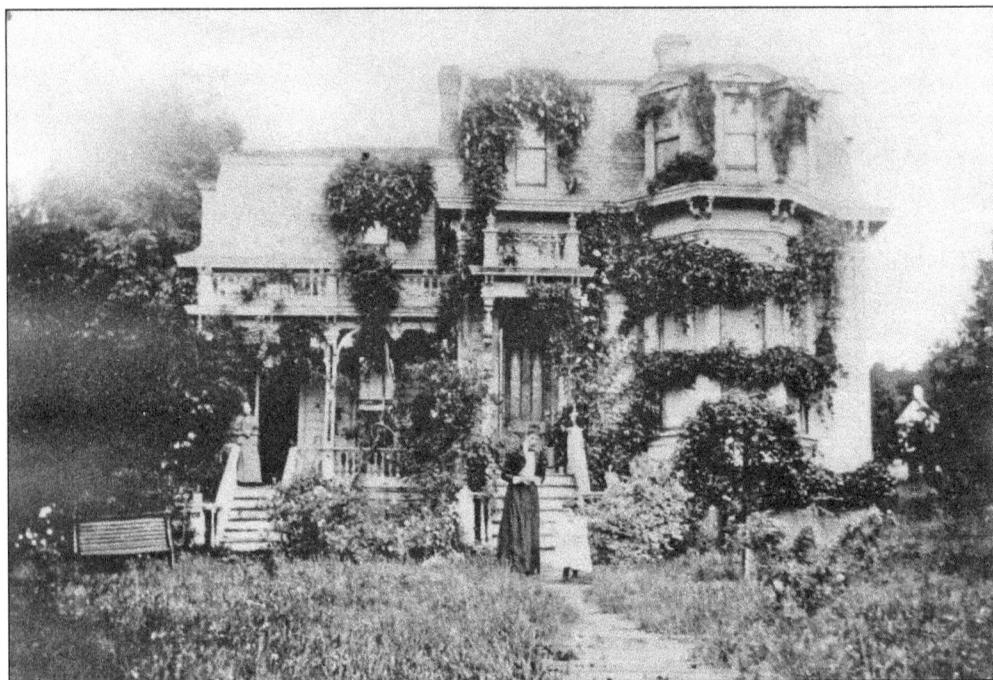

The beautiful home of Claiborne and Louisa Walker was located in the Spring Valley area of West Salem. Claiborne came to the area in 1845 and was a brother to Walter M. Walker. In this c. 1890s photograph, Louisa (Purvine) Walker is seen on the porch, with Frances (Reid) Purvine and Walker Reid Purvine in front of the house. The house later burned down. (PCHS-SVC.)

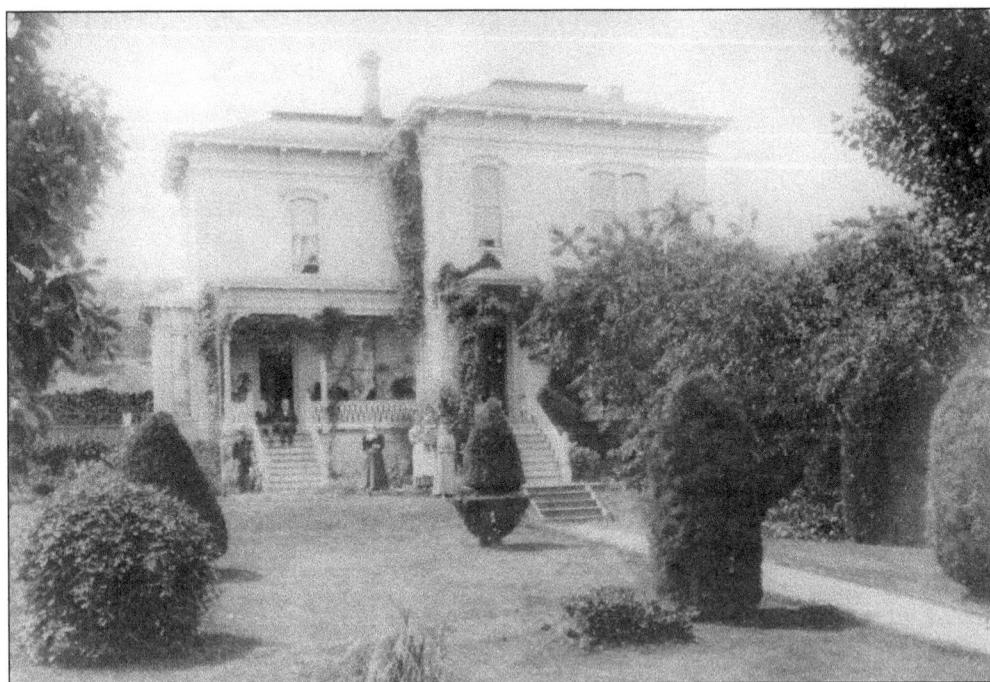

This two-story, Italianate-style house was built in Spring Valley around 1886 by Joshua L. Purvine and his wife, Mary V., one of the five daughters of Walter M. and Jane Walker. (PCHS-SVC.)

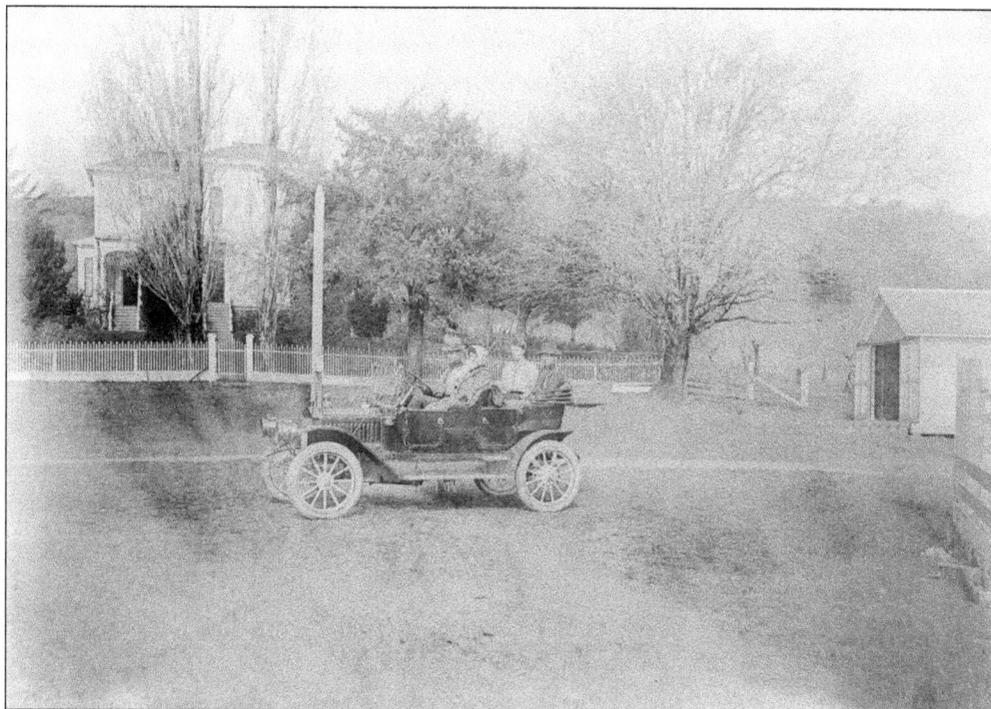

Lynn and Florence Purvine, with an unidentified couple, are photographed driving their new Maxwell motor car in front of their home on Spring Valley Road in 1912. (PCHS.)

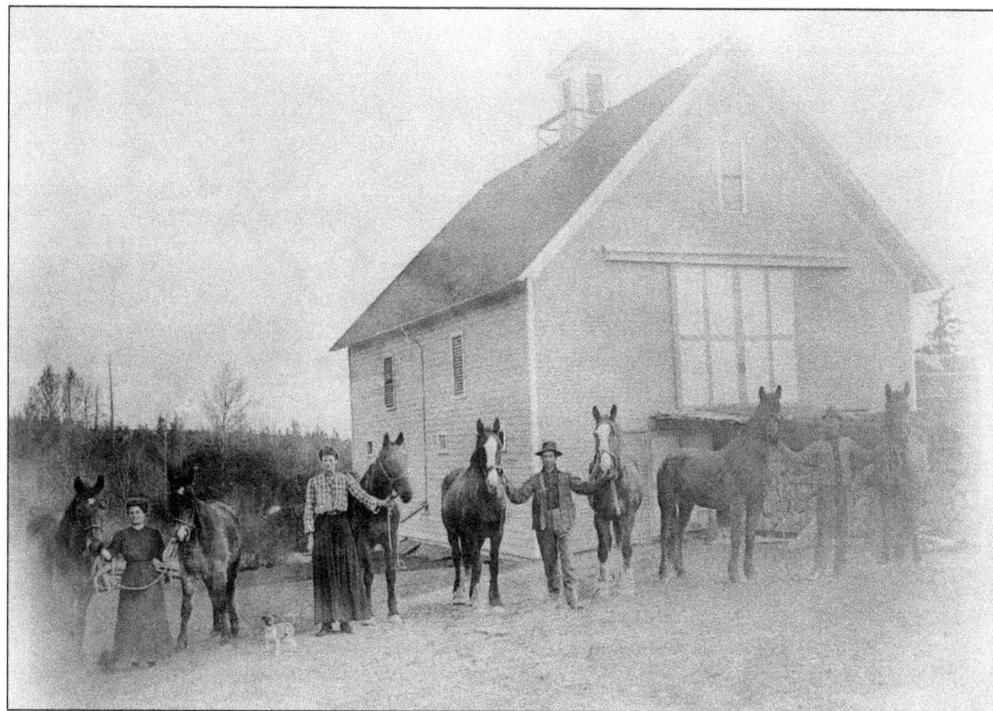

A 1912 photograph of Florence Purvine (far left) and Lynn Purvine (far right) shows them displaying their horses for unidentified friends in front of the family's very well-kept barn. (PCHS.)

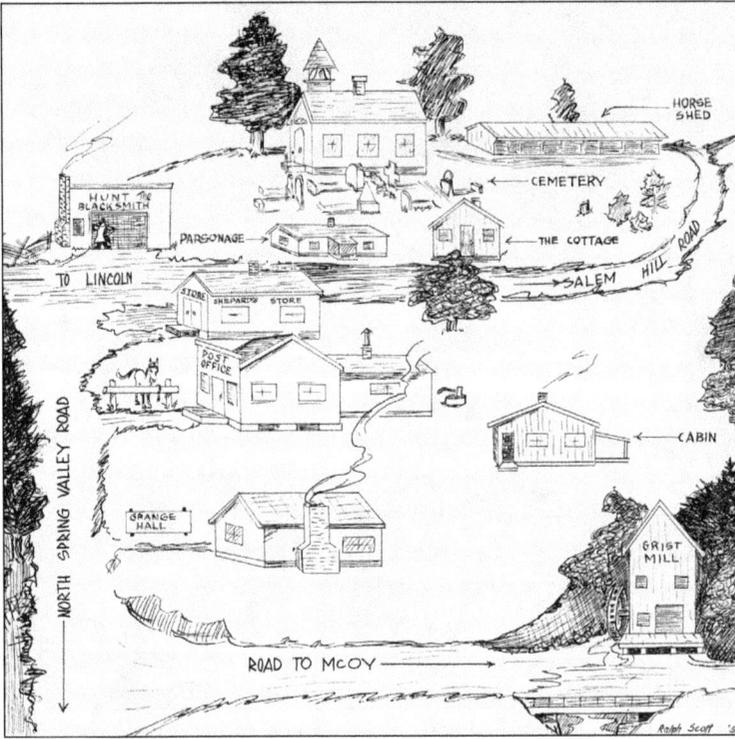

In 1958, longtime Zena resident Ralph Scott sketched what he called "An imaginary picture of Zena Corners, As Remembered By Old Timers," which depicts the 1880–1890s period. The village of Zena was given its name around 1866, when D.J. Cooper and his brother built a store and obtained the post office rights. They coined the name from the last syllables of their wives' names, Arazena and Melzena, who were sisters. (PCHS-SVC-Ralph Scott.)

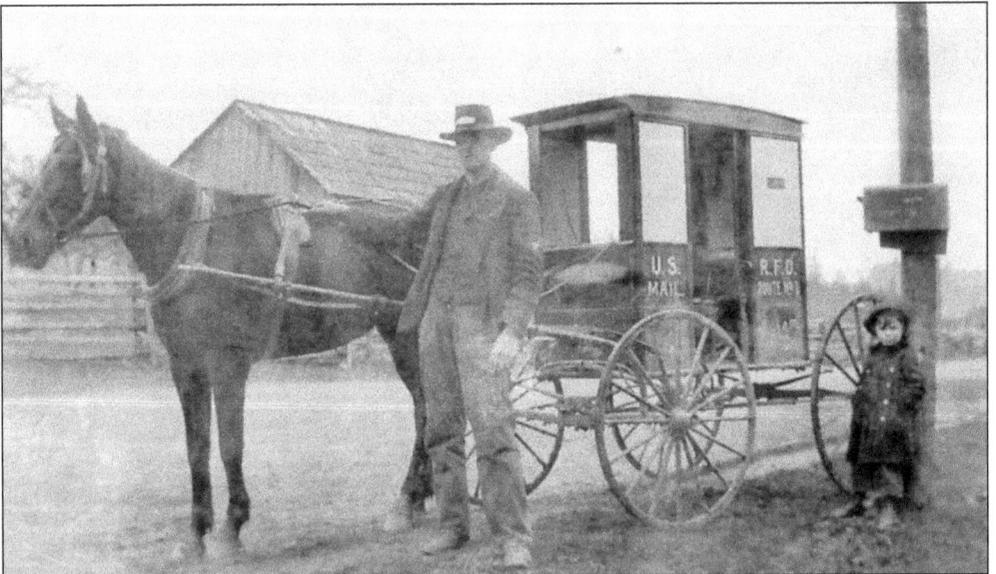

James Remington was the first rural postal carrier on the 26-mile rural route No. 1 out of Salem, beginning in 1901. Remington arrived at Zena around noon every day and usually ate his home-packed lunch under the cover of the large horse shed on the Spring Valley Church grounds before finishing the rest of his route. He was married to Gertrude Purvine, daughter of Andrew J. Purvine of Spring Valley. (PCHS-IM.)

Pictured is a side view of the second Zena School, built around 1913 to replace the earlier school, which had been built years before. The new building included a covered porch and a concrete basement and was located a little north of the first school site. The school closed in 1961, and students were transferred to Brush College Elementary School. (PCHS-SVC.)

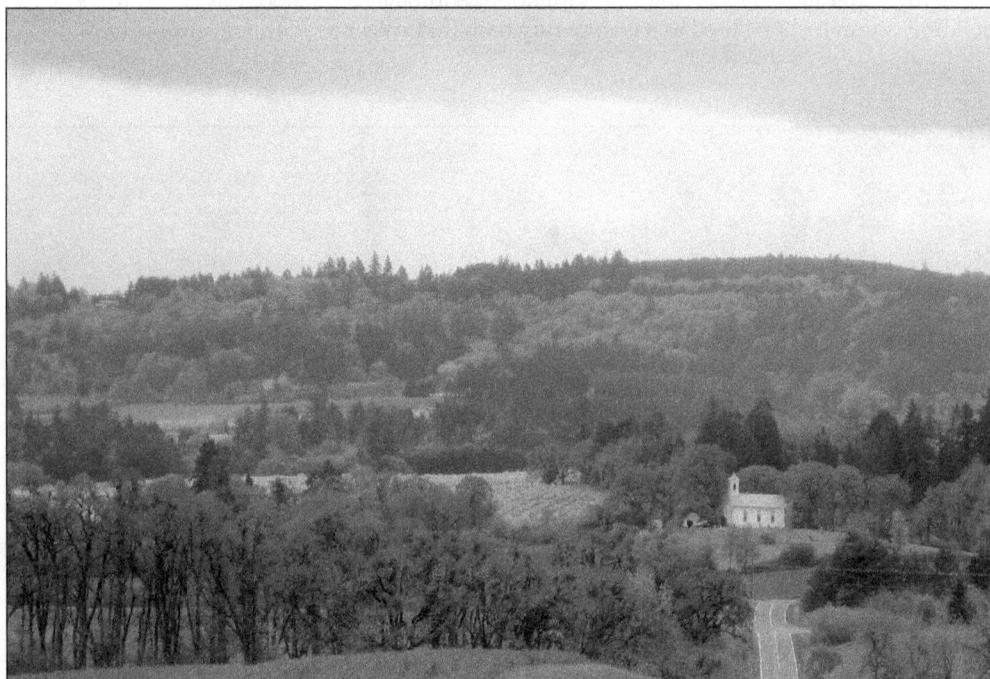

A recent photograph shows the Spring Valley Church at Zena surrounded by the beautiful hills and farmland of the Spring Valley area.

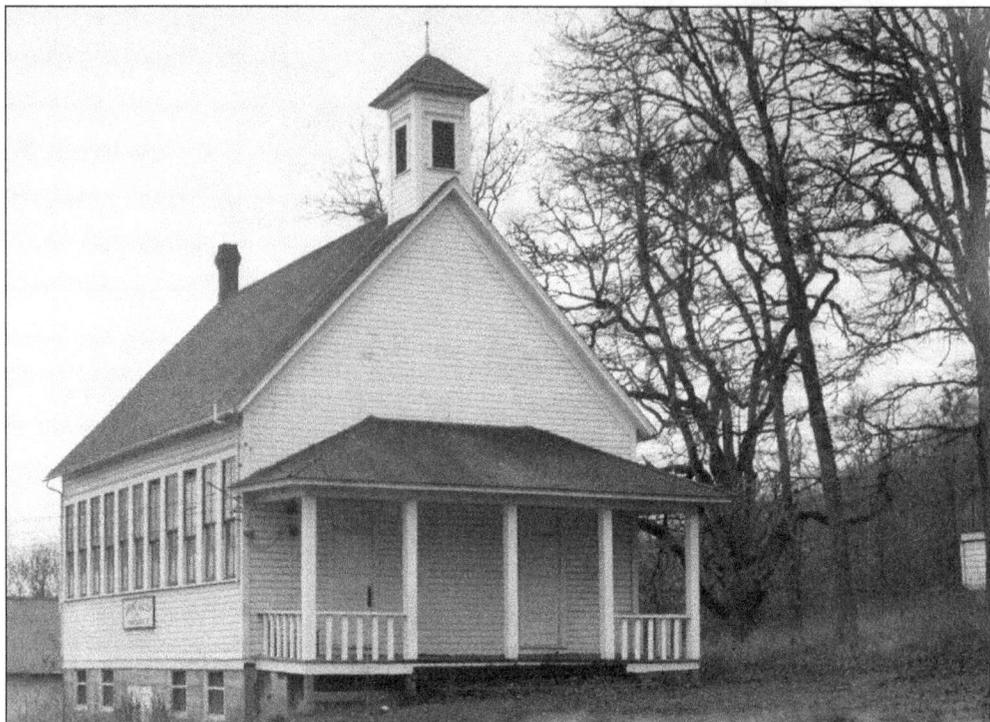

Here is a 1954 photograph of the Spring Valley School, built around 1907 northeast of the village of Zena. The wall of windows, basement, and concrete foundation show the period's emphasis on providing better lighting, heating, and sanitation. Although the school was closed in 1953, the building continues to be used as a community hall. (SPL-BM.)

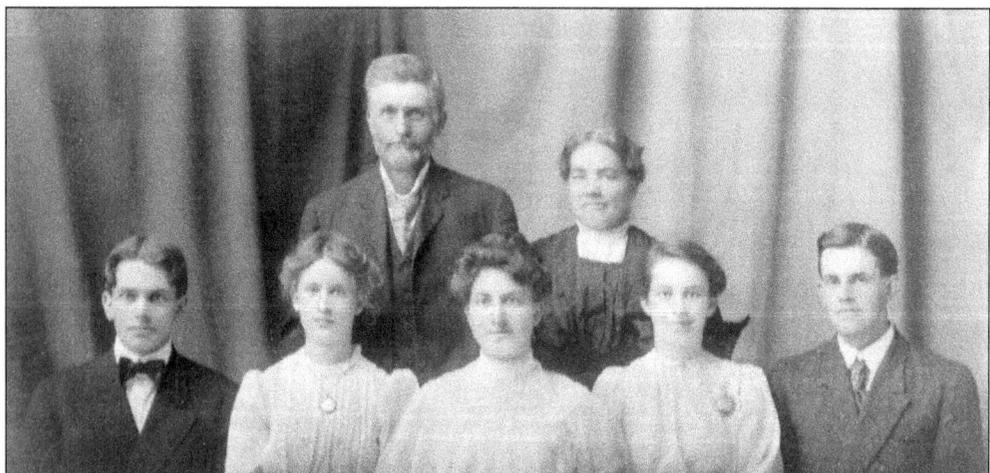

Rev. William J. Crawford was a Baptist minister, later becoming a professor of mathematics at McMinnville Baptist College (now Linfield). Although purchased in 1888, the family didn't reside on the Zena farm until about 1903. Crawford often preached at the Spring Valley Church in Zena on "Baptist Sundays." Shown from left to right are (first row) Philo, Joyce, Stella, Marie, and Frank Crawford; (second row) William J. and Mary B. Crawford. (PCHS.)

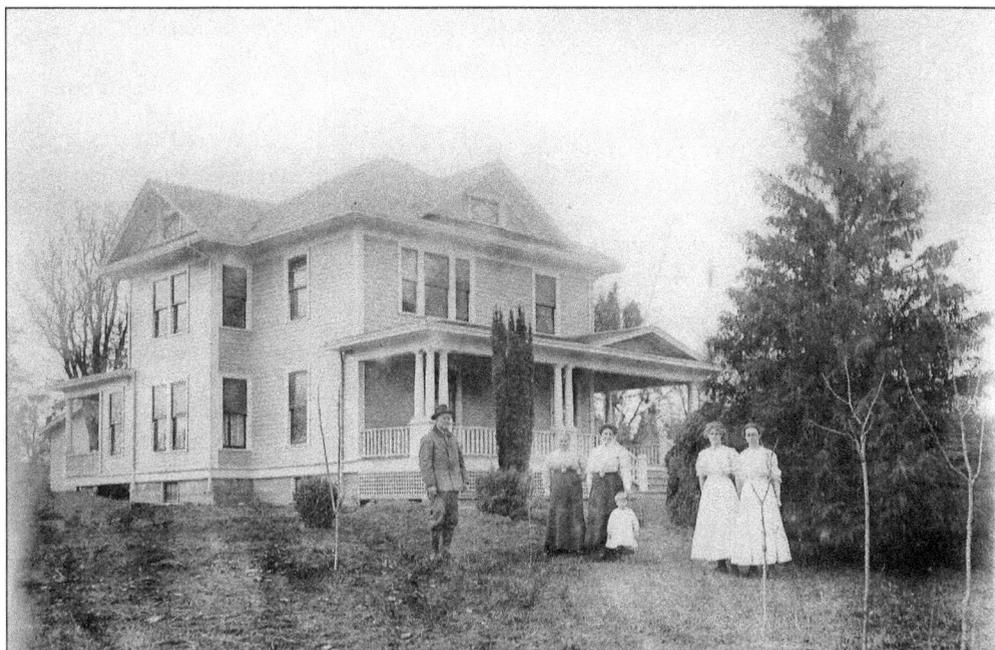

Pictured is the home of Rev. William J. Crawford, built around 1911 just across from Spring Valley Church at Zena. The house still stands today. From left to right are William J., wife Mary B., daughter Mrs. Wayne Henry (Stella Crawford), grandson Kenneth Henry, and daughters Joyce and Marie Crawford. (PCHS.)

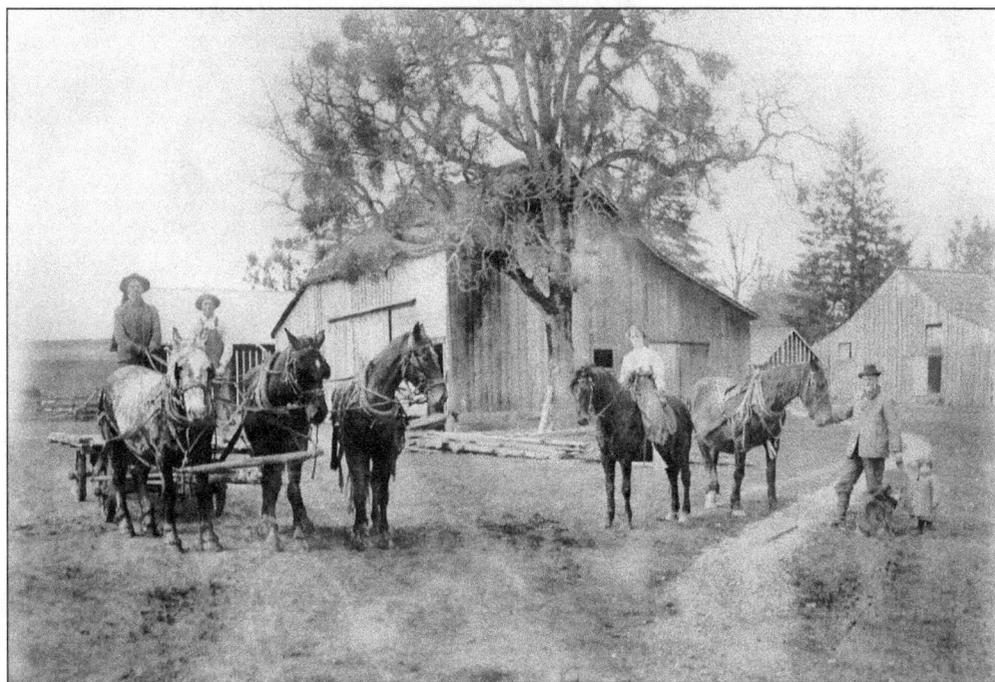

This photograph of Rev. William J. Crawford's barn and yard, taken around 1912, shows two unknown men in a wagon at the left, daughter Joyce Crawford on the pony, Crawford, and grandson Kenneth Henry at the far right. (PCHS.)

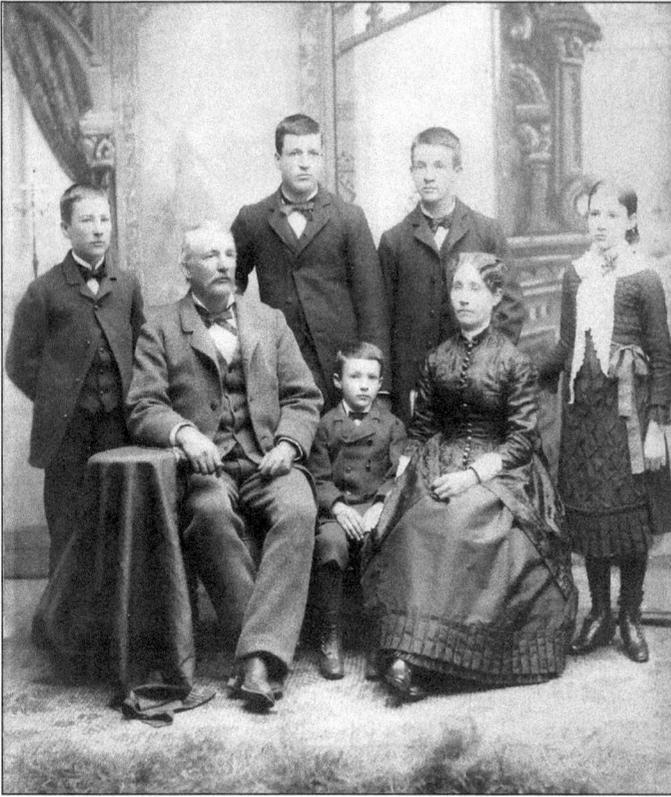

Seen here is the John Phillip Emmett family of Spring Valley around 1883. Standing, from left to right, are Charles, Franklin, Elmer, and Effie. Seated, from left to right, are John, Fred, and Celestine. John was 12 years old when he traveled the Oregon Trail with his family in 1852. Brother James Emmett settled in the Brush College area. (PCHS-JW.)

The 13 children of Jesse D. and Eliza Walling are shown in this photograph around 1893. Walling and his wife, Eliza, came to Oregon in 1847, settling in Spring Valley. In 1860, Walling purchased land and a ferry business from A.J. Doak, who had operated Doaks Ferry across the Willamette River since 1852. Walling renamed the community Lincoln and operated a store there until his accidental death in 1870. (MCHS 2007.001.1475.)

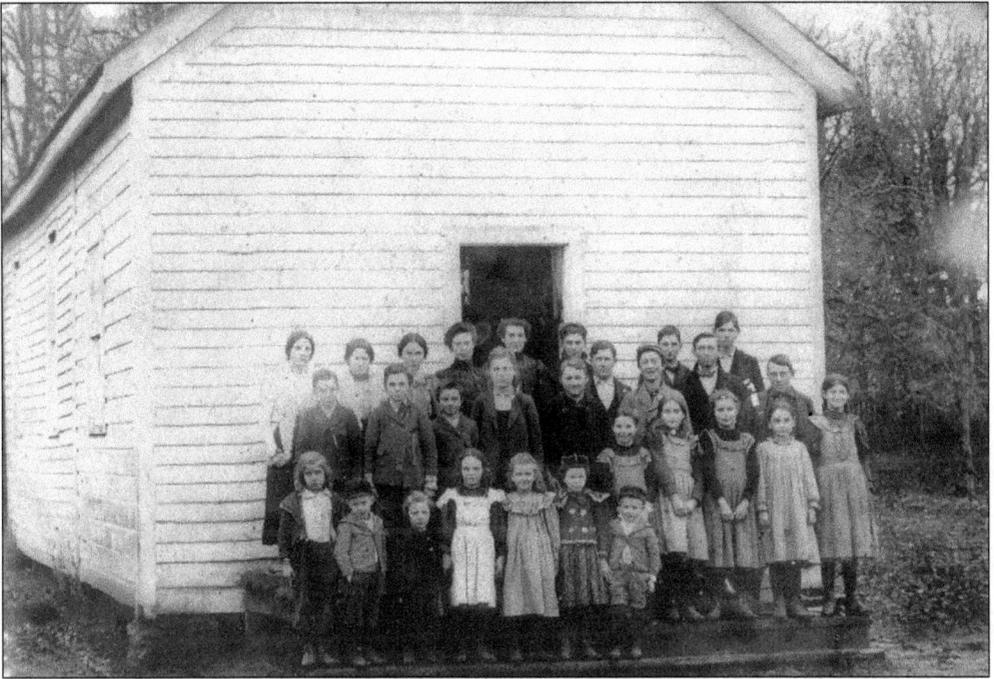

Lincoln School and students are pictured around 1896. Some of the families represented here are Walling, Burger, Spong, Price, Hackett, Eliot, Abrams, Windsor, Penrose, and Boehringer. The teacher is Mrs. Michael. Land for this school was deeded in 1880 by Lewis Abrams. A second school costing $1,200 was built on higher ground around 1911. (PCHS.)

This ferry operated on the Willamette River between the village of Lincoln on the west side and Spong's Landing on the east. The ferry ran from 1852 until its last regular run in 1898, possibly when this photograph was taken. Another ferry begun in the 1850s by Daniel Matheny continues to operate today, albeit as a modern cable version, several miles to the north at the Polk-Yamhill county line. (SPL.)

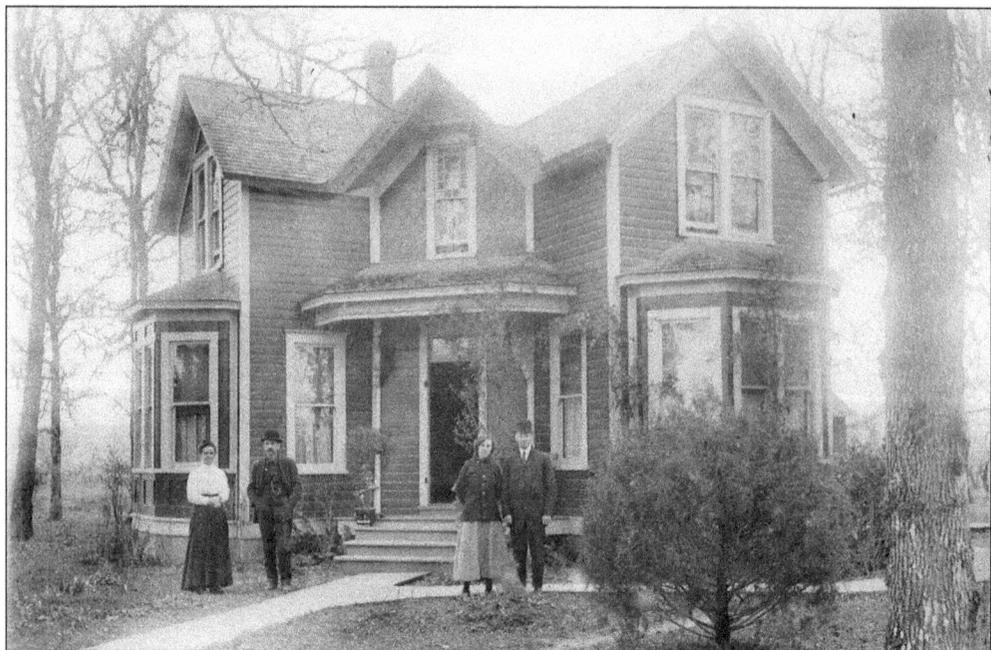

Here is the beautiful two-story home of Jesse D. Walling Jr. and his family in the Lincoln area of Polk County around 1912. The house featured a center entrance with bay windows on at least two sides. Shown in front of their home, from left to right, are wife Cora (neé Loose), Jesse D., and two of their grown children. (PCHS-SVC.)

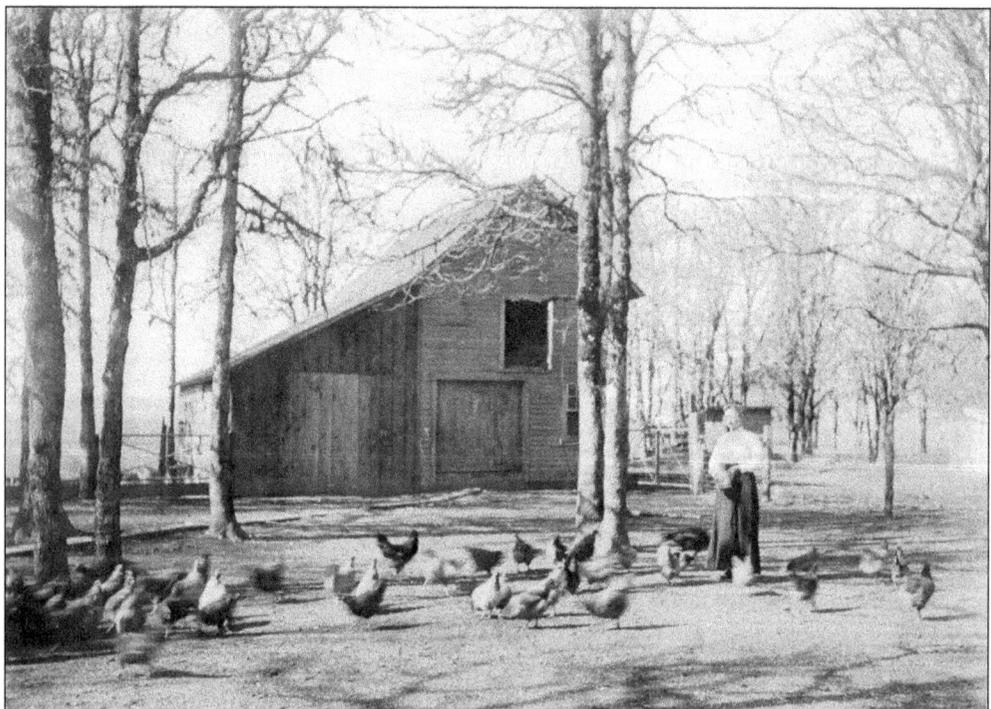

Cora (Loose) Walling, wife of Jesse D. Walling Jr., is photographed feeding chickens in the barnyard of her Lincoln-area home around 1912. (PCHS SVC.)

Three

ORCHARD HEIGHTS AND BRUSH COLLEGE

The rolling hills of the West Salem area became home to many orchards, growing cherries, pears, peaches, and prunes. Both natural and cultivated cane berries grew prolifically. Early families included the Harritts, Hosfords, and Emmetts. These self-sufficient farming families and others would join together to build a school or a church, which would soon become the center of a growing community. Such was the case with Brush College and Popcorn School. In 1860, neighboring families cleared the ever-present brush to make room for a school that became known as Brush College, both for the recalcitrant wild rose brambles and the advanced age of the students who had often delayed their schooling to work on the farms. Around 1873, the area surrounding the Popcorn School became known as Orchard Heights, most likely due to the blossoming trees that blanketed the hills in the spring and early summer.

One of the most visionary community members was Robert S. Wallace, a prominent Salem man who moved his family "across the river" where he planted huge orchards in the Brush College area of West Salem. His work to improve the wagon road leading to his farm earned it the name Wallace's Road (now Highway 221), while providing better access to the many business enterprises he established. He was instrumental in construction of the 1886 bridge across the Willamette River to provide easier transportation of the fruit from his orchards in West Salem to his fruit evaporator and cannery on Twelfth Street in Salem.

Although these communities had unique identities and characters, they often worked cooperatively to realize common goals. They came together to share in the celebration of life events as well as to exercise friendly rivalries for the enjoyment of all.

One of the oldest houses still standing in West Salem is this house on Orchard Heights Road NW. The original portion of the house was built in 1850, with several additions being constructed over the years. Built on the donation land claim of John Martin, the house has been home to many families over the years, including former Oregon governor Robert Straub and his wife, Pat, shown here. (Western Oregon University–Straub Archives.)

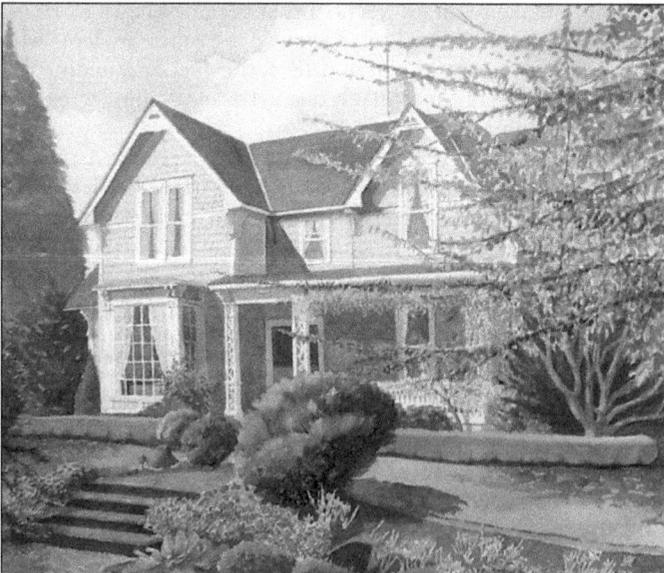

Another historic house still existing in the Orchard Heights area is the beautiful 1870 farmhouse shown in this painting; it has been home to many families, including the Bouffleurs and, most recently, the Lindbecks. The house was extensively remodeled by John and Carolyn Lindbeck, who added the gingerbread trim, a bay window, and other ornamentation. The Lindbecks' orchard and fruit stand were well known here for many years. (PCHS.)

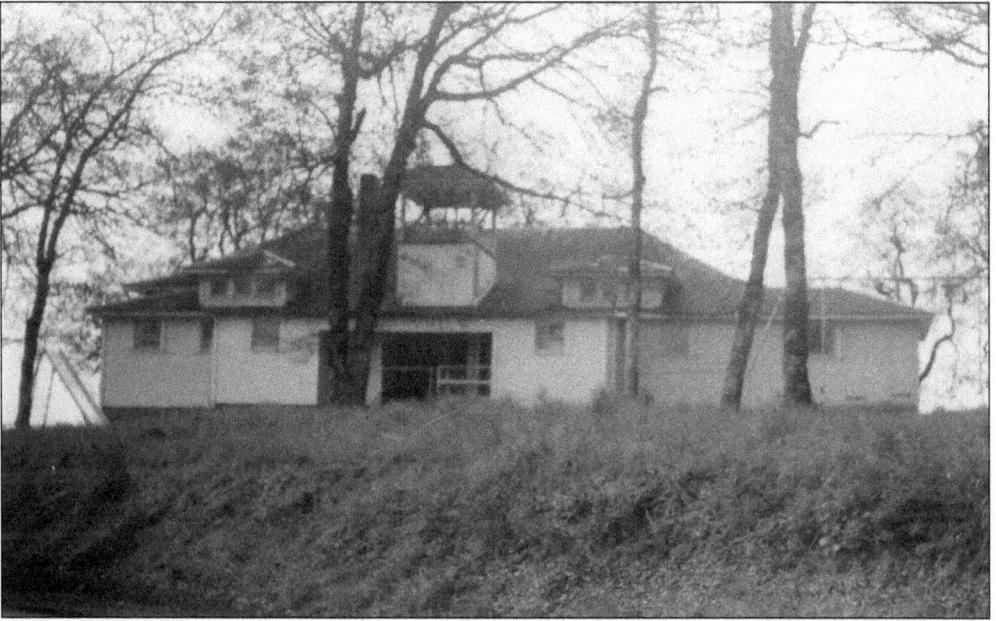

In 1873, Elisha Starbuck donated land and a one-room schoolhouse was built, later replaced by a larger building (above) erected nearby around 1912. The school acquired its name at the end of the first term, when students demanded a treat from teacher Napoleon Nelson. The larger boys carried Nelson, who was of small stature, down to the creek and dunked him until he agreed to provide a treat. Nelson soon brought them popcorn, and the school became known as "Popcorn School." Some community members attempted to rename the school Pleasant Hill, but the change was vetoed. Early members of the Summit Church, shown in the c. 1912 photograph below, met in the old schoolhouse until the church building was completed in 1903 on the same knoll off Orchard Heights Road. The church burned down in the 1960s, and the school burned in 1992. (Both, PCHS.)

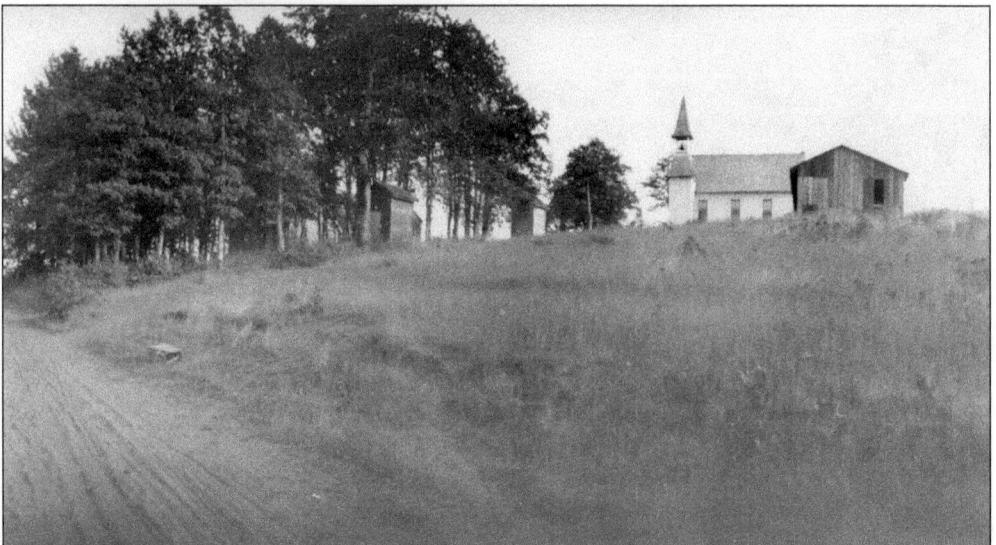

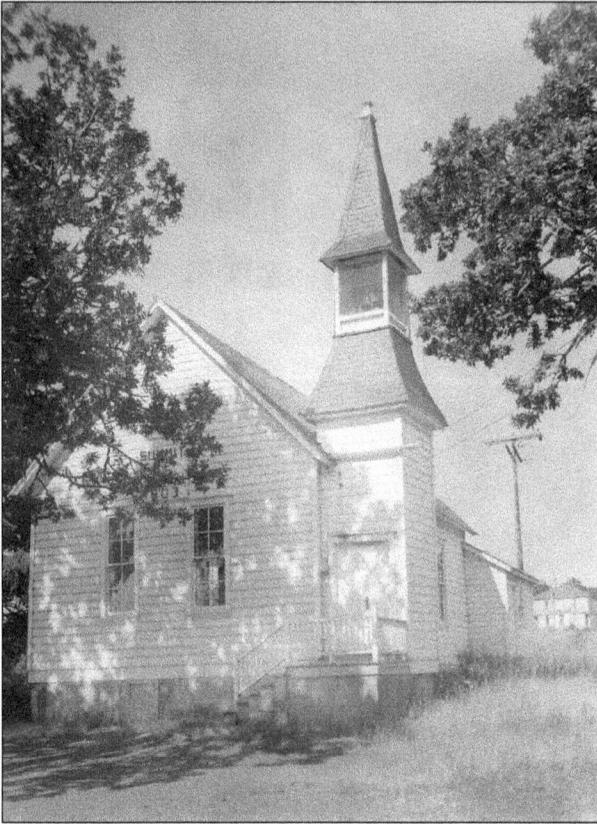

A Methodist congregation was established in 1889 with A.C. Fairchild as minister. They met in the old Popcorn School until the building shown here, Summit Methodist Episcopal Church, was built in 1903. The church was named for its location atop a hill with beautiful views of Salem and the Willamette Valley. The church building held many community events, including the Epworth League. (SPL.)

The Wilson House was built in 1900 on the north side of Orchard Heights Road, not far from the Popcorn School and Summit Church. Pictured around 1912, from left to right, are Mabel, Nettie, Fred, Ralph, Wilfred, and Frank Wilson. Today, the house is owned by Gary and Carole Griesen. (PCHS-Griesen.)

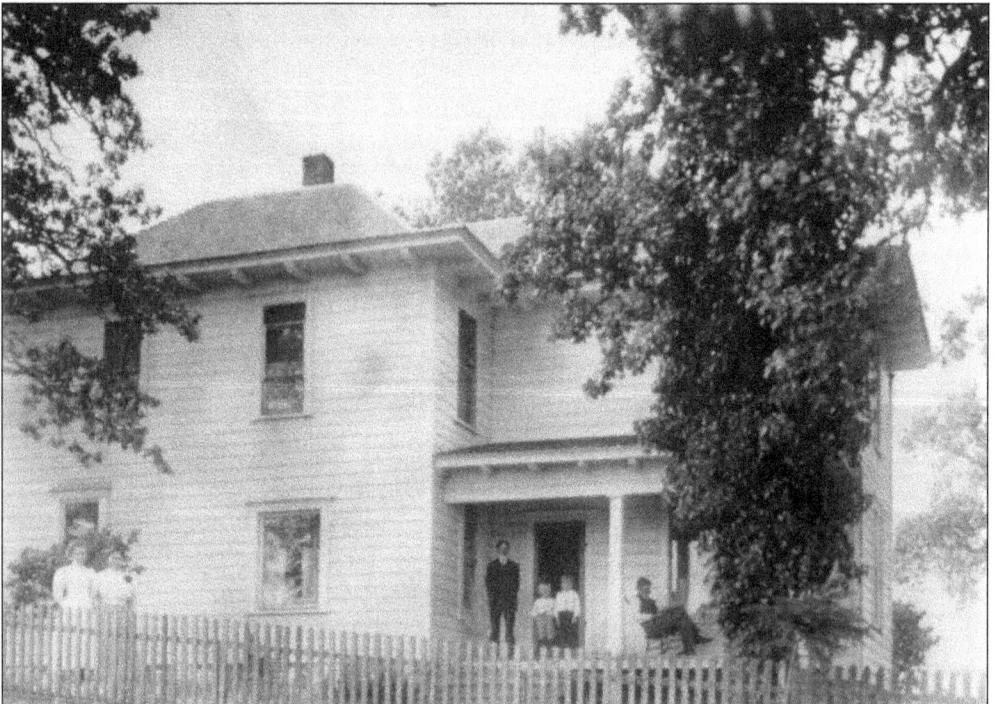

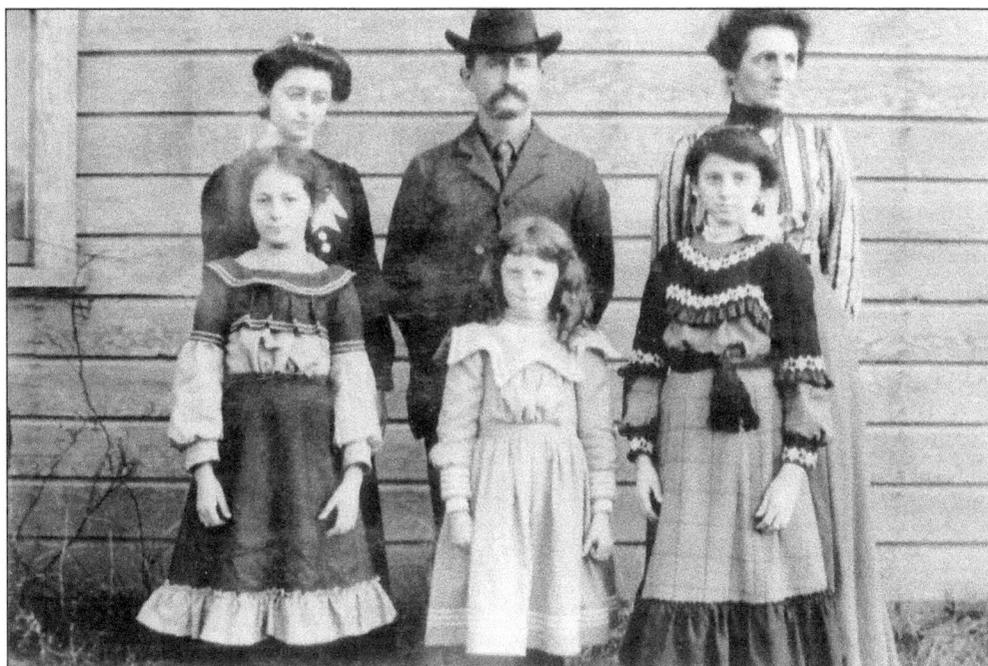

Here is the Andrew Vercler family of Orchard Heights Road. Pictured from left to right are (first row) Winifred, Pearl, and Viola Vercler; (second row) Fannie (May), Andrew, and wife Jessie. Jessie sewed all the girls' clothing by hand. (PCHS-IM.)

The Vercler home was on the north side of Orchard Heights Road, a short distance west of Doaks Ferry Road. Andrew Vercler specialized in growing prunes, which were dried and shipped east. (PCHS-IM.)

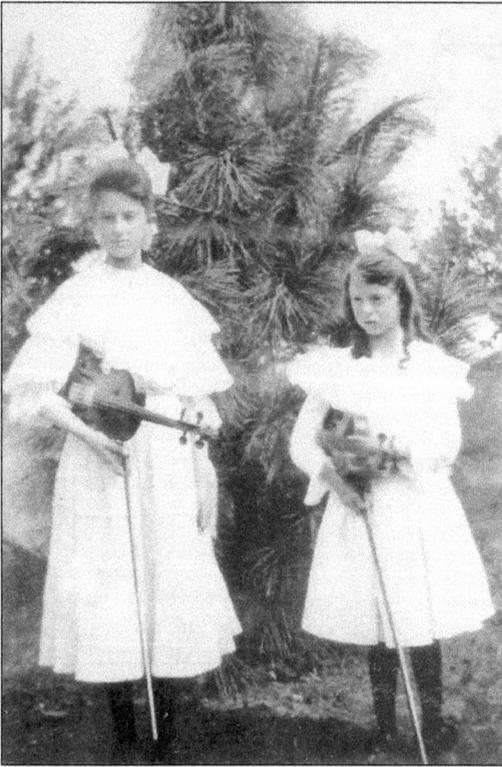

Viola (left) and Pearl Vercler, of Orchard Heights Road, are all dressed up for a violin recital around 1915. Viola was an accomplished musician who later taught piano and violin lessons to local students. (PCHS-IM.)

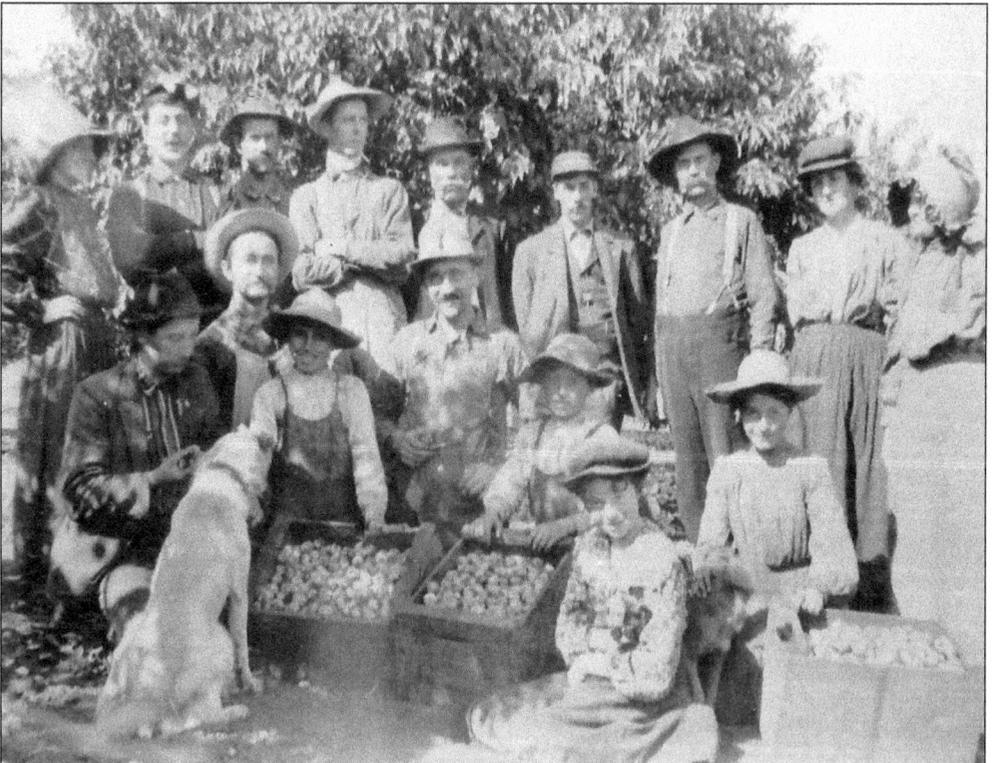

Seen here is the Vercler family and a prune-picking work crew around 1914. From left to right are (first row) Jim Best, Andrew Vercler, Fred Norwood, unidentified, Howard Norwood, Pearl Vercler, and Winnie Vercler; (second row) Viola Vercler, Guy McDowell, R.L. Stradley, Lee Gibson, Will Daley, Dick Pearce, unidentified, Jessie Vercler, and unidentified. (PCHS-IM.)

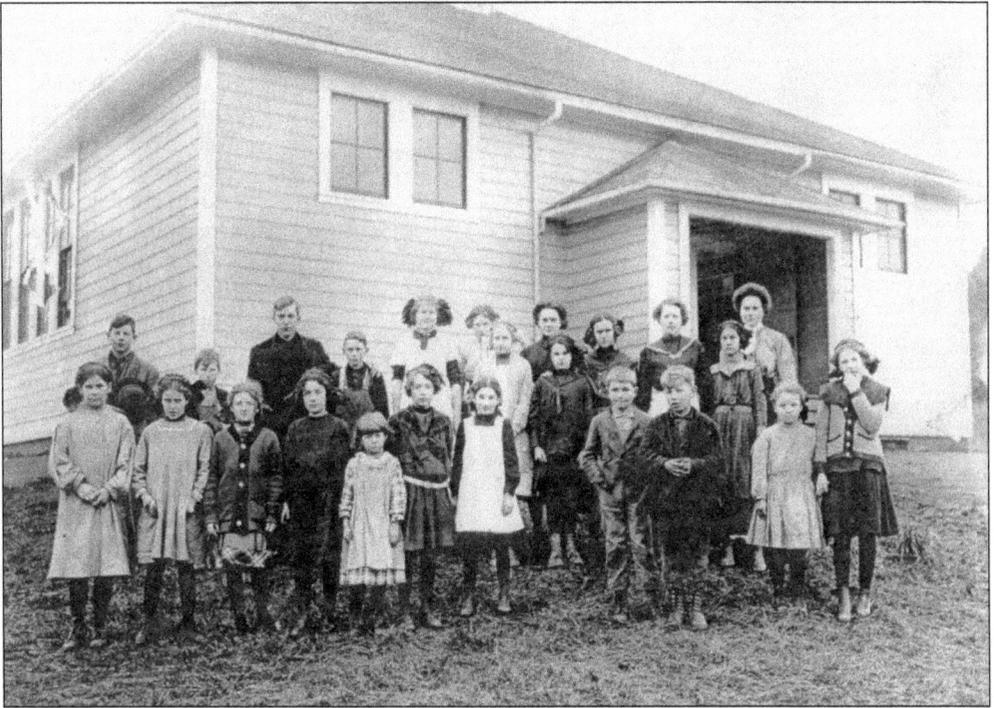

Mountain View School opened on Orchard Heights Road in 1905 with May Vercler as the first teacher. Shown here, in no order, are the students of the 1911–1912 school year: George Lewis, Leo Drake, Charlotte Cain, Ethyl Finley, Rose Adams, Esther Bailey, Marian Fox, Venard Moore, Ammon Grice, Rita Finley, Mildred Imlah, Nora Olsen, Flora Grice, Flora Lewis, Nettie Norwood, Jean Bailey, Blanche Gibson, Etta Cannoy, Lester Savage, Vera Southwick, John Lewis, Marian Miller, Helen Fields, and Myrtle Lewis. (PCHS.)

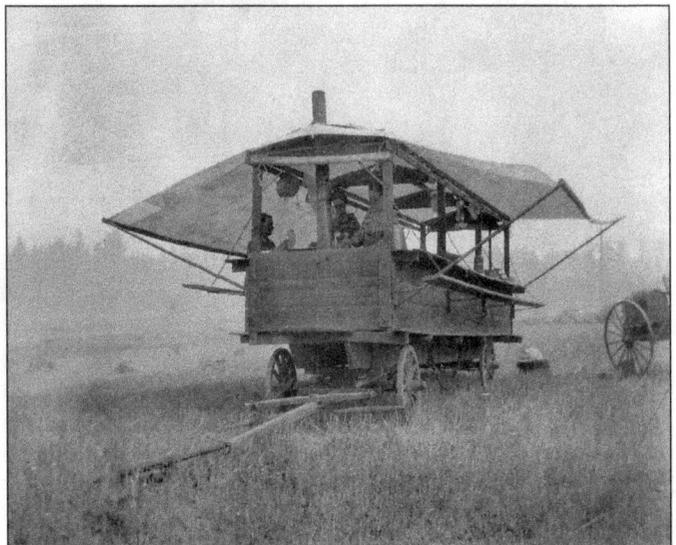

The Grice family of Orchard Heights Road owned Grice's Cook Shack. The cookshack, staffed by local women hired to cook hearty meals, followed threshing crews from farm to farm. The cookshack sported a tent covering for shade, with each side of the wagon having a lower rail for feet, a middle rail for seating, and a top rail as the tabletop. Grice's Cook Shack became well known throughout the local communities during the harvest season. (PCHS-IM.)

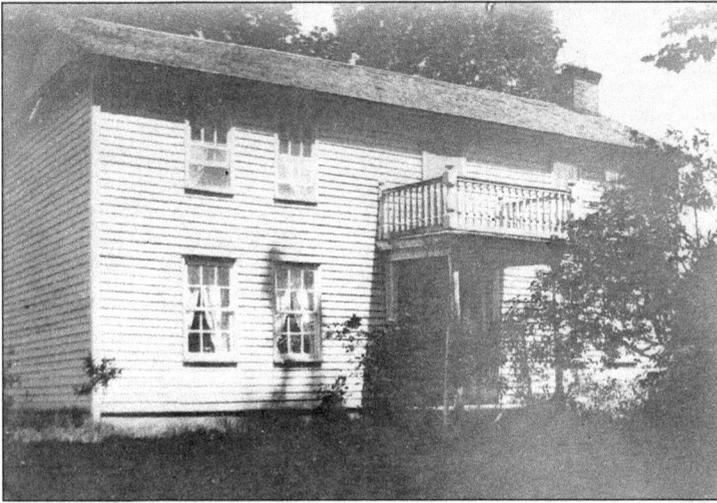

The Harritt house, built in 1858, is one of the oldest homes still in use in the West Salem area. The Reverend Jesse Harritt came to Oregon in 1845 and was a minister of the United Brethren Church and a leader in the community. A school built in West Salem in 2003 was named Harritt Elementary School in his honor. (PCHS-IM.)

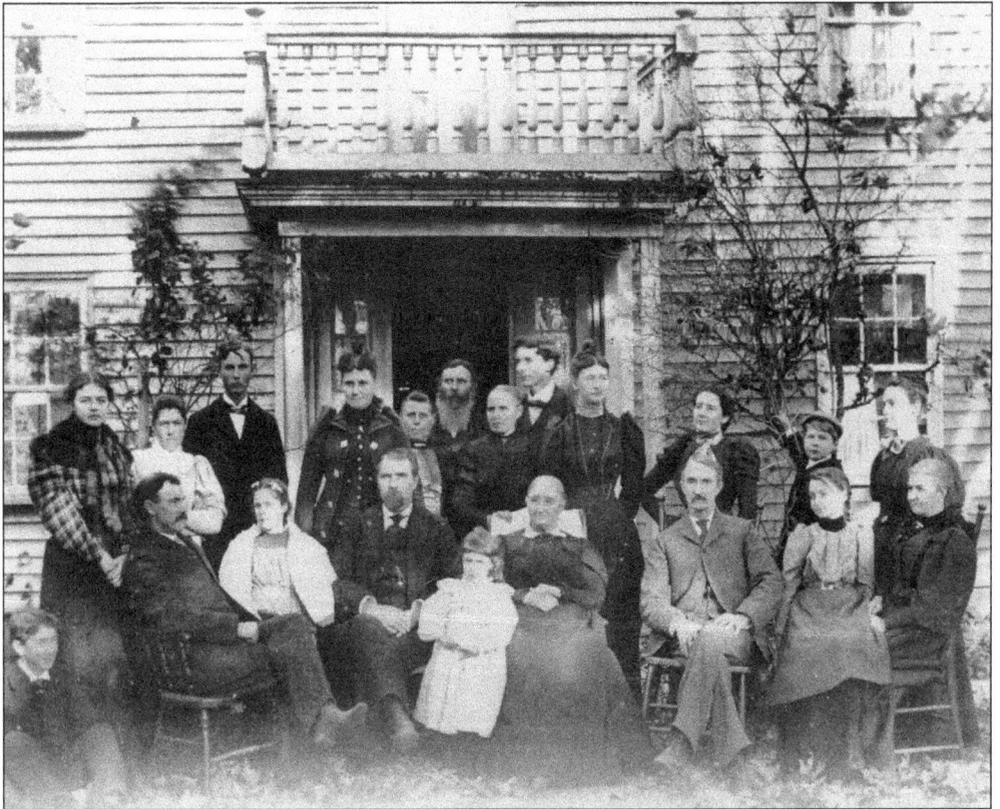

This is a portrait of the Jesse and Julia Harritt family, taken around 1897, several years after the death of Jesse. Julia is seated at the center with her hands in her lap. The family was active in the early Brush College community. A Harritt family member later donated the land for the Brush College Park. (PCHS-IM.)

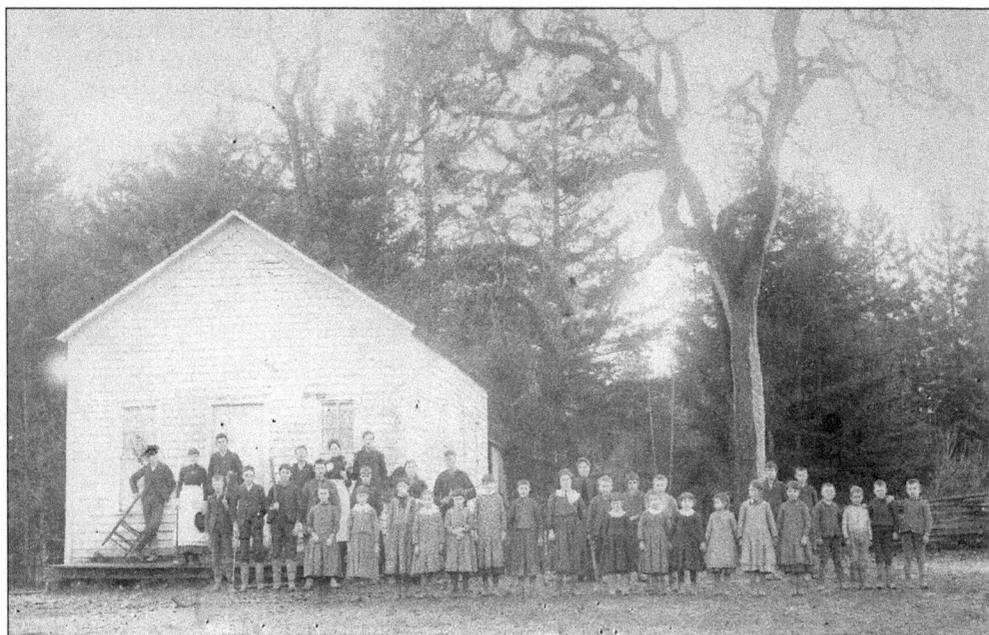

In the earliest days of the area, school was conducted in log cabins or homes. In 1860, this 25-by-30-foot schoolhouse was built for the growing community. Historic accounts indicate that the school was named Brush College for its location among thick brush and trees and because some of the original students were of an advanced age, often due to the farm work that took precedence over attending school. Both photographs were taken on the same day around 1889. In the photograph below, Bertha Emmett, daughter of James and Alice (Harritt) Emmett, is in second row, second from left. (Both, PCHS.)

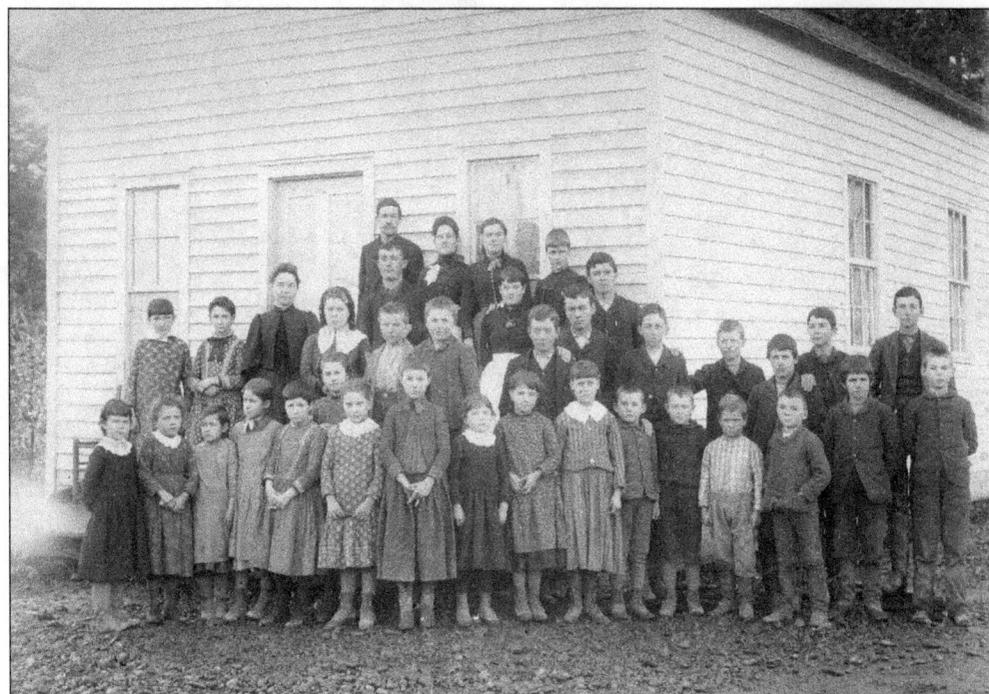

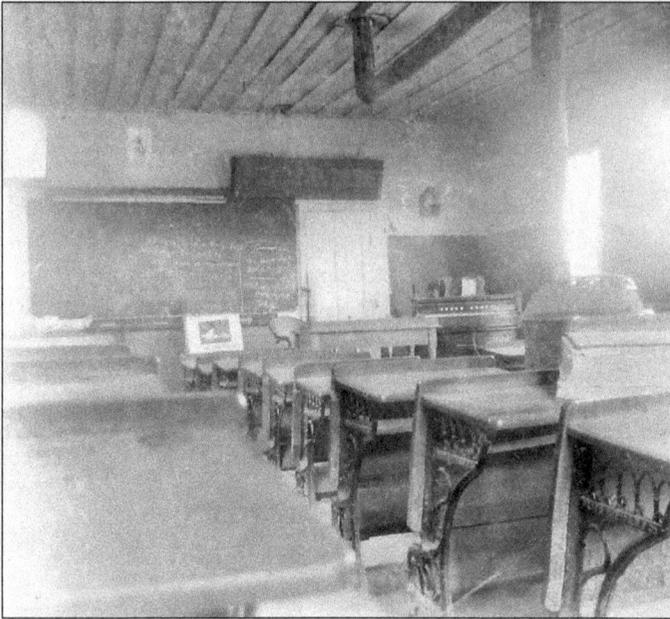

Here is an interior view of the Brush College schoolhouse facing the teacher's desk and chalkboard. Although the photograph is undated, it was definitely taken before 1909. (PCHS-IM.)

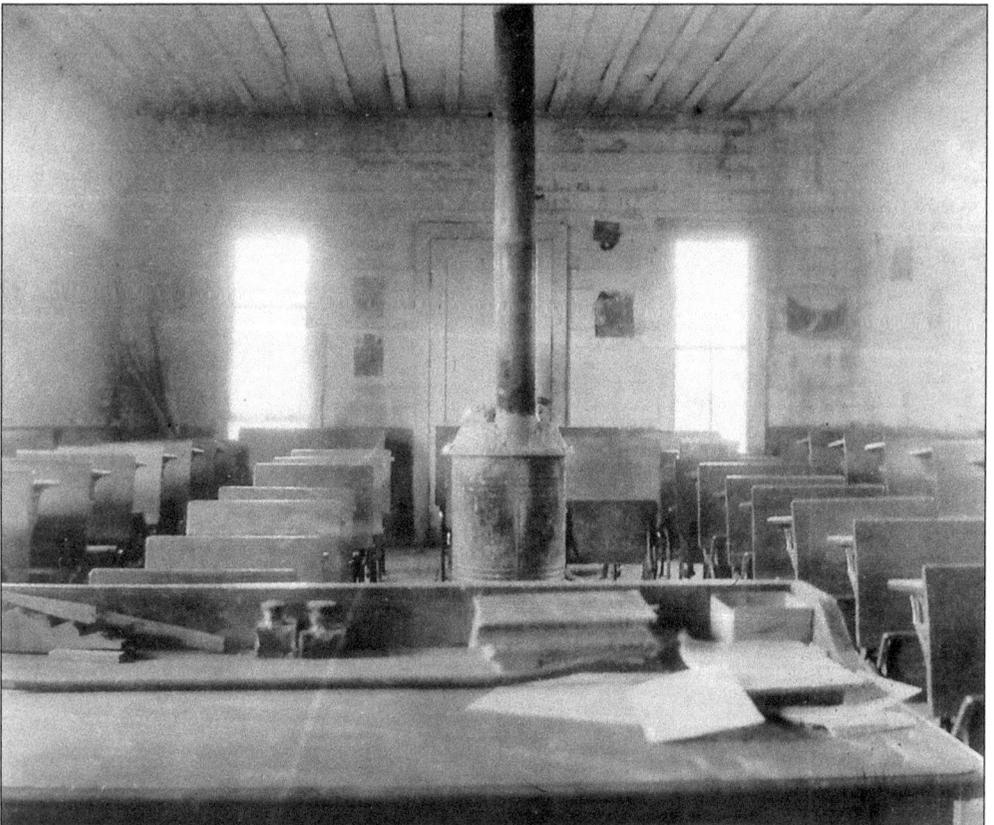

This is another view of the interior of the Brush College schoolhouse, facing the front door. Note the ink jars on the teacher's desk in the foreground and the wood-burning stove in the center of room. Although this photograph is also undated, the date is before 1909. (PCHS-IM.)

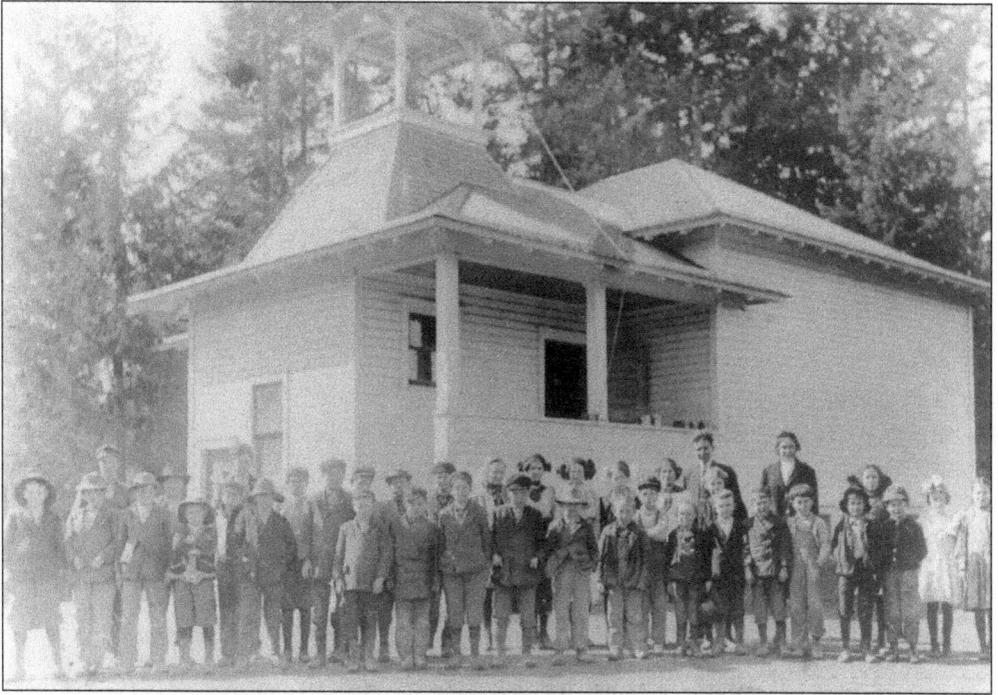

Students and their teacher are outside the second Brush College school building. This schoolhouse was built in 1909 just east of the old school building, which was later torn down. (PCHS.)

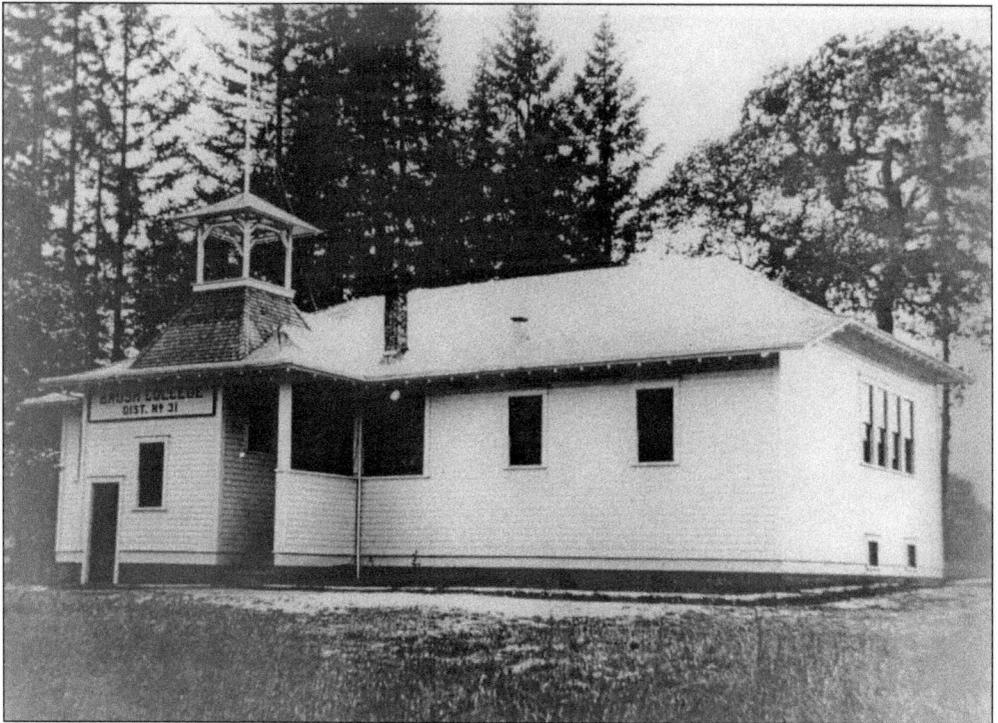

An addition including another classroom and a basement was added to the north side of the school in 1912. This section of the school still exists today. (PCHS.)

Pictured is a c. 1912 view of Brush College Road heading west from the intersection of Doaks Ferry Road. To the left of the road, Frank Olsen can be seen cultivating his berry field. (PCHS-IM.)

James and Alice Emmett built this Italianate-style house on Brush College Road beginning around 1875. Alice was the daughter of Jesse and Julia Harritt and was born on their nearby donation land claim in 1851. James was about 10 years old when he traveled over the Oregon Trail with his family in 1852. He was the son of Daniel Emmett and the brother of John P. Emmett of Spring Valley. (PCHS-IM.)

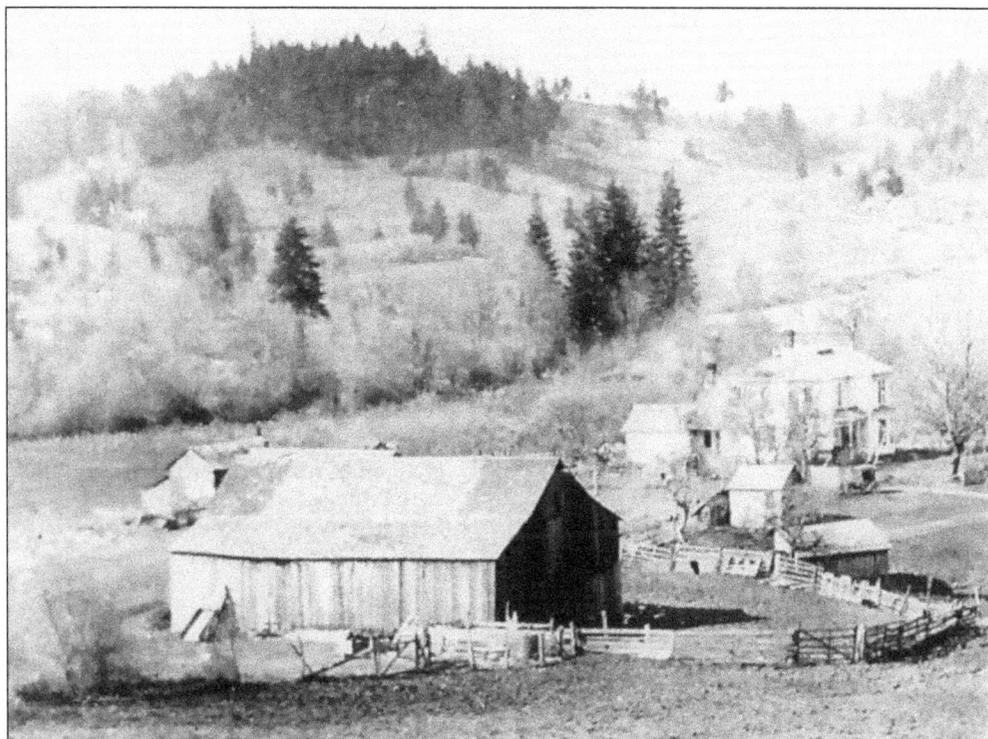

Here is another view of the James and Alice Emmett house and farm. The house, which lies on the south side of Brush College Road, has been home to several families over the years and today is home to the Meyers family. (PCHS-IM.)

In this photograph is an early-1900s view of Doaks Ferry Road looking south from its intersection with Brush College Road. Ferns and greenery still grow freely at this corner. (PCHS-IM.)

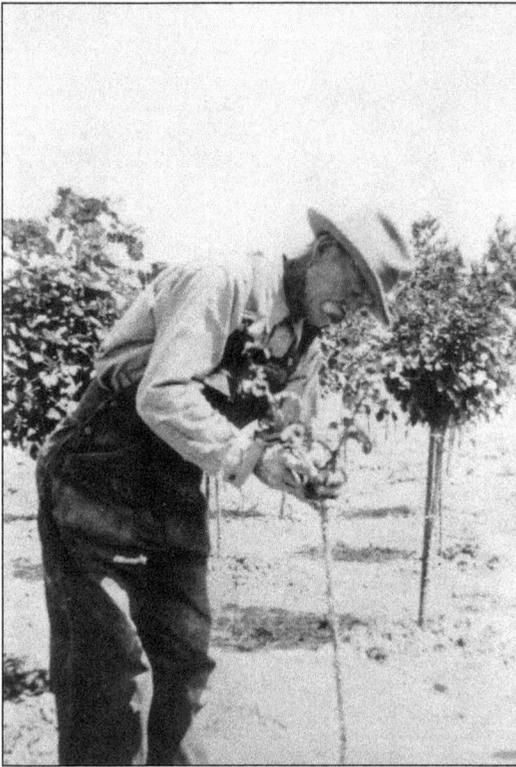

Ferdinand Singer was a farmer who also worked at the Wallace Farm spraying and pruning fruit trees. Shown at left working with his specialty roses, Singer had a great love for growing things. In the late 1920s, Ferdinand and his wife, Antonia, opened Singer's Tree Rose Gardens at their farm, which was located at the intersection of Michigan City Lane and Wallace Road. There, tree roses could be viewed and purchased. Their rose gardens were a showplace and brought in people from near and far. Antonia (Bayer) looks at a tree rose in the photograph below. The Singers are the grandparents of Irene (Cutler) Maynard, a longtime Brush College resident and historian. (Both, PCHS-IM.)

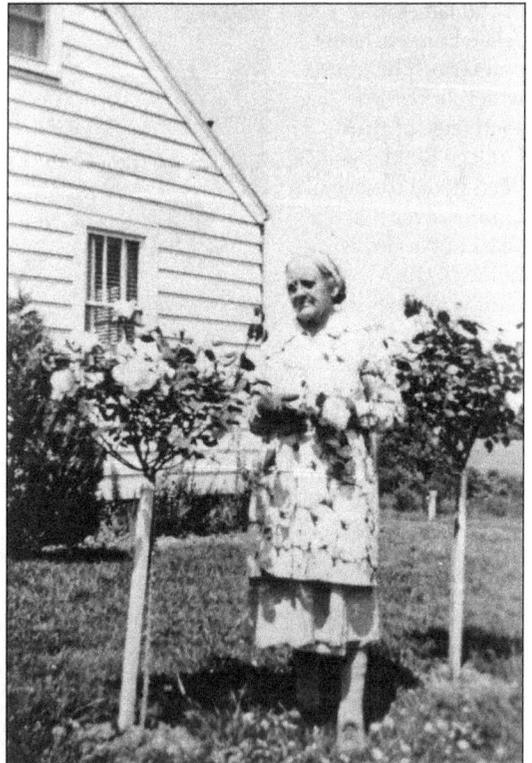

Robert S. Wallace met his wife, Nancy (below), while they were both students at Monmouth College in Illinois, where Nancy's father was a professor and Wallace's brother David was the school's president. In 1867, Nancy and 11 other women founded Pi Beta Phi, the first national secret college society of women to be modeled after the Greek-letter fraternities of men. As a young, successful businessman, Wallace moved his family, including sons Robert "Lee" and Paul, from Chicago to Salem in 1885. Almost immediately, he became involved in Salem's business community, including founding the Capital National Bank, running the Salem Water Company, building the first cannery in Salem, and rallying support to get the first, then the second, Big Bridge built between Polk County and Salem. He was also a candidate for state representative of Polk County in 1890. (Both, PCHS-WC.)

In addition to his business interests in Salem, Robert S. Wallace purchased more than 300 acres of farmland in Polk County for the purpose of planting fruit orchards. This photograph shows the main gate to the farm, which was located a few miles north of Salem along the old wagon road between the bridge and the town of Lincoln. The farm is now home to Salemtowne, a retirement community. (PCHS-WC.)

In 1889, Robert S. Wallace built a summerhouse on the farm that soon became the family's year-round home. This home and farm he named The Willows. The orchard soon became one of the largest in the Willamette Valley. The farmhouse still remains and is used as the clubhouse for the Salemtowne community. (PCHS-WC.)

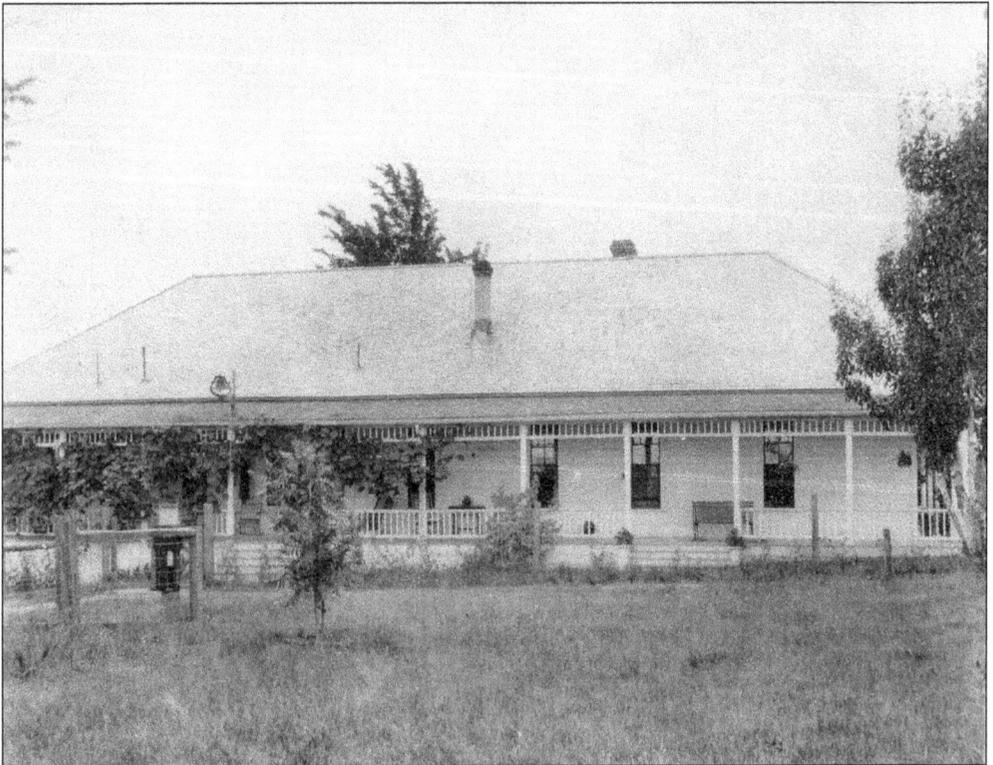

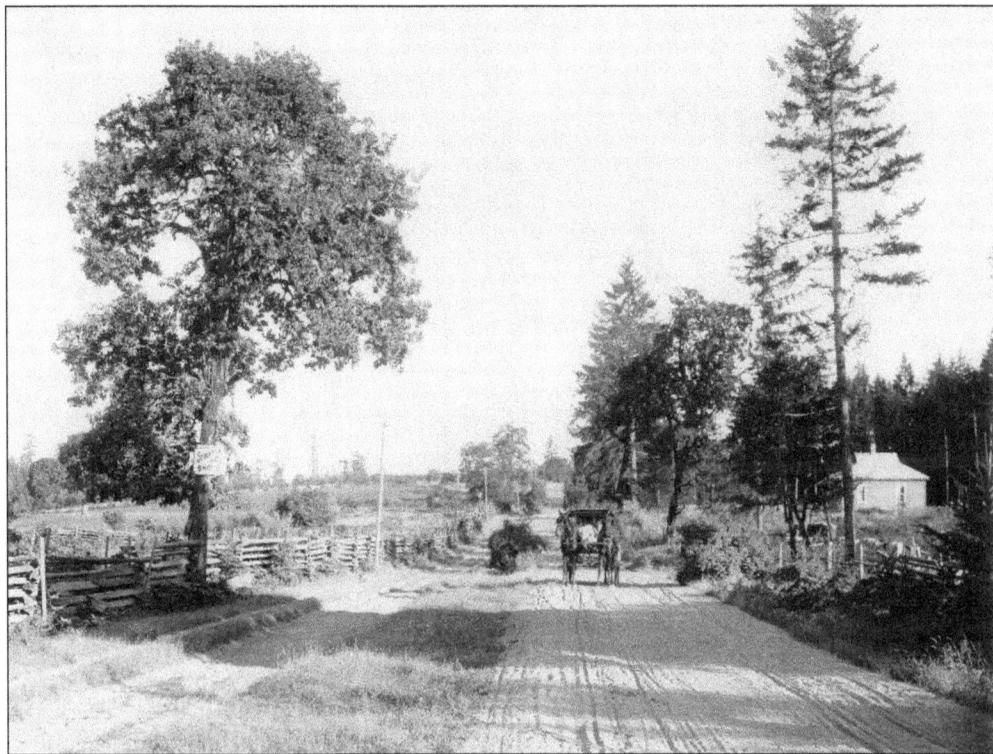

In 1889, in order to make travel easier between Salem and his farm in Polk County, Wallace graded and graveled a large stretch of the old county road from Salem to Lincoln at his own expense. This photograph shows a carriage traveling north from Salem on a section of Wallace Road around 1908. (PCHS-WC.)

The improved road began at the Polk County side of the Big Bridge and ended at the bottom of the Wallace Farm. The road soon became known as "Wallace's Road" or "the Wallace Road." This is a photograph of Wallace Road looking southeast toward Salem. Rev. Jesse Harritt's house is just out of the picture to the left. (PCHS-IM.)

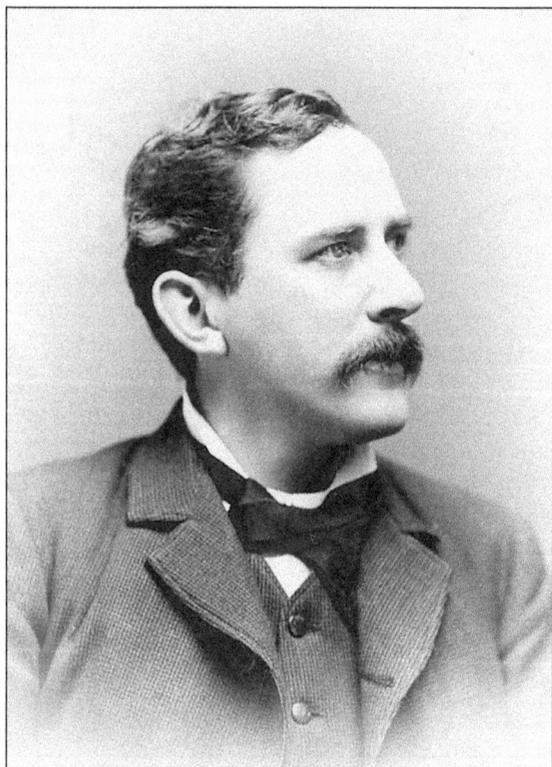

In October 1891, Robert S. Wallace (left) died unexpectedly at 42 after a short illness. Both Polk and Marion County citizens turned out in large numbers to honor his memory during what the *Oregon Statesman* reported was "perhaps the largest funeral procession that ever passed through Salem's streets." It was Robert's wish that the work he began continue. His brother John M. Wallace, 20 years his senior and a bank president in Colorado, took over management of Robert's vast estate, including the farm, the Salem Water Company, and the Wallace Cannery. John faithfully executed Wallace's mandate until his own death in Salem in 1901, at which time John's daughter Mary and her husband, Charles A. Park, took over operation of the estate and businesses. The Parks resided on the farm for many years and were active in the Brush College community. (Both, PCHS-WC.)

In addition to his widow, Nancy Wallace, Robert S. Wallace was survived by two children, Paul Black Wallace, born in Chicago in 1879, and Ruth Lee Wallace, who was born in Salem in 1887. This photograph was taken in 1895, when Paul was 16 and Ruth was eight. (PCHS-WC.)

The Wallaces' eldest son, Robert "Lee" Wallace, drowned in Salem's Mill Creek while fishing in April 1886, less than a year after the Wallaces arrived in Salem. He was 11 years old at the time of his death. This photograph was taken in Chicago several years earlier, before the family moved west. (PCHS-WC.)

The Wallace farm was like a small community in itself, with several workers and their families residing in houses scattered around the property. In addition to the orchards and other crops grown on the farm, the Wallaces raised horses, cattle, hogs, sheep, chickens, and other livestock. This large packinghouse was located on the farm and was used by workers when it was time to pack the harvested fruit. (PCHS-WC.)

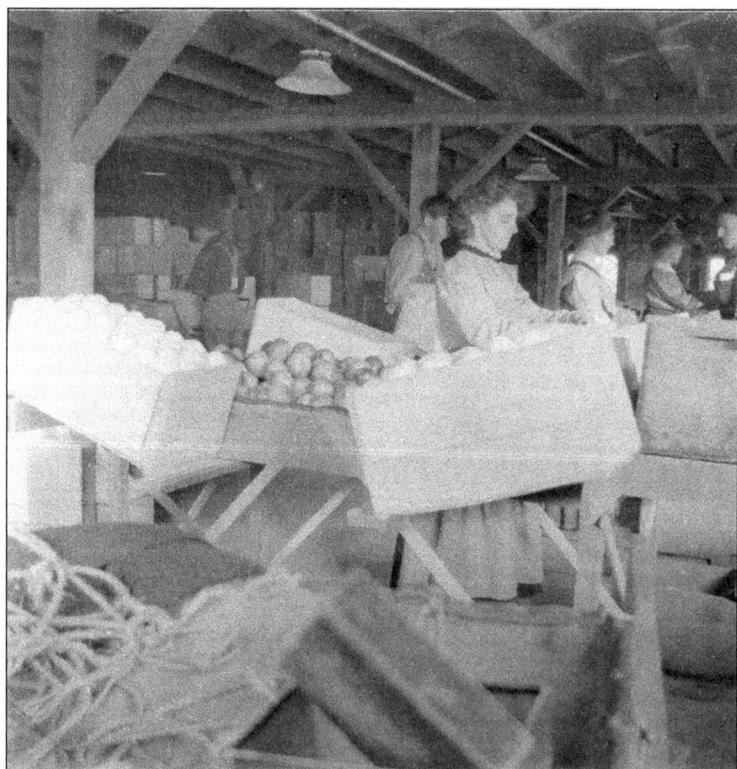

During harvest time, the residents of the farm, along with other hired workers coming from miles around, worked in the packinghouse "fancy packing" the fruit. This consisted of washing and drying the fruit, then individually wrapping each piece in tissue before placing it in the box. (PCHS-IM.)

After being washed and wrapped, the fruit was carefully packed into labeled wooden boxes for shipping. Although the farm specialized in pears (mainly the Bartlett variety), other fruits were grown as well. This photograph shows wooden crates stacked for the next shipment of Spitzenberg apples, the main type of apples grown on the farm. (PCHS-IM.)

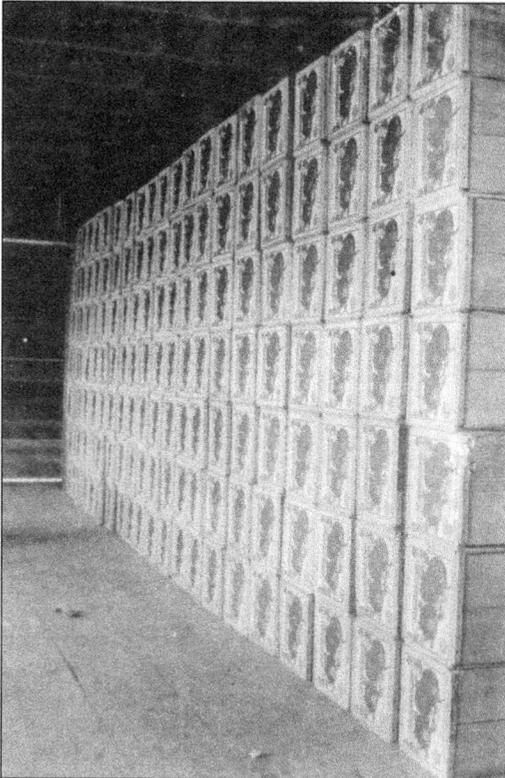

The fruit-filled boxes were taken by wagon to the Wallaces' warehouse in Salem, where they would wait to be loaded onto the next available railroad car. Most of the fruit was transported to cities in the East, but Wallace fruit was even shipped as far as London, England. In this photograph, Elmer Smith is driving one of the Wallaces' teams. (PCHS-IM.)

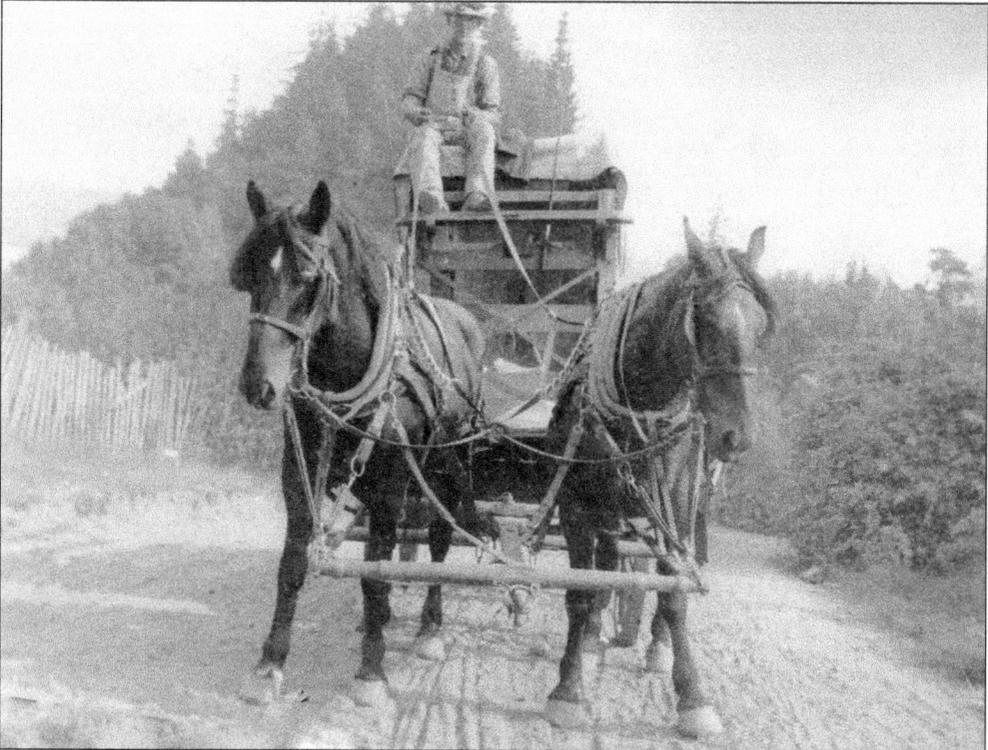

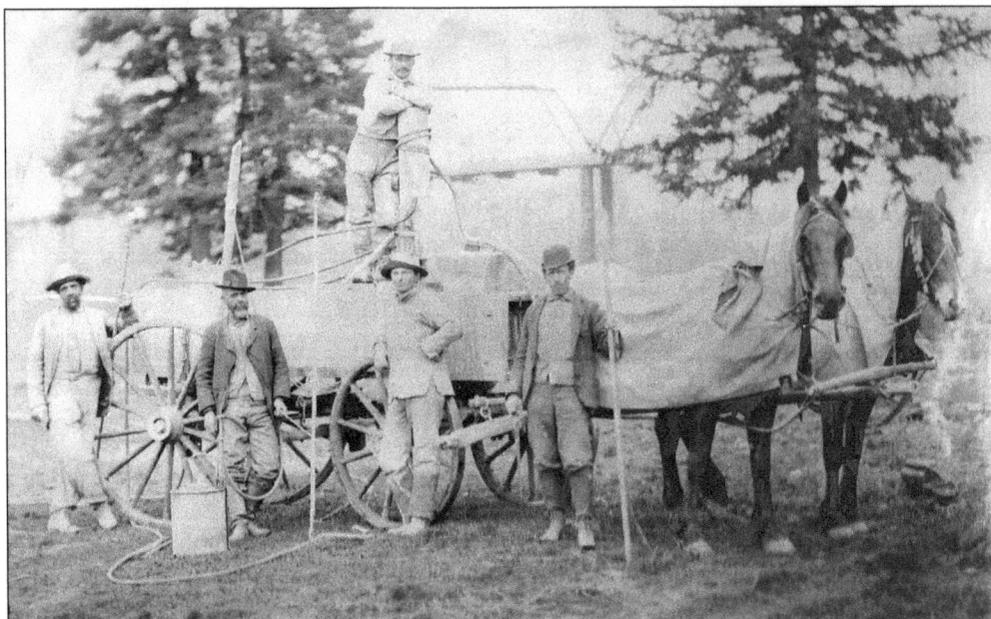

This photograph shows one of the Wallace orchard spraying crews with the second Big Bridge (built 1890–1891) in the background. The dreaded codling moth was only one of the pests fruit growers had to battle. Different mixtures of chemicals were continually being concocted to combat various pests and diseases. Here, the horses are covered to keep the spray from irritating their skin. (PCHS-WC.)

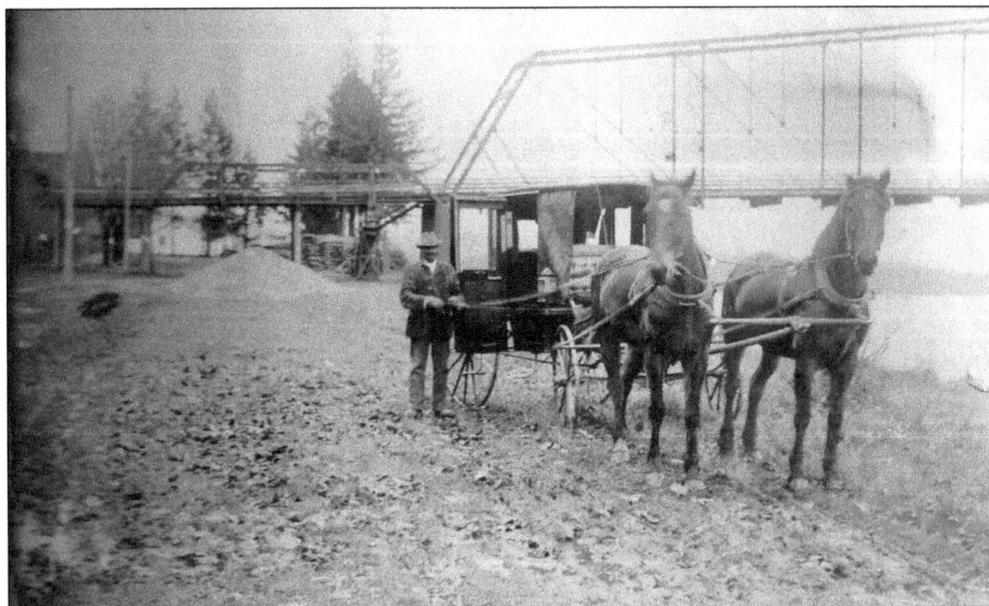

Here is the Wallaces' carriage and driver on the Salem side of the Willamette River, with the second Big Bridge in the background. Although the man in the photograph is unidentified, he may have been Thomas King, a longtime and valued employee of the Wallaces. Robert S. Wallace's sister Eliza B. Wallace was a principal at Knoxville College, a school for African Americans in Knoxville, Tennessee, from 1876 until her death in 1897. (PCHS-WC.)

Four

THE TOWN IS BORN

Early settlers understood that transportation systems were important in the development of a successful community. In order for the people to prosper, they had to have a way to get their crops and products to market. This often encouraged settlement to begin along a river where heavy loads could be transported by boat to and from other communities. These same rivers also created a problem: there must be a way for men, wagons, and livestock to cross them. This was the case in West Salem when James White's ferry was established in 1846. The ferry served as an important crossroad, linking the east side of the river with the newly established communities in West Salem as well as the more distant communities in Polk County and beyond.

By the 1880s, growth had occurred in such a way that Marion County and Polk County leaders determined a bridge was needed to connect West Salem and the larger city of Salem to the east. With the opening of the bridge commonly called the Big Bridge across the Willamette River in 1886, a crucial link was forged that sparked even further development. The town of West Salem was officially platted in 1889.

Twenty years later, the railroad arrived, bringing even more opportunities for commerce and transportation to the community. When such new opportunities open, longtime services often suffer, as seen when local farmers found shipping by rail to be preferable to boat transport, dramatically impacting that once-vital industry. However, other additions continued to follow, such as the Kingwood Park area, which boasted its own railroad station and park. The foundation for this new town called West Salem was in place, and its future was very bright indeed.

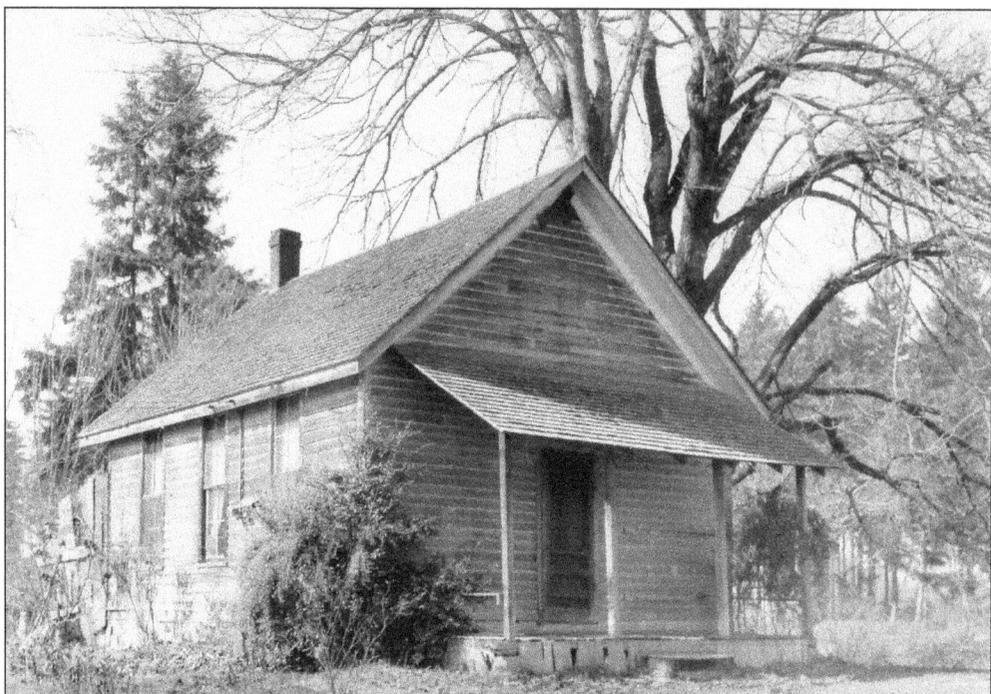

In April 1868, the Fairview School House opened on the hill just west of what is now Eola Drive, above Edgewater Street NW. The area was given the name Fairview by the White family, although it was later changed to Fair Oaks, probably because of other nearby communities being called Fairview. Students knew that when the Corvallis-bound steamboat went chuffing by, it was time for the school day to end. (SPL.)

This drawing from an 1876 photograph of the Salem area gives a glimpse of the West Salem riverfront and ferry landings. At this time, the ferry was being operated by Henry Hewitt, whose house was just west of the Polk County landing.

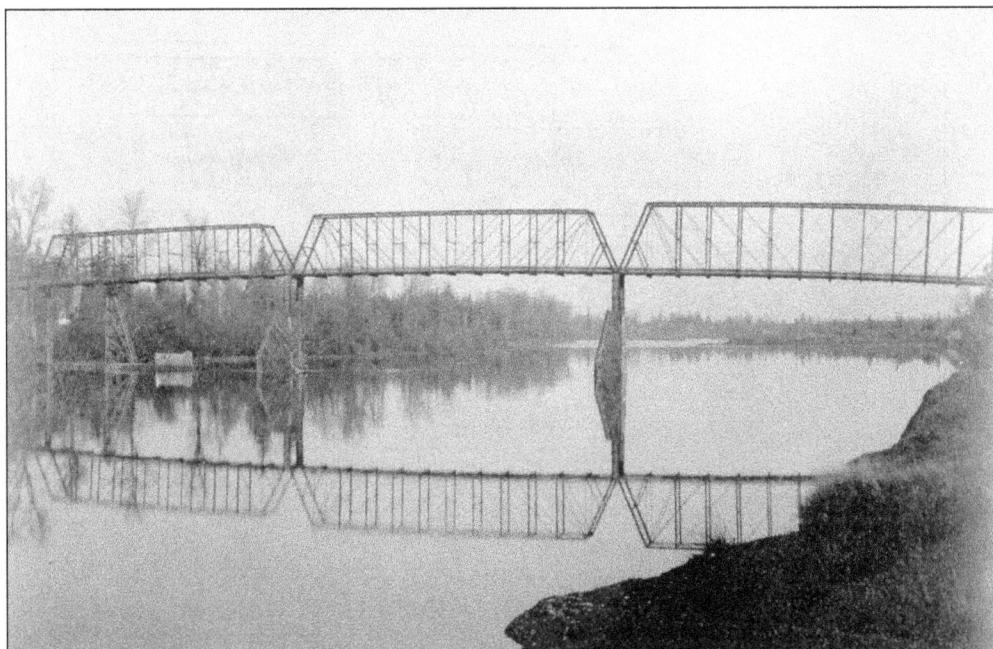

On December 2, 1886, the Big Bridge linking Salem and Polk County opened. The City of Salem, Polk County, and Marion County contributed to the $50,000 cost. This was the first bridge to span the Willamette River anywhere; another bridge opened a year later in Portland. (SPL.)

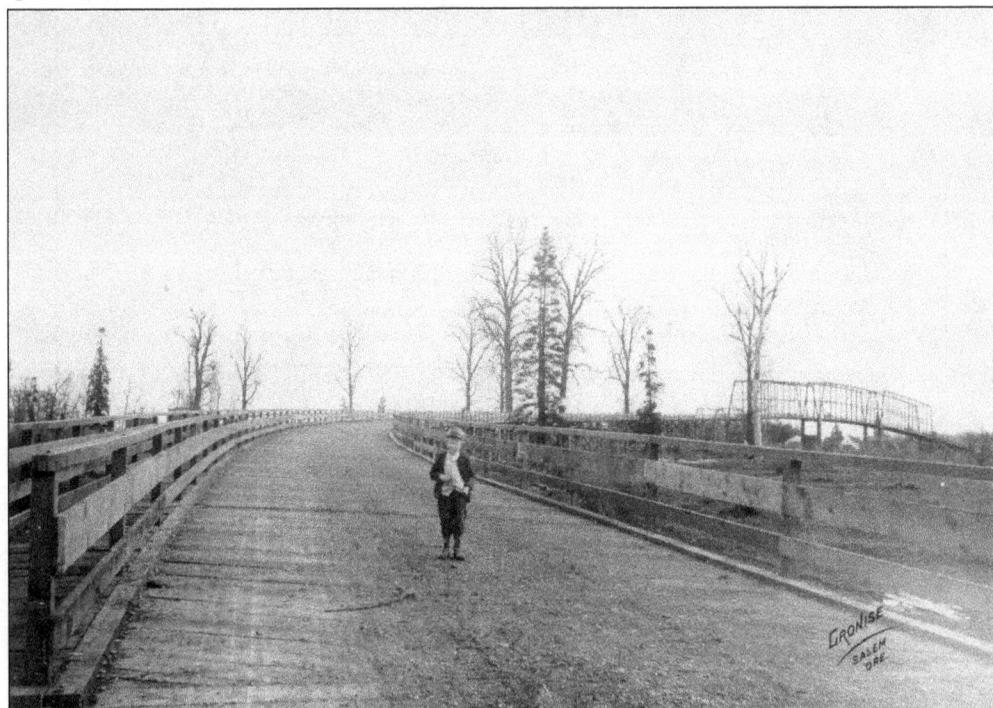

This photograph, taken by the Cronise Studio of Salem around 1887, shows a young boy on the "Polk," or West Salem, entrance ramp to the Big Bridge. The three-span bridge can be seen in the distance. (SPL.)

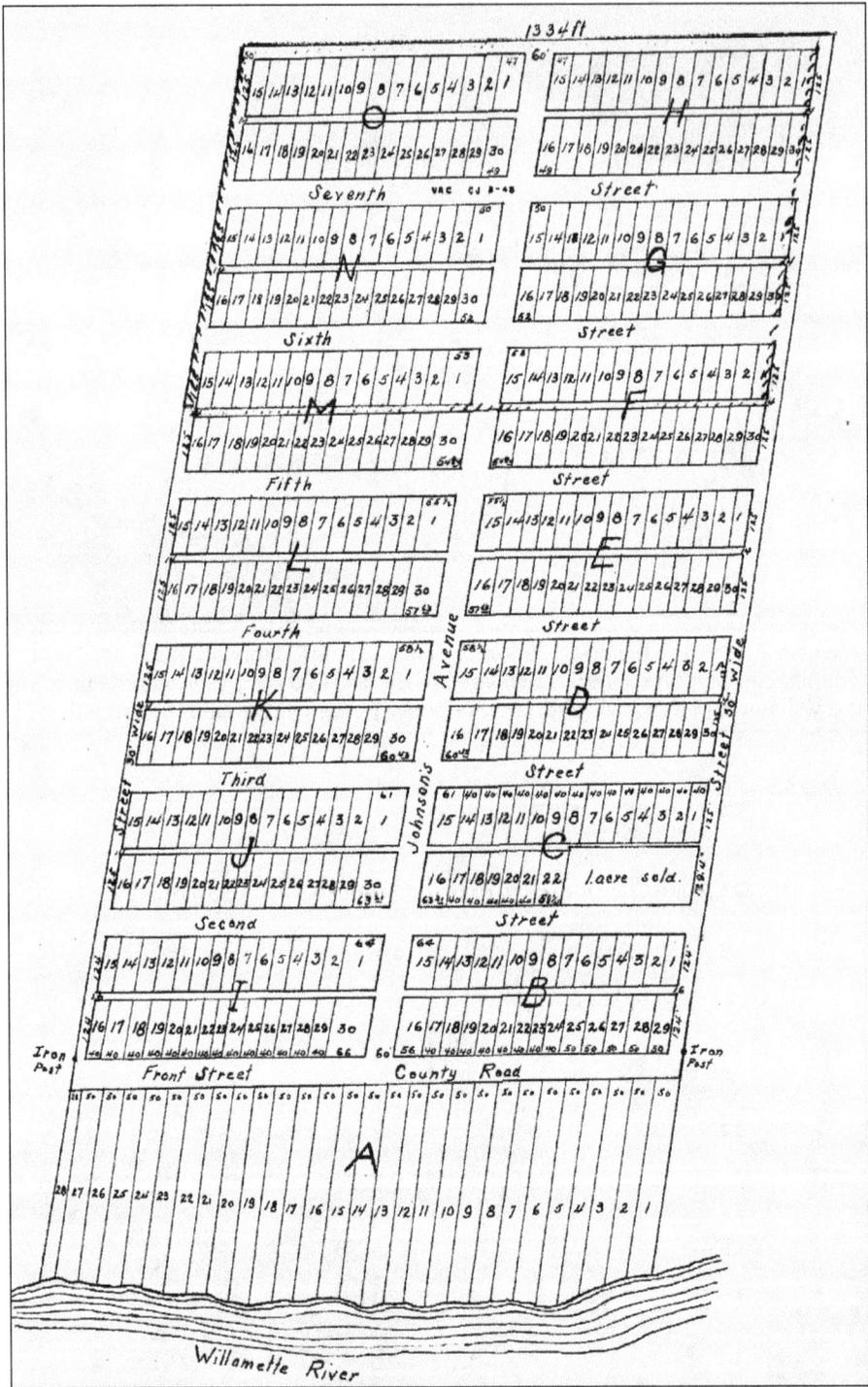

With the new bridge in place, the lower West Salem area really began to grow. George and Mary Johnson officially platted the town of West Salem in 1889. Several of the street names shown here were later changed to avoid confusion with existing streets in the city of Salem, across the river.

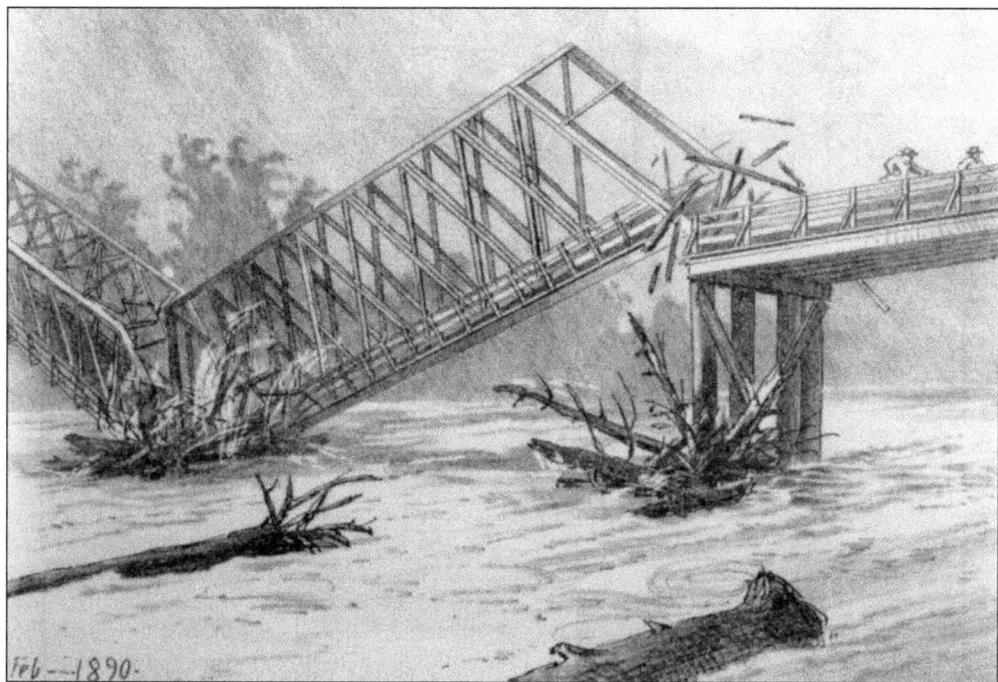

In February 1890, less than a year after the town of West Salem had been platted, the Big Bridge washed out during a major flood. One pier suddenly bent and cracked, quickly followed by two main spans of the bridge crashing loudly into the river; the third span followed later. All pieces were quickly carried downriver while people on both sides of the swollen river watched in dismay. (SPL.)

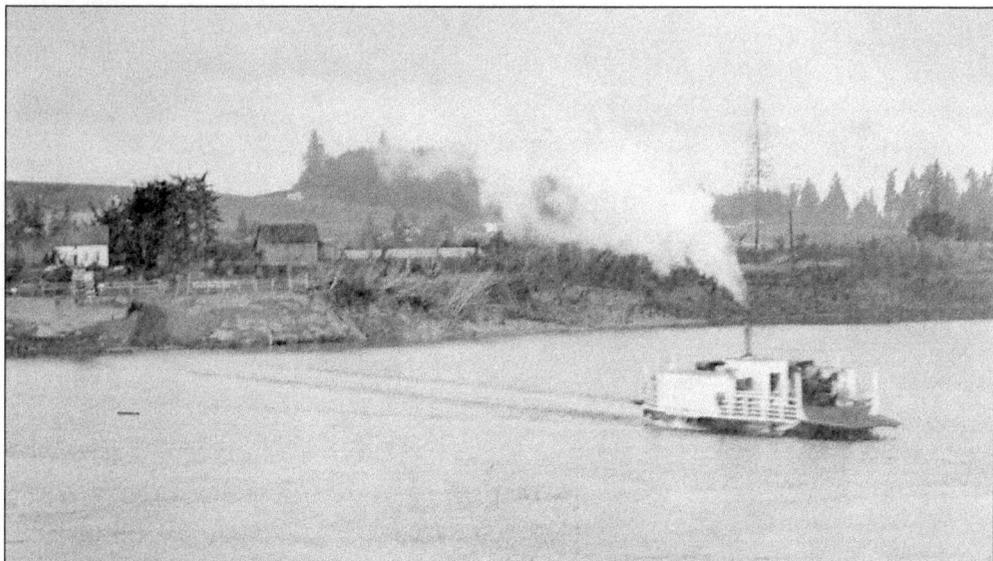

After the bridge washed out, ferry service was quickly reestablished between Salem and Polk Counties. Thomas Holman's ferry is shown making its way from the West Salem riverbank, seen in the background. Holman, who owned the rights to local ferry service, built this seven-horsepower steam ferry named the *Alice V* and put it into service while the new bridge was being built. (SPL.)

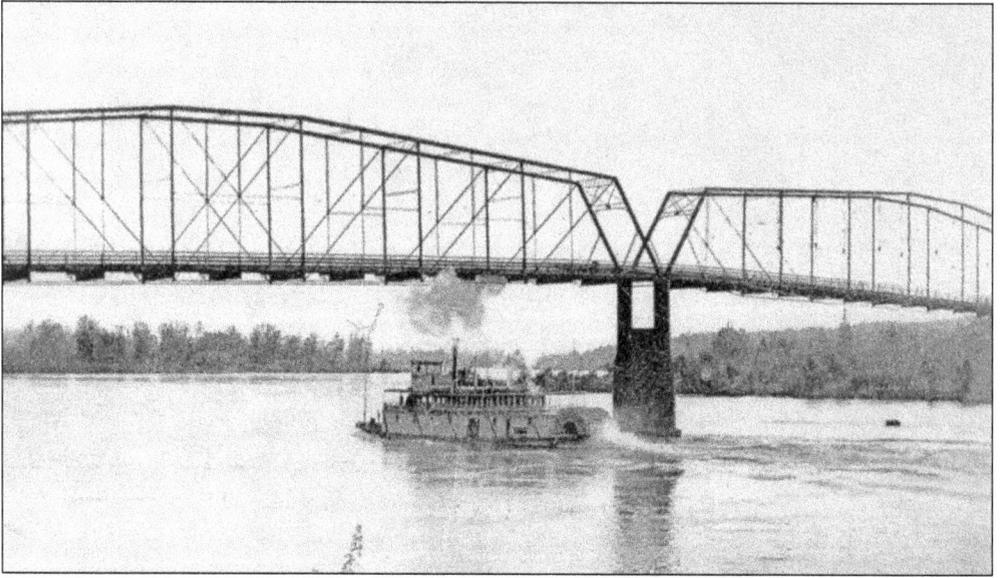

After the bridge was destroyed, the leaders of both counties began discussing the need for a new bridge. Among the issues facing citizens was whether the bridge should be free or tolled. The "free" bridge, shown above, opened early in 1891 amid much controversy, including charges of mismanagement, structural concerns (which proved to be justified), and a significant budget overrun. Above, the stern-wheeler *Pomona* cruises beneath the bridge. (SPL.)

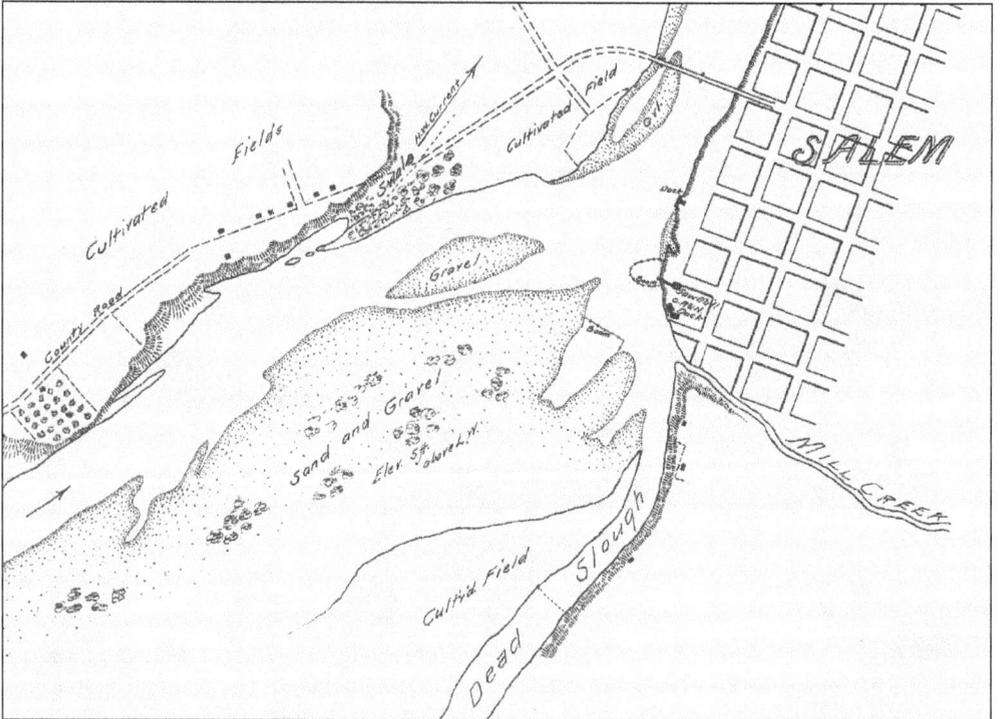

This map, drawn in 1895, provides a glimpse of the West Salem riverbank as well as part of Minto-Brown Island and the Salem waterfront. Note the large cultivated fields on the west bank, evidence of the agricultural value of the West Salem area.

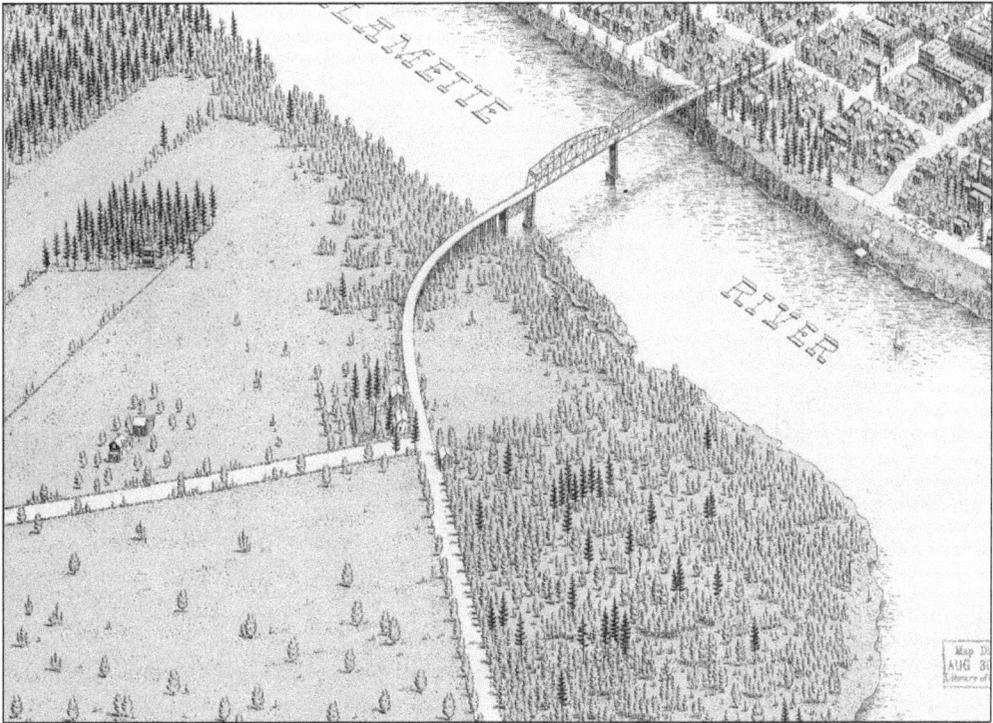

A 1905 view of the Big Bridge and waterfront is shown here. Visible is the old Hewitt house, center, near the foot of the bridge at the intersection of Wallace Road NW. Unfortunately, the growing area of the community of West Salem is not shown in this drawing.

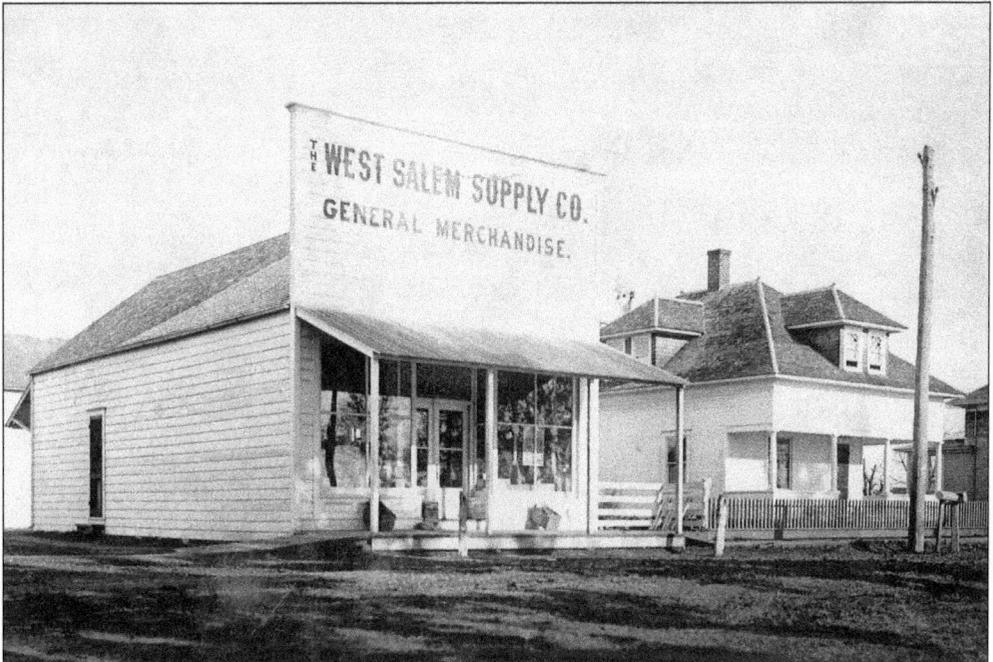

In 1906, Charles Spitzbart opened the first general store in West Salem. It was located on Edgewater Street NW at the east corner of McNary Avenue NW. (PCHS-Culp.)

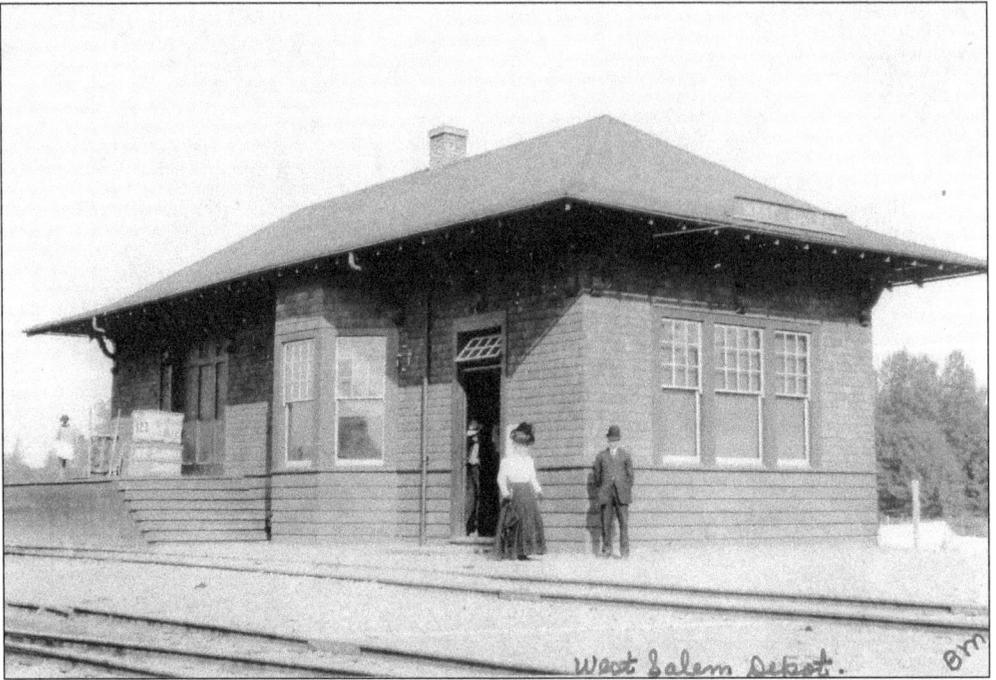

West Salem Depot.

In 1909, train service arrived in West Salem, bringing with it the excitement and promise of increased industry and development. This depot stood along the tracks just east of Wallace Road NW. The new train made traveling west and connecting with the existing northbound and southbound rail lines at Gerlinger possible. It would still be four years before the railroad bridge crossing the Willamette River to Salem would open. (SPL.)

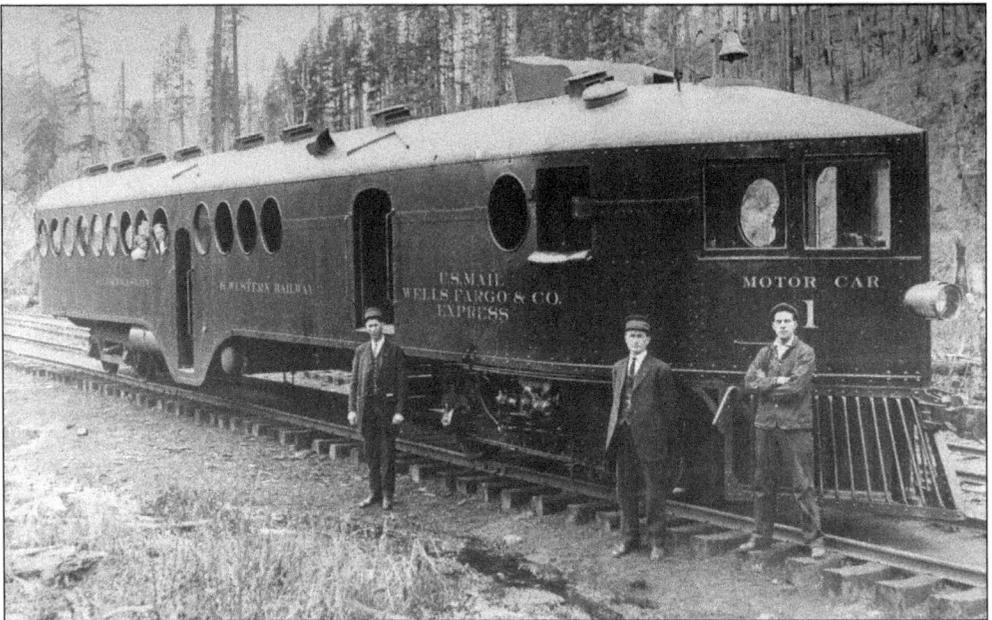

This gasoline-powered motorcar, called the McKeen Car, was used for passenger travel. It was nicknamed "the Skunk" for its bad-smelling fumes and the smoke plume left in its wake. It held 80 passengers. (SPL.)

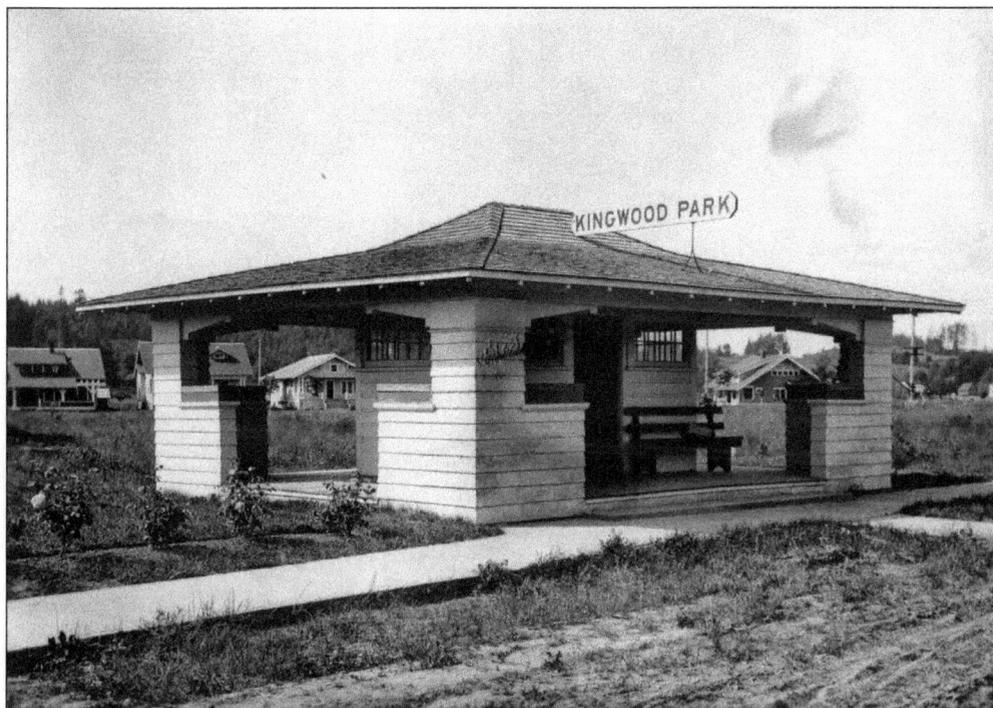

In this c. 19220 close-up view of the Kingwood Park passenger train stop, glimpses of a few of the newly built houses in the recently platted Kingwood Park addition nearby can be seen. (PCHS-Culp.)

Pictured is a Salem, Falls City & Western Railway timetable from around 1911. Passengers could catch the train in West Salem and arrive in Dallas in 40 minutes.

LOCAL TIME TABLE
Salem, Falls City & Western Railway

WEST BOUND

STATIONS	Miles from W. Salem	PASSENGER Daily Except Sunday			PASSENGER Sunday Only		
		No. 2 A.M	No. 4 P.M	No. 6 P.M	No. 10 A.M	No. 12 P.M	No. 14 P.M
West Salem...Lv.	0	9 00	1 30	4 35	9 00	1 35	5 50
†Kingwood Park	0	9 03	1 33	4 38	9 03	1 38	5 53
†Log Dump	2	9 06	1 36	4 41	9 06	1 41	5 56
†Eola	4	9 10	1 40	4 45	9 10	1 45	6 00
†McNary	6	9 14	1 44	4 49	9 14	1 49	6 04
†Greenwood	7	9 18	1 48	4 53	9 18	1 53	6 08
†Derry Orchard	8	9 21	1 51	4 56	9 21	1 56	6 11
So. Pac. Cross'g	9	9 22	1 52	4 57	9 22	1 57	6 12
†Rickreall	10	9 24	1 54	4 59	9 24	1 59	6 14
†Bowersville	11	9 27	1 57	5 02	9 27	2 02	6 17
DALLAS....Ar.	14	9 40	2 10	5 15	9 40	2 15	6 30
DALLAS....Lv.	14	9 45	2 15	5 20	9 45	2 20	
†Teats	18	10 00	2 30	5 35	10 00	2 35	
†Gilliam	19	10 02	2 32	5 37	10 02	2 37	
†Bridgeport	21	10 06	2 36	5 41	10 06	2 41	
Falls City	24	10 15	2 45	5 50	10 15	2 50	
Black Rock	27	10 35			10 35	3 10	

EAST BOUND

STATIONS	Miles from B. Rock	PASSENGER Daily Except Sunday				PASSENGER Sunday Only		
		No. 3 A.M	No. 5 A.M	No. 7 P.M	No. 9 P.M	No. 11 A.M	No. 13 A.M	No. 15 P.M
Black Rock...Lv.	0		11 00				11 45	4 0
Falls City	3		11 15	3 00	6 05		12 00	4 1
†Bridgeport	6		11 24	3 09	6 14		12 09	4 1
†Gilliam	8		11 28	3 13	6 18		12 13	4 2
†Teats	9		11 30	3 15	6 20		12 15	4 2
DALLAS.....Ar	13		11 45	3 30	6 35		12 30	4 3
DALLAS.....Lv	13	7 35	11 50	3 35		7 35	12 35	4 5
†Bowersville	16	7 48	12 03	3 48		7 48	12 48	5 0
†Rickreall	17	7 51	12 06	3 51		7 51	12 51	5 0
So. Pac. Cross'g	18	7 52	12 07	3 52		7 52	12 52	5 0
†Derry Orchard	19	7 54	12 09	3 54		7 54	12 54	5 0
†Greenwood	20	7 57	12 12	3 57		7 57	12 57	5 1
†McNary	21	8 01	12 16	4 01		8 01	1 01	5 1
†Eola	23	8 05	12 20	4 05		8 05	1 05	5 2
†Log Dump	25	8 09	12 24	4 09		8 09	1 09	5 2
†Kingwood Park		8 12	12 27	4 12		8 12	1 12	5 2
West Salem	27	8 15	12 30	4 15		8 15	1 15	5 2

†Trains Stop on Signal Only.

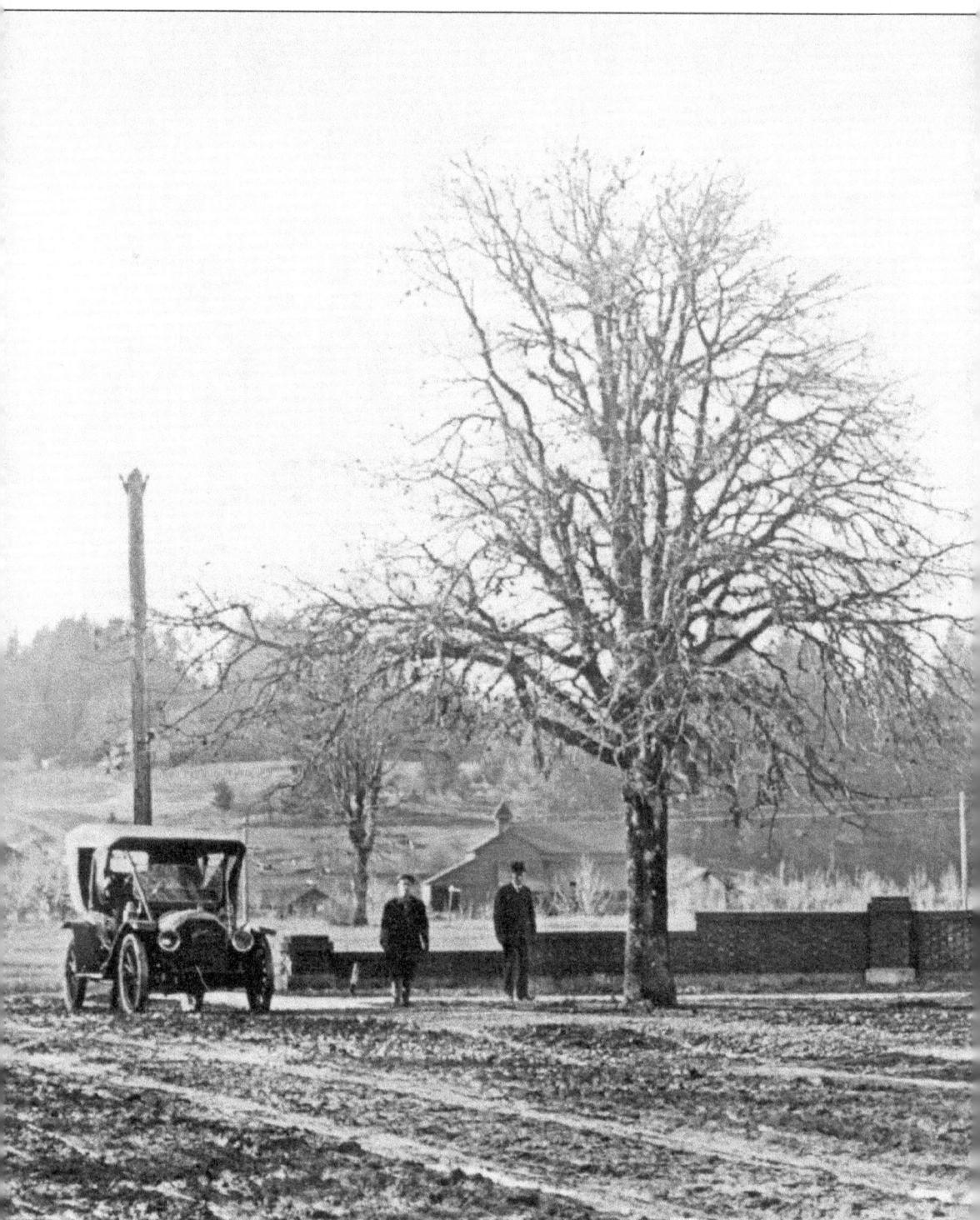

A new subdivision, Kingwood Park, was platted in West Salem in 1910. Within its boundaries, Kingwood Park offered its own passenger train stop and a small forested park. This c. 1911 photograph of the Kingwood Park subdivision shows the intersection of a muddy Edgewater

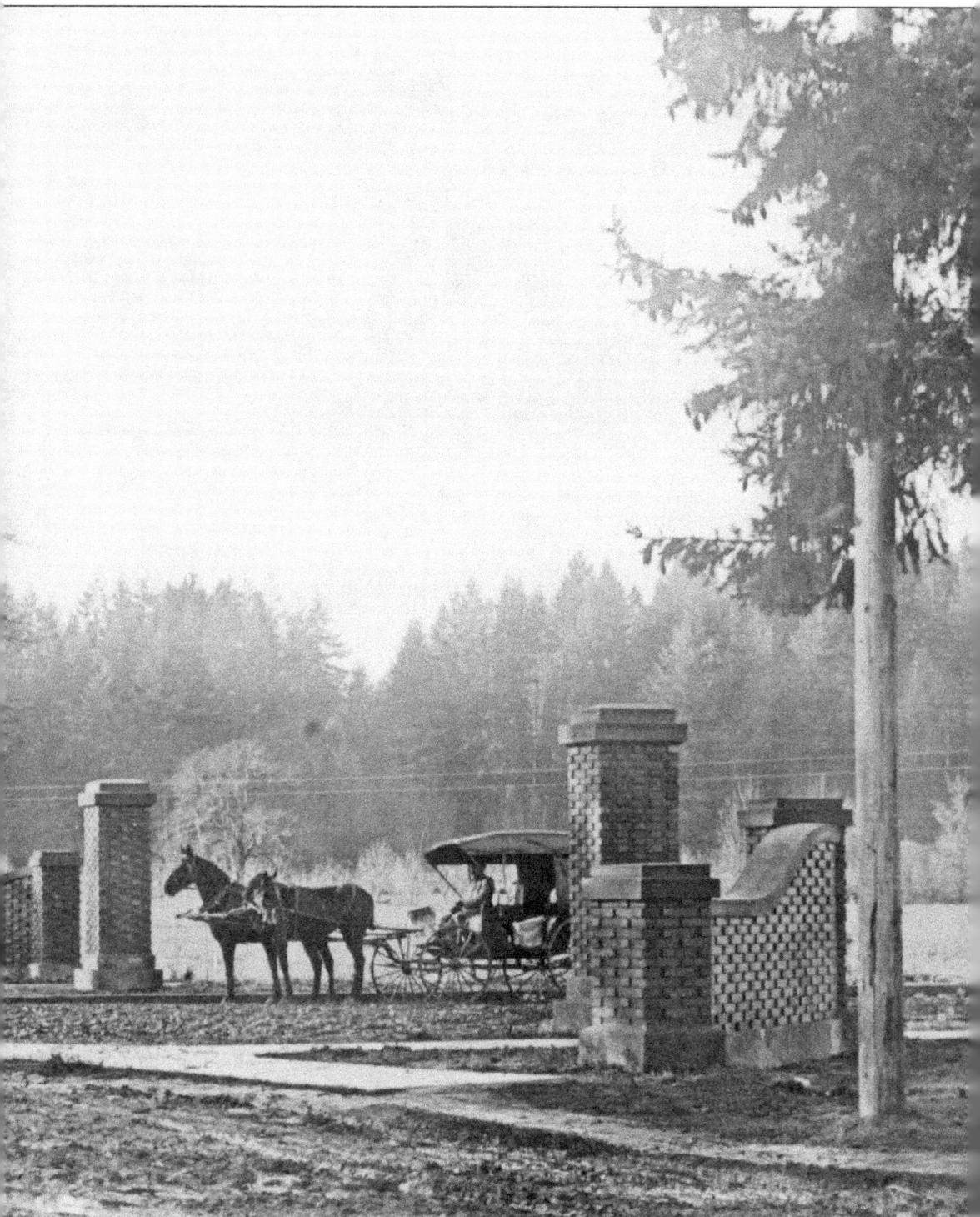

Street with the newly graded and brick-gated Kingwood Avenue. The Kingwood Park train stop was located along the railroad tracks on Second Street, just west of Kingwood Avenue. (PCHS.)

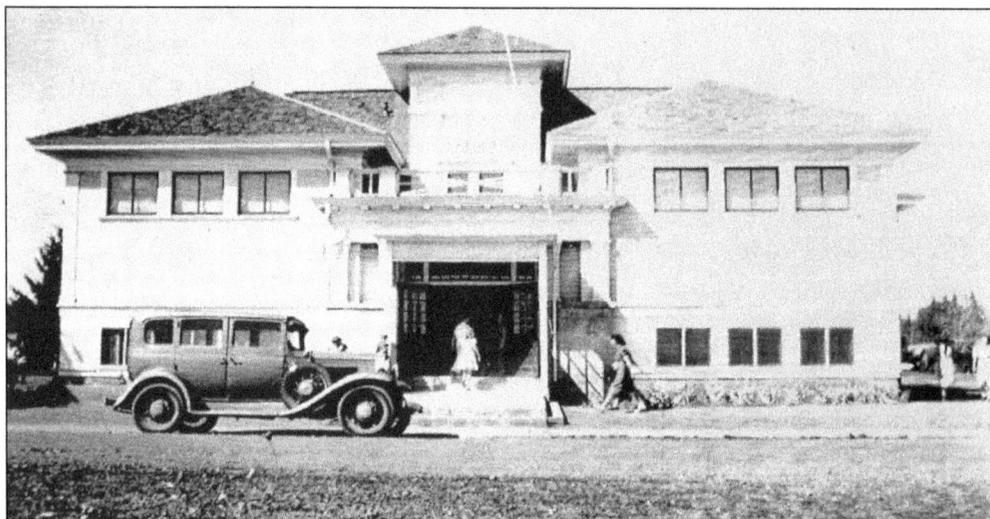

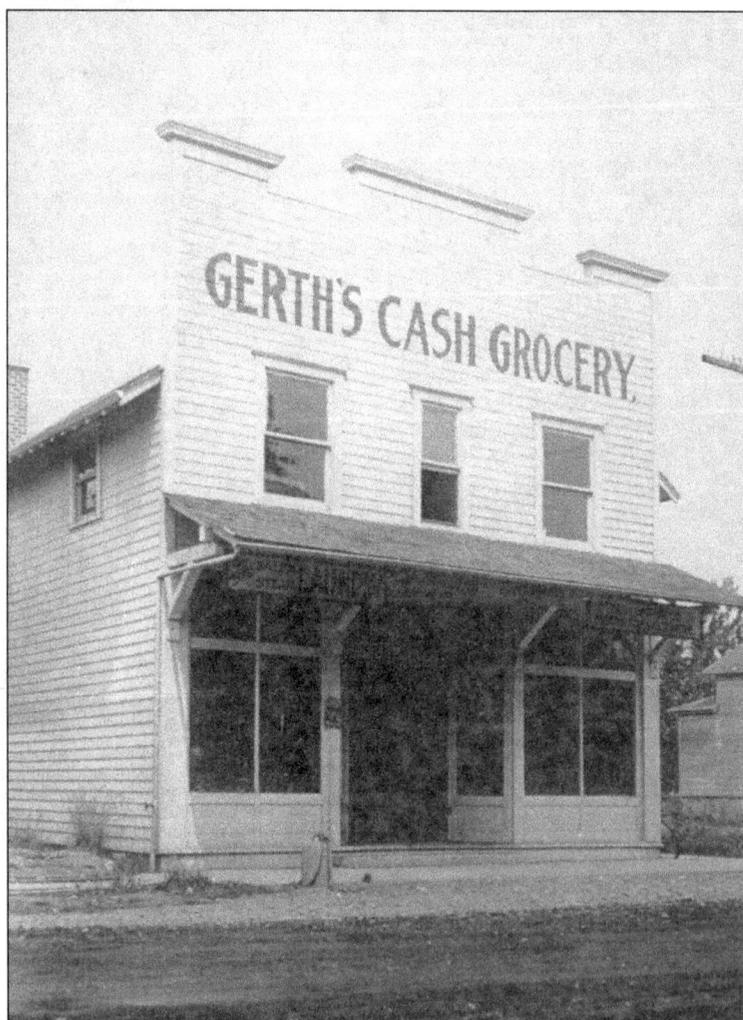

The West Salem School was built in 1911 on the corner of McNary and Third Streets. The upper level contained four classrooms and a smaller room that served as a library. The basement provided a place to play on rainy days. Water was provided by a pump located by the front entrance.

Walter B. Gerth opened Gerth's Cash Grocery, the town's first two-story building, on Edgewater Street NW in 1912. Gerth was active in the West Salem community for many years and was an important person in the area's history. (Sannes Collection.)

Five

THE CITY MATURES

By 1913, the new railroad bridge was in place over the Willamette River between West Salem and Salem, and the town was ready to become a city in its own right. That same year, the voters of West Salem approved the city charter, along with Prohibition and a warning against future bawdy houses. This was a town of families used to the hard work of farming and other agricultural endeavors. The bounty of fruit and vegetables produced on the nearby farms provided both sustenance and employment. With railroad service now also available to the east, complementing the vehicle bridge connection, "city folks" from Salem were relocating their homes to West Salem to enjoy a more rural experience while being just a short ride or drive from their downtown Salem workplaces. An elementary school had been built in 1911 and a junior high school would be constructed in 1927 to accommodate the growth.

As with the rest of the nation, the Depression years were hard for this area, but West Salem also benefitted from major Works Progress Administration (WPA) projects undertaken during that time. WPA projects included West Salem City Hall, an Art Deco building that also housed the jail and the firehouse, and the city's water system. The popularity of the automobile gave rise to new businesses such as service stations, an automobile park with cabins for travelers, and restaurants to serve locals and traveling visitors. Houses of worship were constructed as well as places for entertainment, including the Mellow Moon Pavilion, first used as a dance hall, then as a roller rink. The war years proved to be an economic boom for most of the nation, and West Salem was no exception. The Blue Lake Producers Co-Operative cannery was one of only three area canneries authorized to provide dried and canned fruits and vegetables for the armed services. And when the servicemen came home from the war, a bustling city was there to greet them.

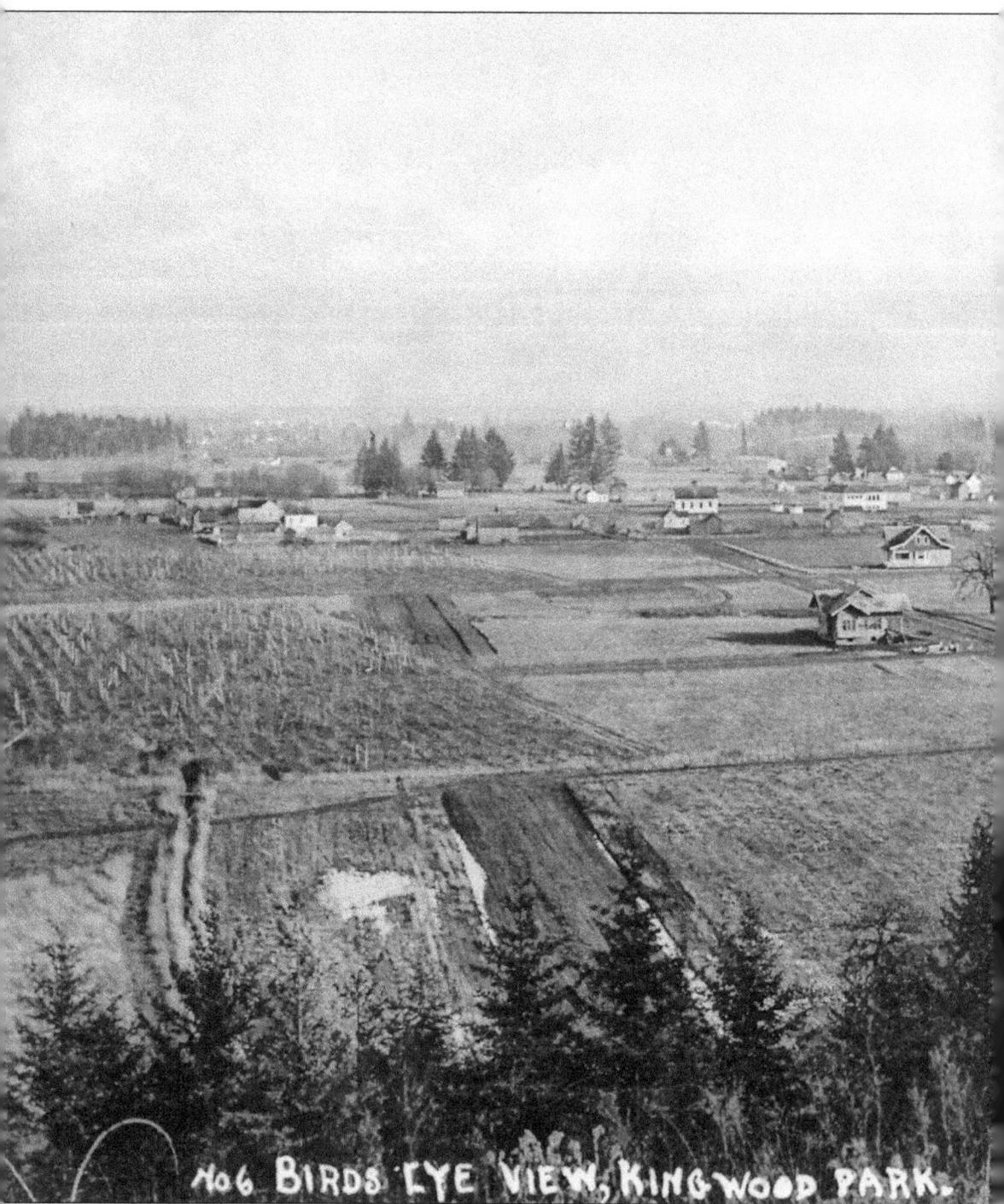

No 6 BIRDS EYE VIEW, KINGWOOD PARK.

This c. 1912 photograph, titled "Birds Eye View, Kingwood Park," displays a great view of the newly developing Kingwood Park as well as the established village of West Salem. The spans of the Big Bridge can be seen in the distance, in front of the grove of trees, and the new West Salem School is mid-center near the right of this page. To the left of the school is the West Salem Community Hall, built in 1895. This building was also used for church services. When the old Fairview (Fair

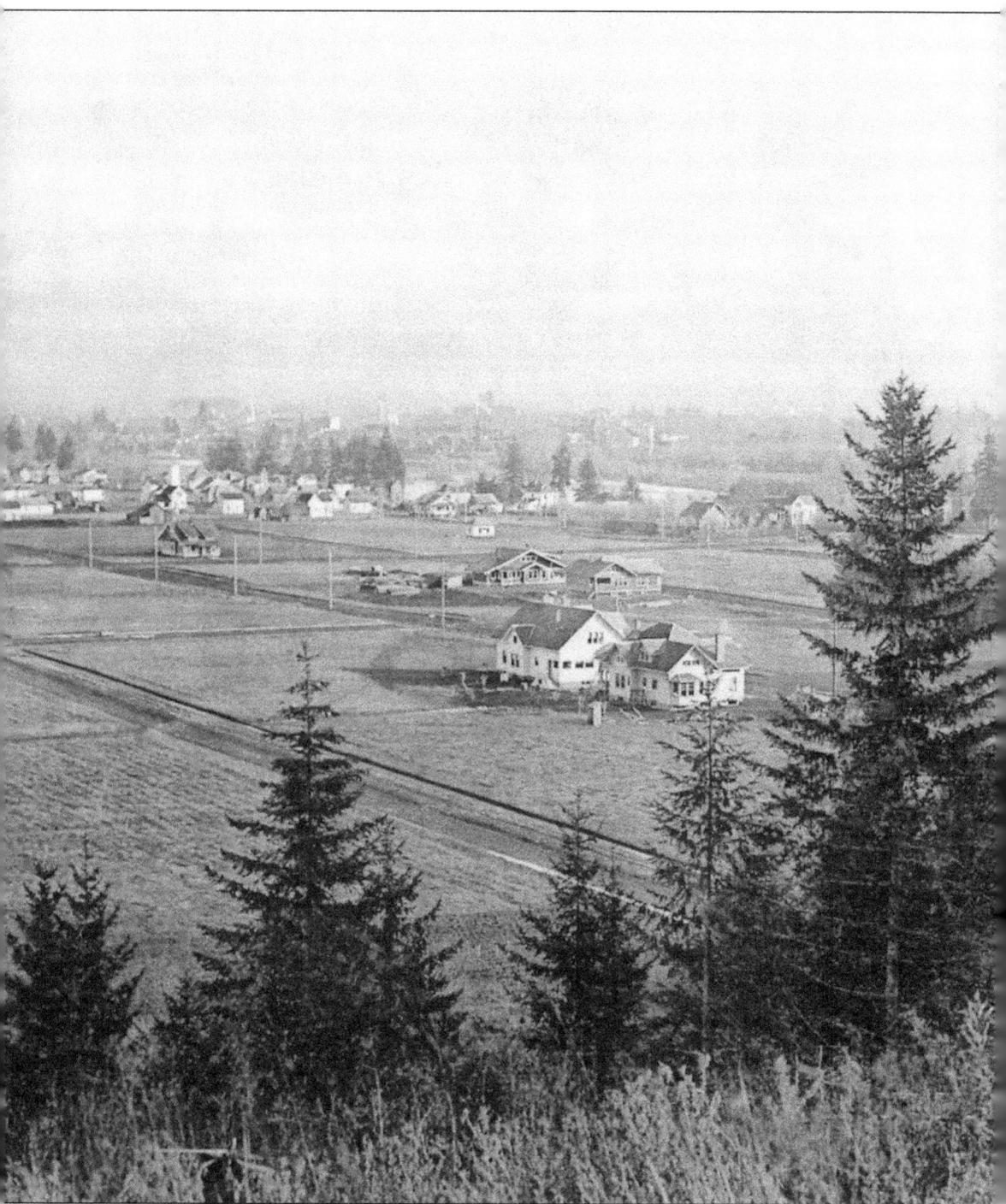

Oaks) School closed in 1902, it served as a schoolhouse until the new structure was built in 1911. The house at the lower right is the Grace Breckenridge house, located at 1515 Elm Street NW. The newly graded street in the foreground is Franklin Street, shown at its intersection with Rosemont Avenue. (PCHS-Culp.)

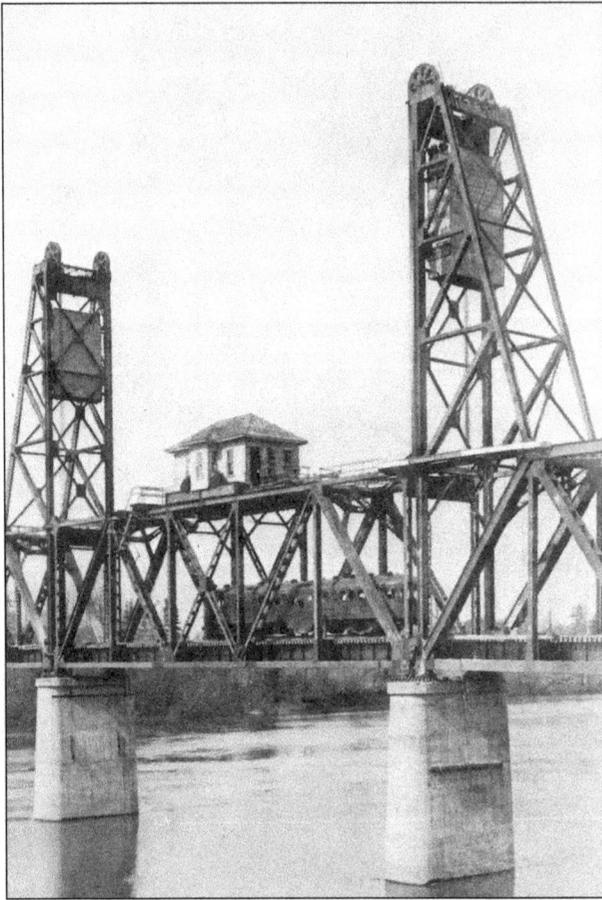

In 1913, the railroad bridge opened between Salem and West Salem, providing Polk County long-awaited rail access to Salem and the east side of the Willamette River. The gasoline-powered McKeen car is shown here crossing the railroad bridge. The residents of West Salem voted to incorporate, and the growing town formally became the city of West Salem in 1913, with George Frazure elected the city's first mayor. (SPL.)

Here is a rare view of the Big Bridge ramp curving into West Salem. The large white house at the end of the bridge was built around 1875 by ferryman Henry Hewitt. At the time this photograph was taken in 1916, it had become part of the Pinckney Brothers Dairy farm, seen at the right of the bridge ramp. The building on the far right is the West Salem train depot. (PCHS.)

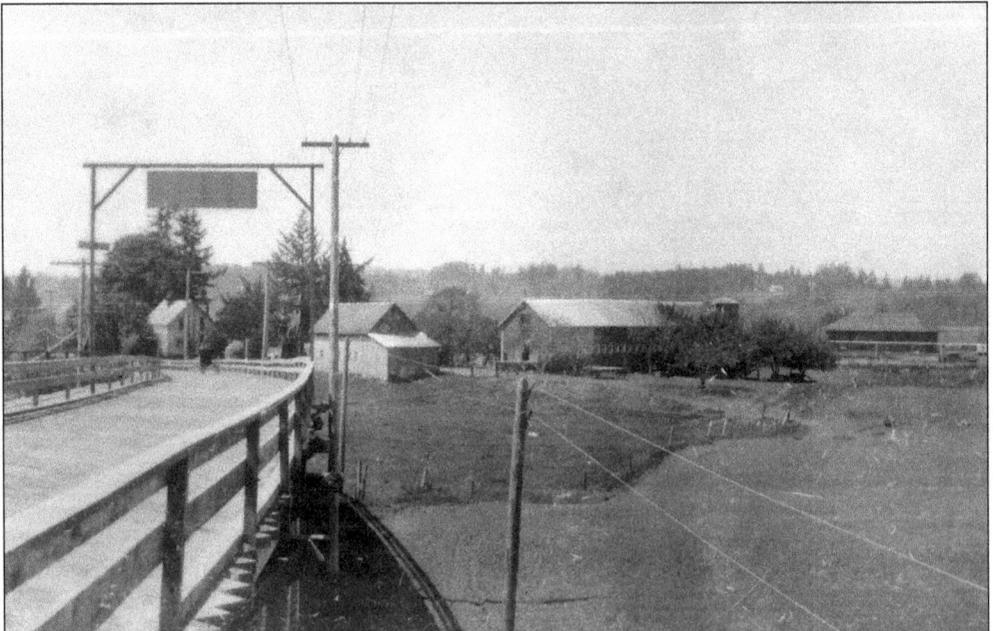

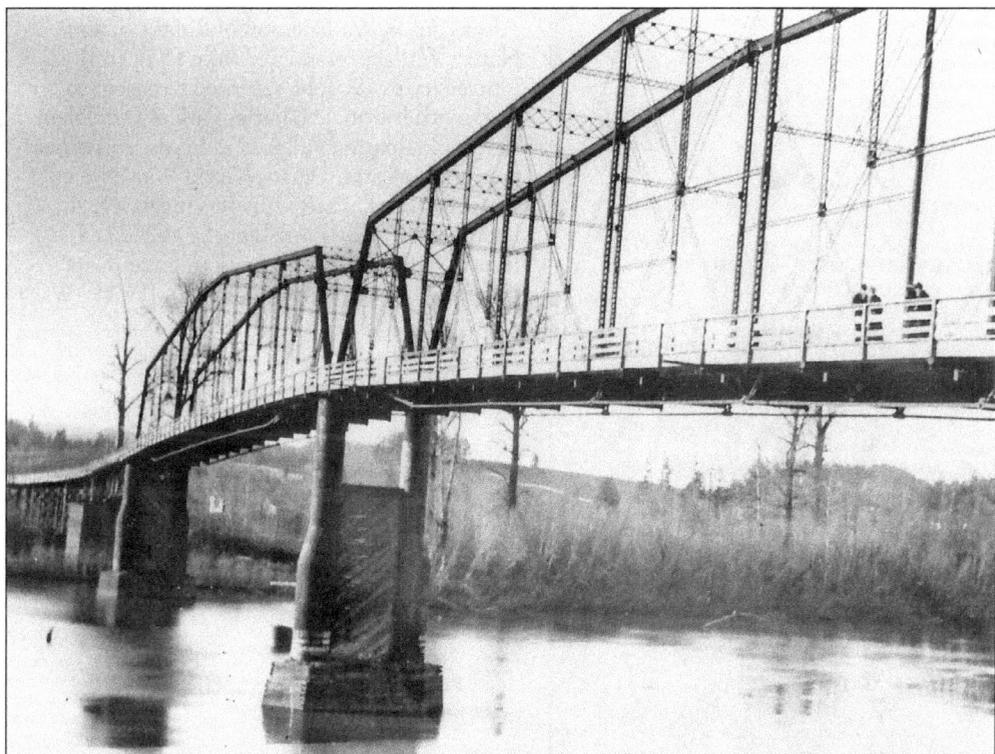

By 1915, the second Big Bridge between Salem and West Salem (above), which had been hastily and poorly built in 1891, was deemed unsafe. Temporary ferry service was reinstated while the bridge was closed for repairs; even so, the bridge closed altogether in 1917. There was some talk of planking the railroad bridge for traffic use in the interim, but it was decided to reinstate ferry service again until a new bridge could be built. The size of the ferry pictured below suggests it was used during a special event, such as the Fourth of July or the state fair. The ferry is unloading passengers on the Salem side of the river around 1917. (Above, author; below, PCHS-Allen Collection.)

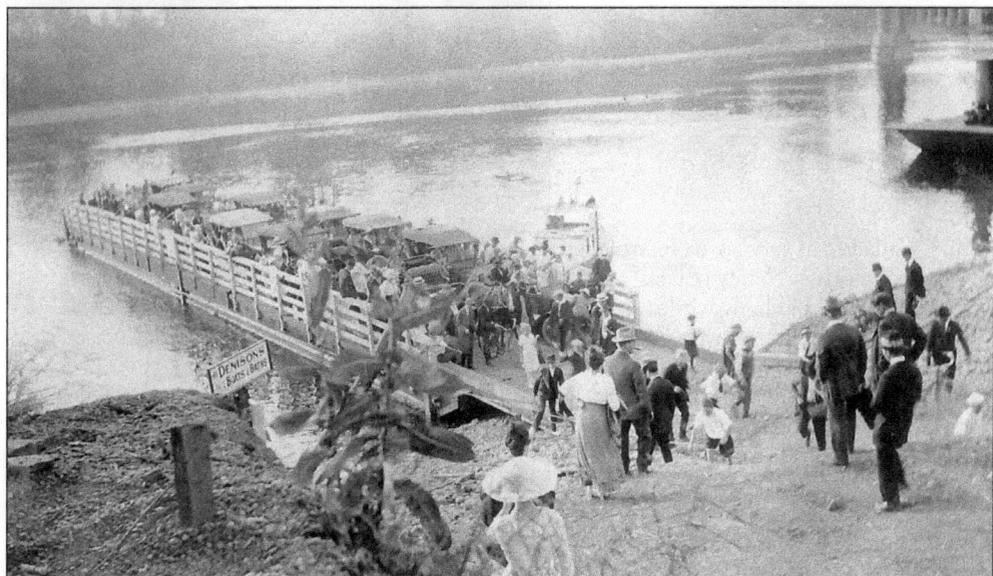

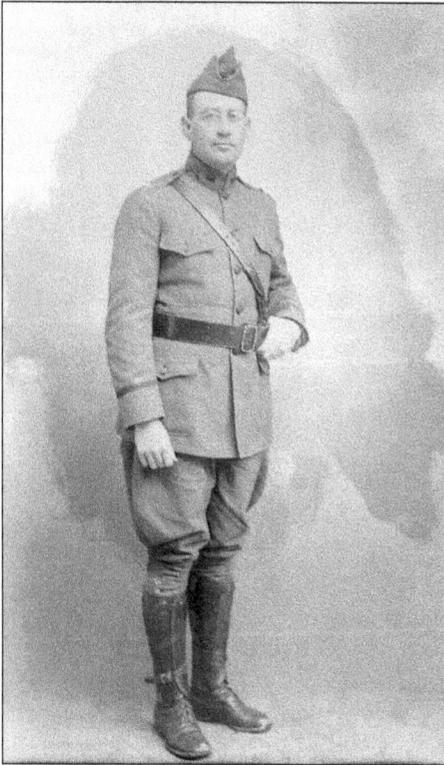

After Paul B. Wallace, son of Robert S. and Nancy Wallace, graduated from Princeton University in 1903, he returned to Salem to work with his uncle Charles Park at the Salem Water Company, Wallace Orchards, and other family businesses. During World War I, he saw action in France while serving as a first lieutenant in Company L of the 162nd US Infantry, 41st (Sunset) Division, under Capt. Conrad Stafrin of Dallas, Oregon. (PCHS-WC.)

While Wallace was serving in France in 1918, his mother, Nancy (Black) Wallace, 72, died suddenly while visiting her daughter and sister back east. Nancy was active in the Salem area, working with the Ladies Aid Society and the United Presbyterian Women's Board of Missions, as well as many other charitable causes. She had also served as a judge representing Oregon at the 1893 World's Fair in Chicago. (PCHS-WC.)

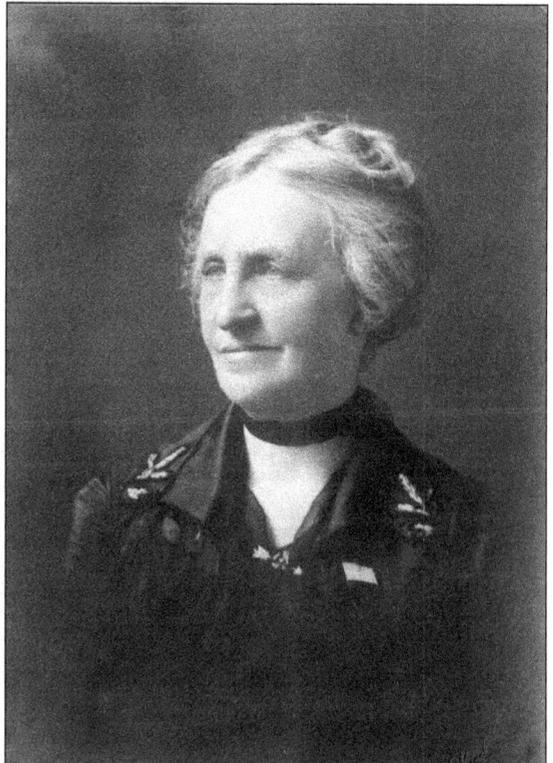

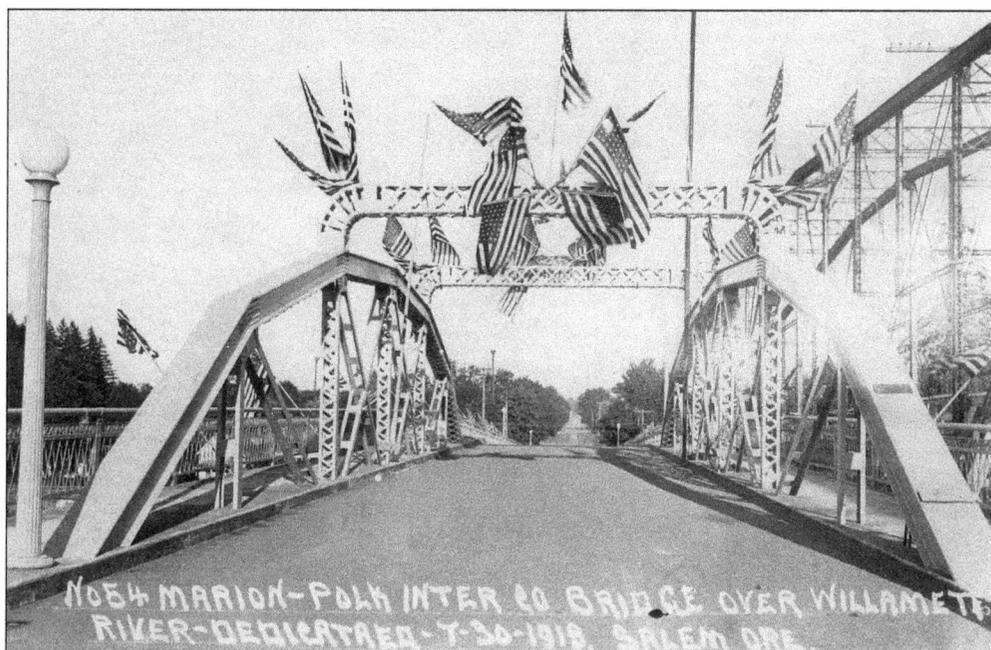

During World War I, the third Big Bridge over the Willamette River opened, ending the need for the ferry between Salem and Polk County after seven decades of service there. Here, the new bridge is patriotically decorated for its grand-opening ceremony held on July 30, 1918. The old bridge is seen to the right; it was later demolished. (PCHS.)

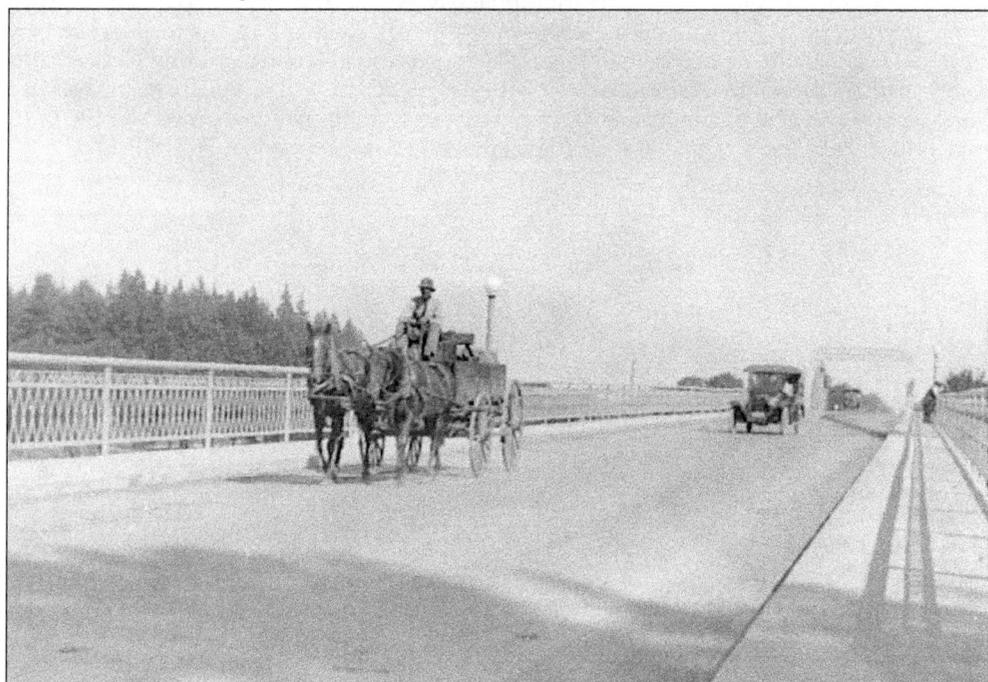

A horse-drawn wagon shares the 1918 bridge, later known as the Center Street Bridge, with the increasingly popular automobile as they travel toward the Salem side of the river from West Salem. Note the round electric lights and sidewalks on both sides of the bridge. (PCHS.)

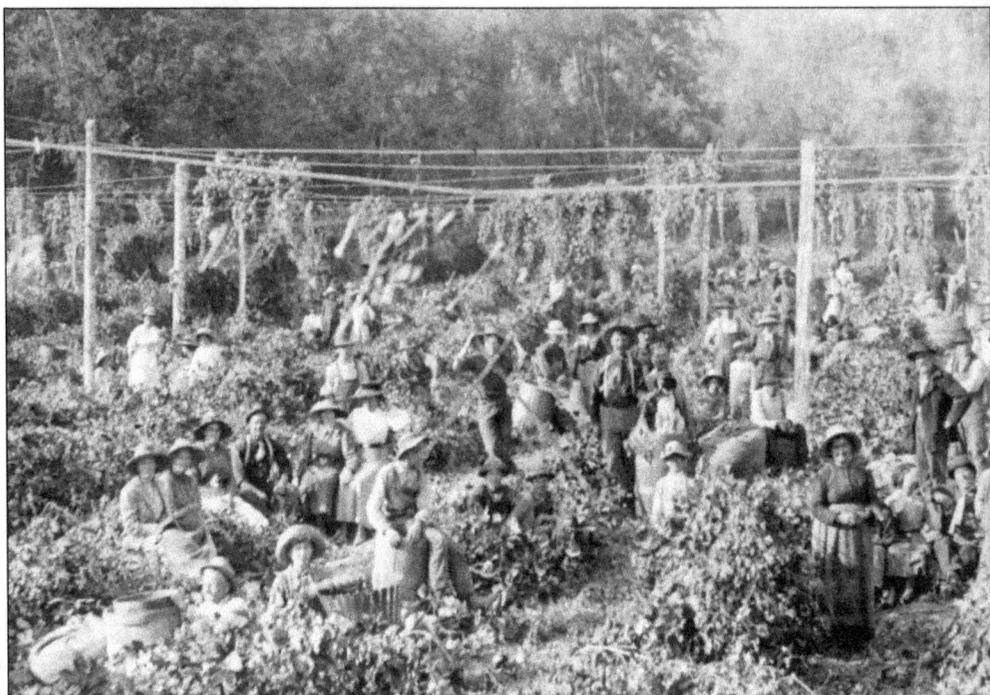

In the above photograph is a view of a West Salem hop field and harvest workers. By 1911, half of the hop crop grown in the United States came from Oregon. Picking hops was a community-wide event. Hop camps were often outfitted with cabins or tents, makeshift restaurants, and grocery stores. Some farmers even hired "sheriffs" to help keep everything running smoothly. Nearby barns were sometimes turned into dance halls on Saturday nights. Shown picking hops in the West Salem area in the 1916 photograph below are, from left to right, Antonia Singer, Ira Blodgett, unidentified, Fred Peterson, and Jessie Cutler. (Above, PCHS-Culp; below, PCHS-IM.)

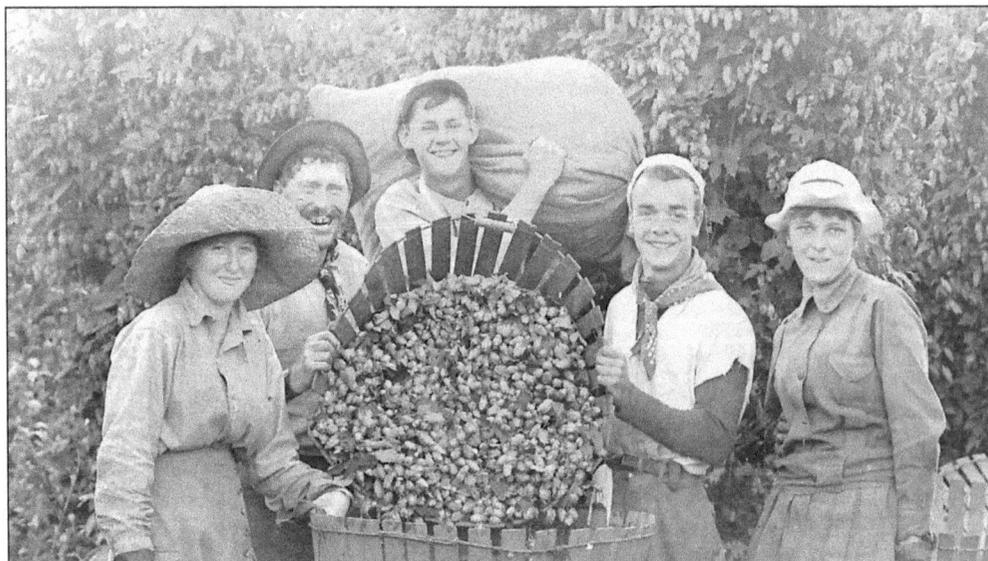

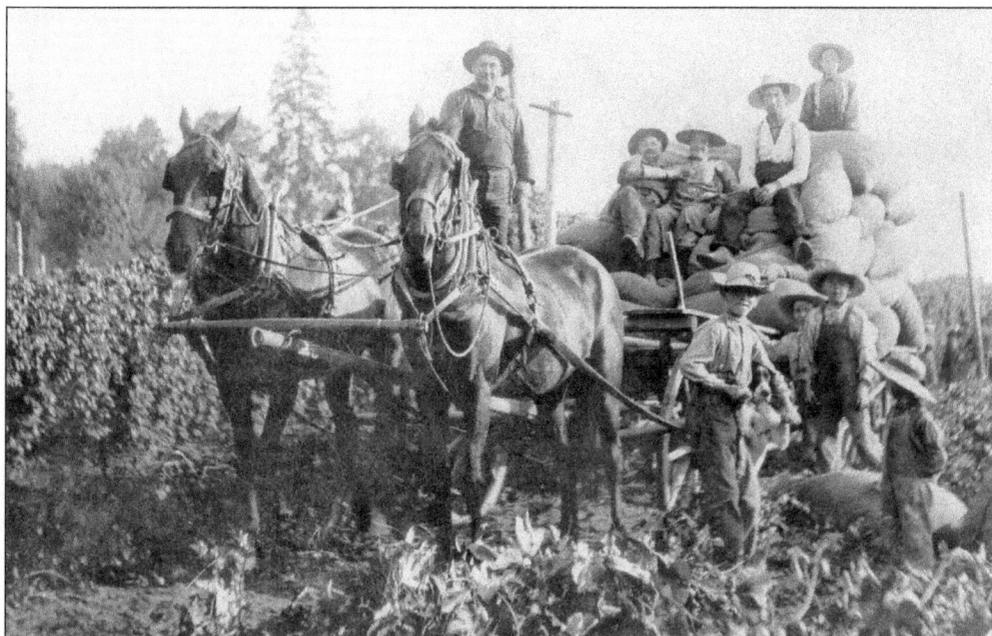

A West Salem work crew and two-horse team is pictured here transporting bags of hops to the hop dryer. Because just-picked hops are nearly 80 percent water, hop dryers were necessary to remove the excess moisture to keep the hops from spoiling. Hops were grown in river bottomlands, with hop dryers built nearby for convenience. (PCHS-Culp.)

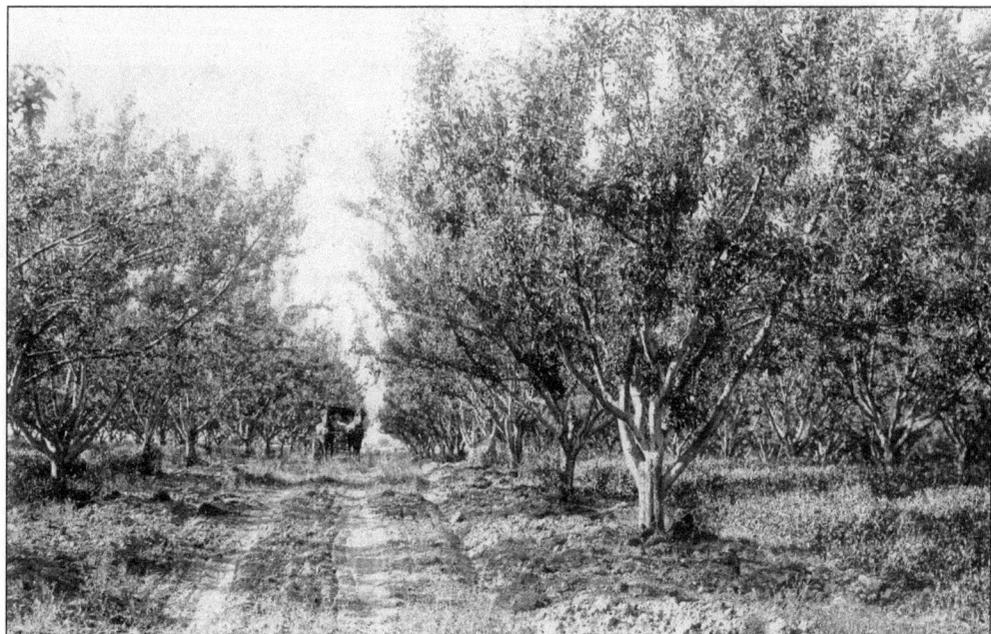

For many years, the West Salem area was home to scores of fruit orchards, such as this one owned by the Wallace family. Apples, pears, prunes, cherries, and cane berries were among the types of fruit grown in nearly all areas of West Salem. Throughout the spring, the West Salem hills would be covered with blossoming fruit trees, drawing local families and visitors to enjoy the views. (PCHS-WC.)

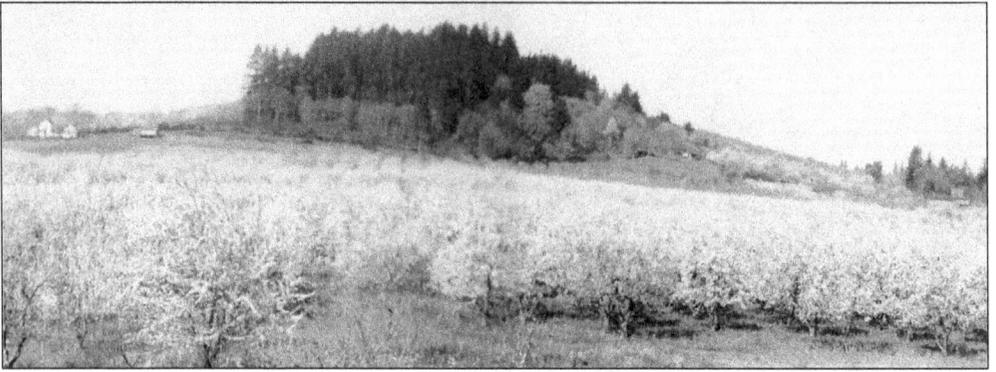

Here is a view of the Wallace pear orchard in full bloom. In the background is Wallace Hill, which is near the intersection of Doaks Ferry Road and Wallace Road. Several other farms are nearby, including F.C. Ewing's, whose house is seen a short way up the hill at the far right. (PCHS-WC.)

In 1920, Cunningham Fruit Company opened an evaporating plant in West Salem on Patterson Avenue, adjacent to the rail line. The building included 10 tunnels for drying, with a boiler used for heating. The tunnels were later removed and the plant was converted into a cannery, becoming Pacific Fruit Canning and Packing Company. Many workers were hired to prepare and can the fruit, as shown in this late-1920s photograph. (PCHS-Lucas.)

The photograph above is from the early 1920s and shows the owners and managers of the Wallace farm. From left to right are Paul B. Wallace, owner; Archie Ewing, foreman; unidentified; Charles A. Park, manager; and Elizabeth (Wallace) Park, manager. Charles and Elizabeth resided on the farm until about 1923, when Paul married Helena Willett. After their marriage, the couple made their home at Wallace Orchards, where they resided for the rest of their lives. Paul and Helena had two children, Nancy and Pauline. The photograph at right was taken in the early 1930s and shows Pauline (left) and Nancy (right) posing with their "Ruth" doll. (Both, PCHS-WC.)

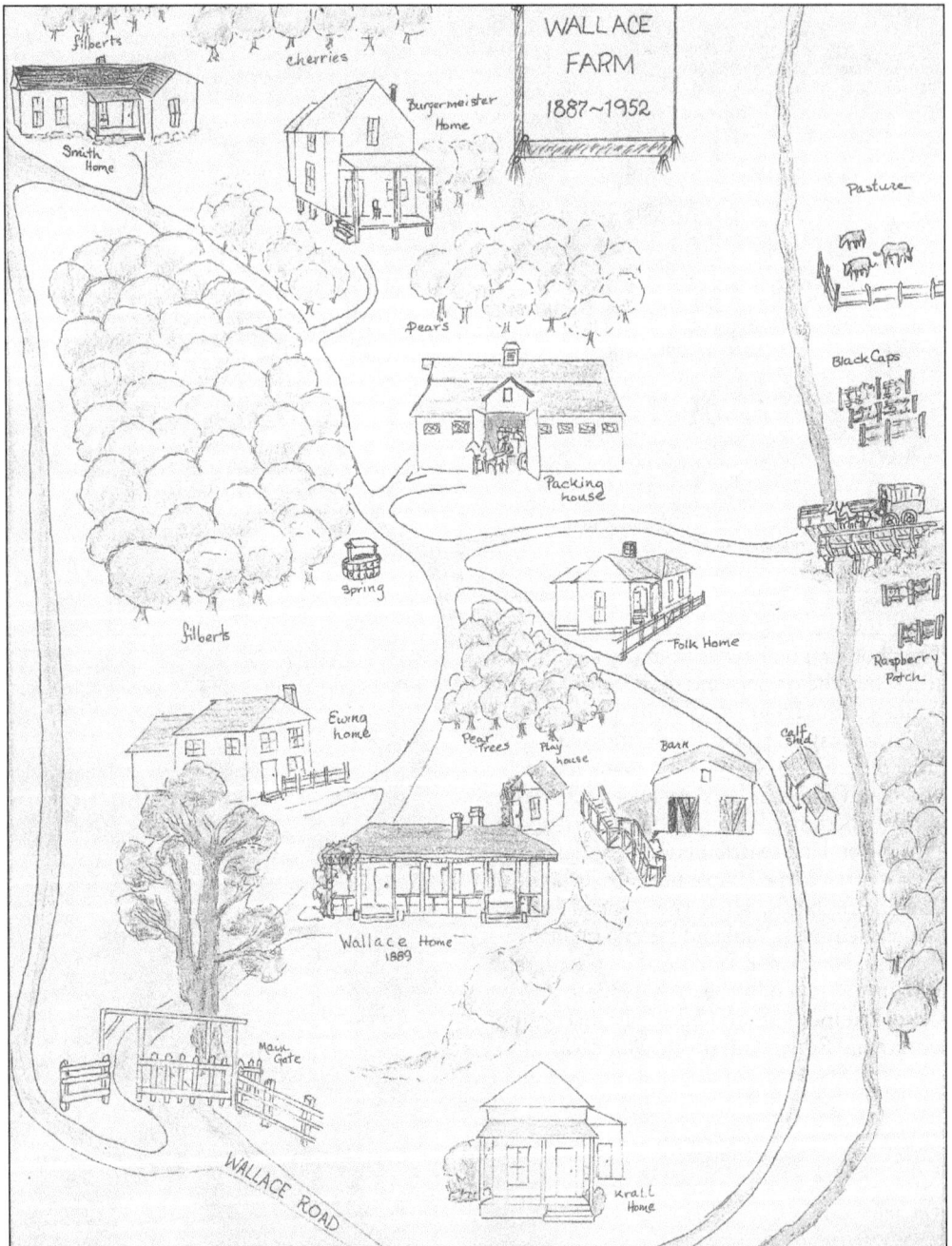

The labels on the drawing read:

filberts • cherries • Burgermeister Home • WALLACE FARM 1887~1952 • Smith Home • Pasture • Pears • Black Caps • Packing house • Spring • filberts • Folk Home • Raspberry Patch • Ewing home • Pear Trees • Play house • Barn • Calf Shed • Wallace Home 1889 • Main Gate • WALLACE ROAD • Krall Home

Here is a view of the Wallace farm as drawn from memories and photographs of the buildings by artist Sonja Ely of the Polk County Historical Society. This drawing gives a glimpse of how the buildings on the farm were laid out. Of all the buildings shown on this map, only the main Wallace house, built by Robert S. Wallace in 1889, remains standing today. (PCHS.)

The home of F.C. and Hazel Ewing was located on Wallace Hill, just west of Wallace Orchards. Here, F.C. and his brother Archie, the foreman for Wallace Orchards, and their wives relax on the front porch. From left to right are Audrey Ewing, Archie Ewing, Hazel Ewing, and F.C. Ewing. Archie lived on the Wallace farm in the house across from the main Wallace house (as shown on the previous page). Robert, son of F.C. and Hazel Ewing, is photographed at right with a calf outside the family's barn on Wallace Hill in the mid-1920s. (Both, PCHS-Ewing.)

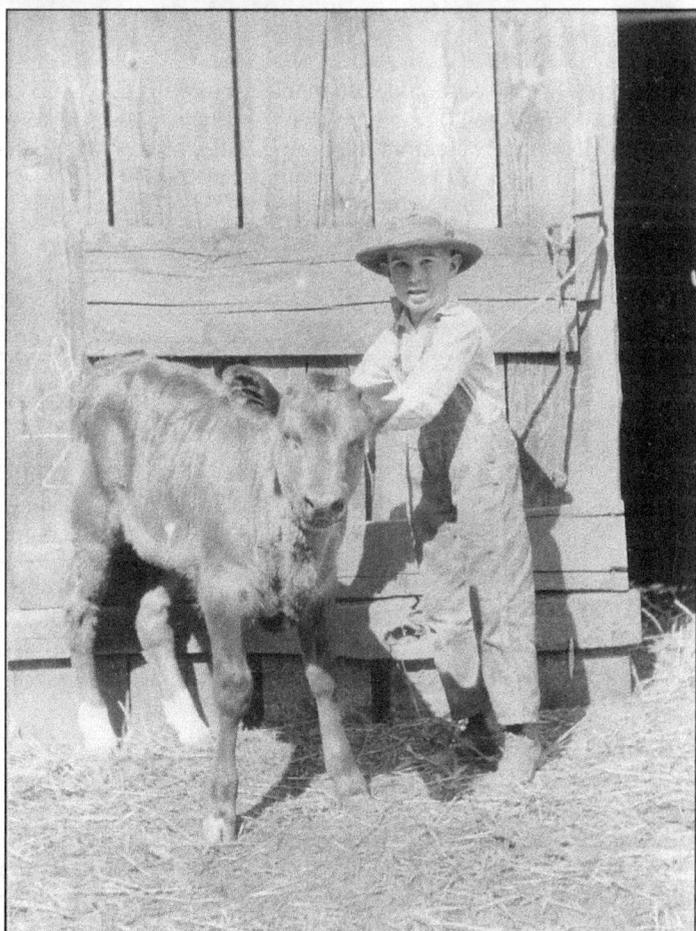

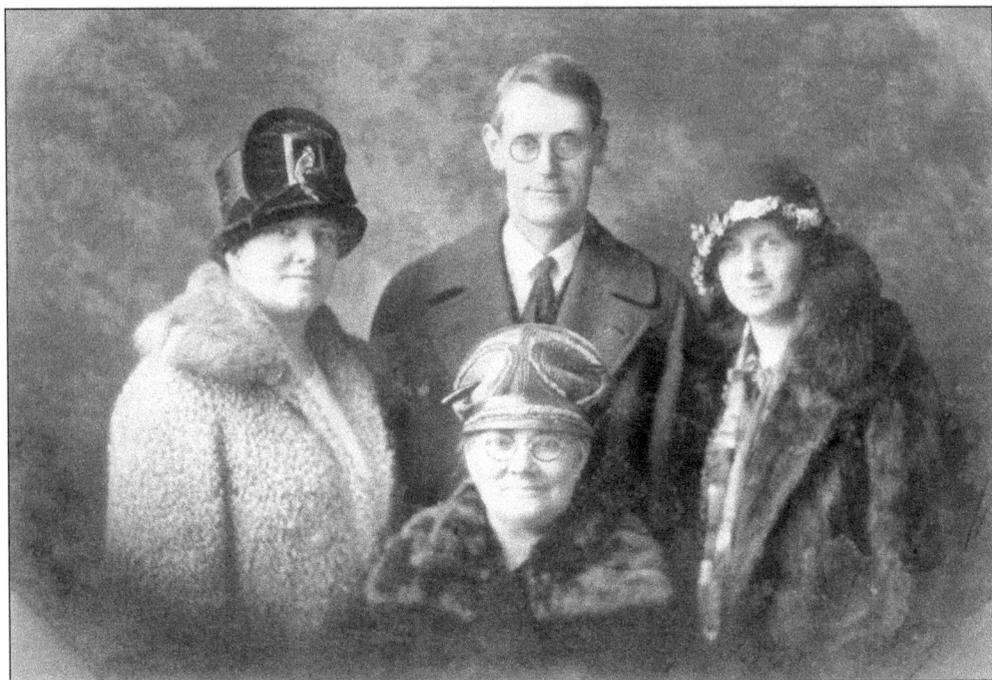

Showing off their fur coats and fashionable hats around 1920 are Mrs. William J. (Mary) Crawford in the center front, Stella (Crawford) Henry at left with husband Wayne Henry, and Joyce Crawford at right. All of them were from the Spring Valley area of West Salem. (PCHS.)

John Moritz was the second mail carrier on the West Salem rural route, now motorized. He replaced James Remington and his horse-drawn wagon. This photograph was taken in 1923 on Wallace Road NW, where it intersects with Michigan City Lane. (PCHS-IM.)

At right, three-year-old Dale Parnell enjoys riding horseback at his family's home in West Salem around 1931. The Parnells' home was on the property that is now home to the Capital Manor Retirement Center. Dale graduated from the University of Oregon and taught at several schools before becoming Oregon state school superintendent in 1968, serving until 1974. Today, he quite fittingly makes his home at the spacious and beautiful Capital Manor. The photograph below shows members of the Parnell family at their home around 1937. Pictured from left to right are Eleanor, Orville, Darrel, father Archie, Irene, and Dale Parnell. (Both, PCHS-Parnell.)

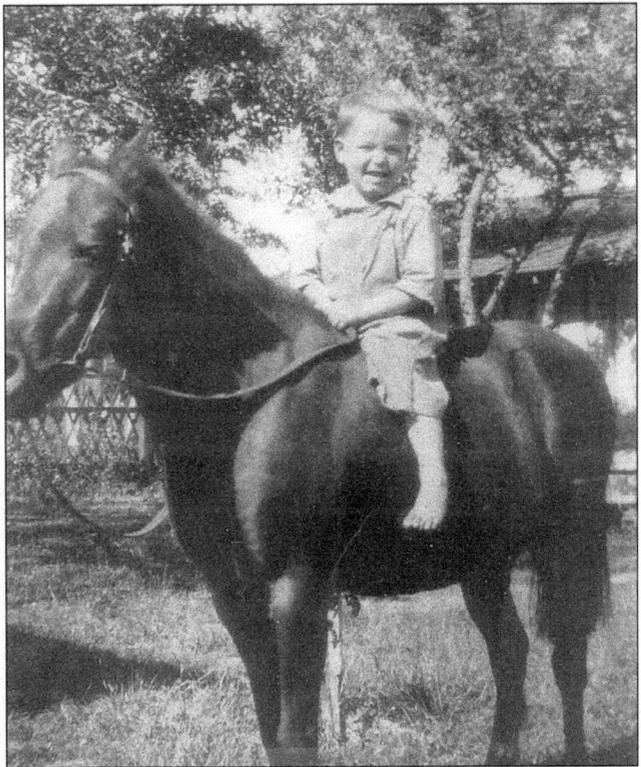

83

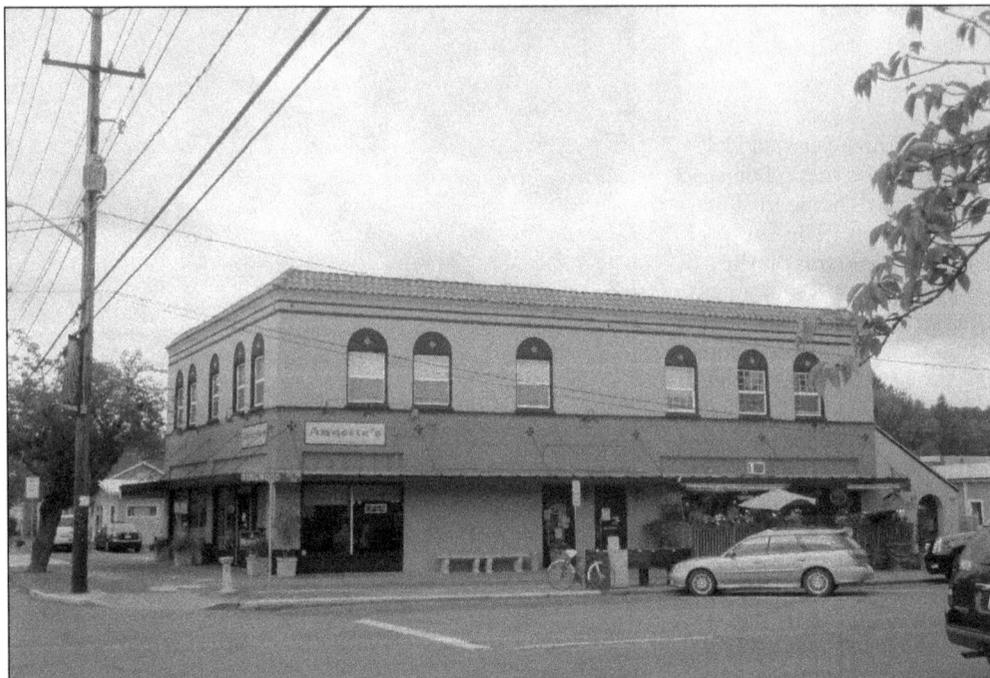

A West Salem landmark, the building above was first known as the Robertson Building. When it opened for business in 1927, the ground floor included Rousch Grocery, Dewitt Real Estate, and a drugstore. The second floor contained the Edgewater Apartments. The building was later home to Busick's and then Walt White's Kingwood Market. Today, it is home to Annette's Westgate Café.

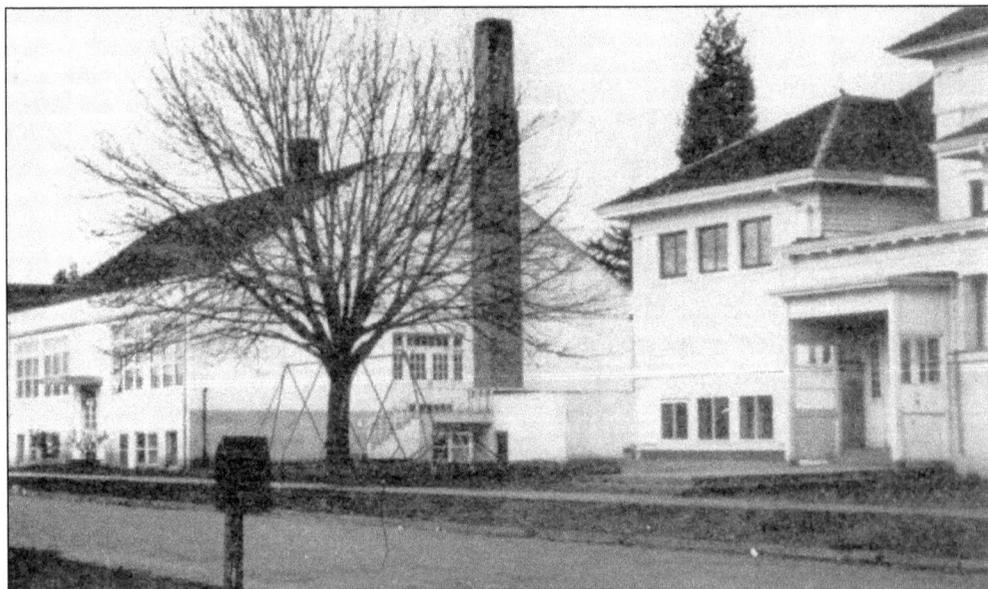

West Salem continued to grow, and by the 1920s, there was a need for a larger school building. An unattached addition, built to the west of the original school building, was added to West Salem School in 1927. The new section, shown at left with the tall chimney, consisted of four classrooms, an office, and a basement.

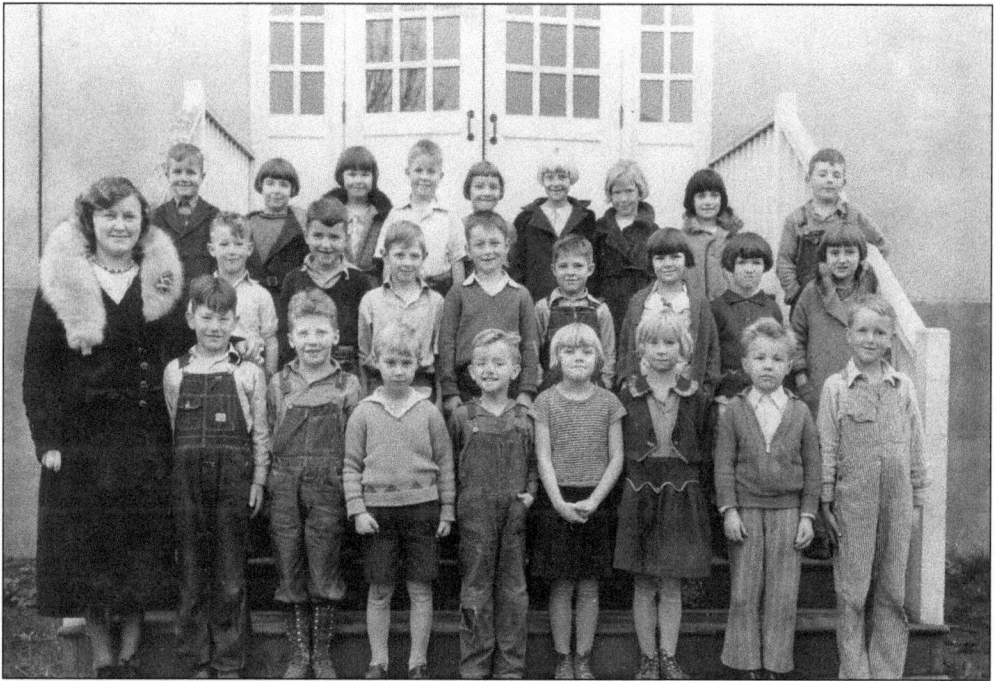

West Salem Elementary School teacher Flora Polley, at left, is shown with her second-grade class in 1932. Frances Friesen (later Finden), daughter of John and Anna (Warkentin) Friesen, is shown in the second row at the far right. (PCHS-FFF.)

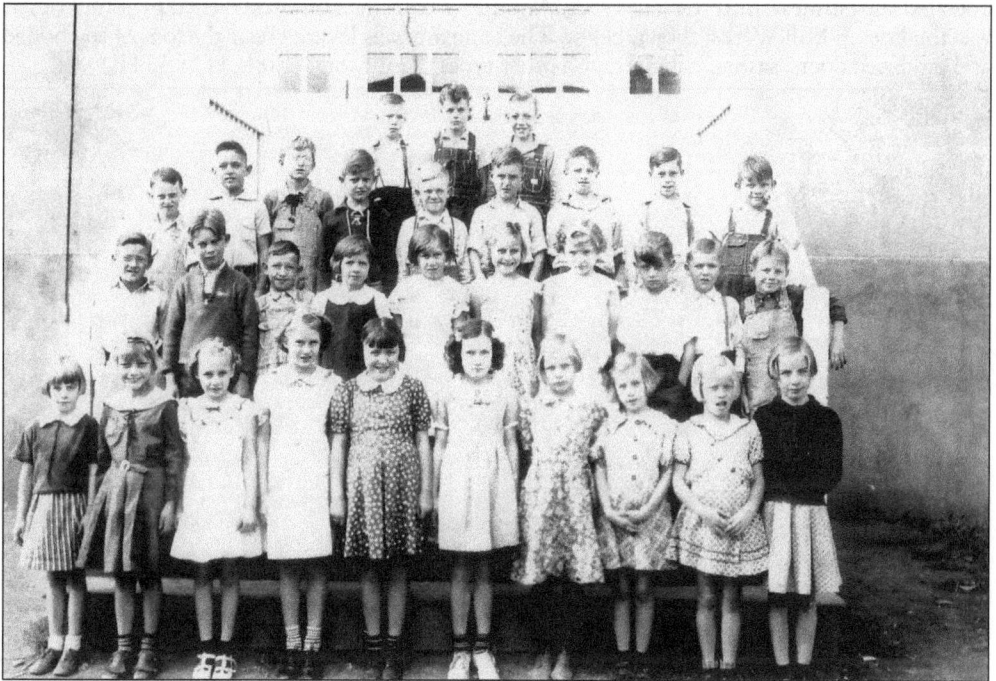

Here is the West Salem School third-grade class photograph of 1937. (PCHS.)

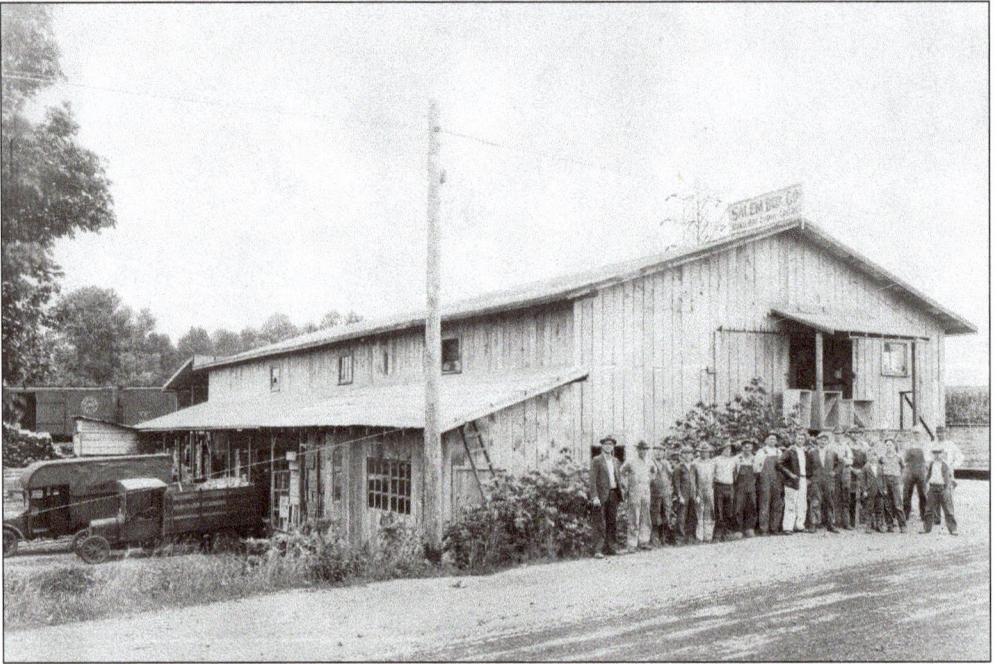

The Salem Box Company was located on the east side of Wallace Road, just north of the railroad tracks, shown here in 1930. Wooden boxes, prune trays, and other wood containers were built here, employing many local men during the Great Depression years. In 1937, the building was destroyed when union organizers set it on fire. They were later convicted of arson. Owner John Friesen (at the far left) and his three sons, Erney, Willard, and Allen (at the far right), rebuilt and operated the business until the late 1950s. Another West Salem business owned by John Friesen was the Friesen Mill Works, shown below. The company was located near the foot of the bridge and produced doors, sashes, cabinets, and other types of millwork. (Both, PCHS-FFF.)

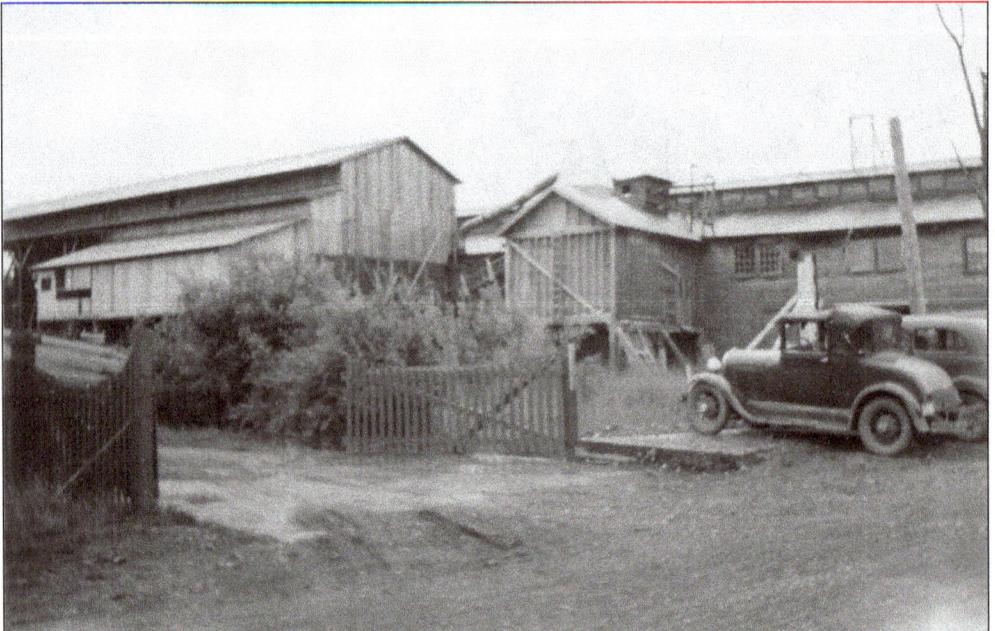

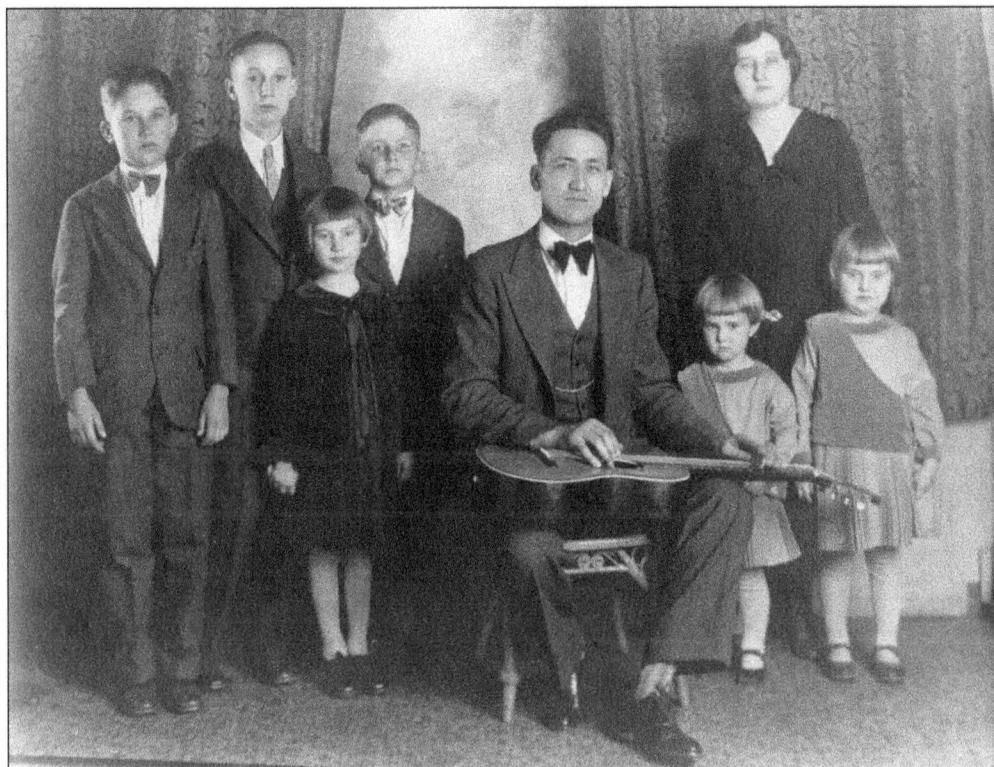

The John Friesen family is shown here around 1930. John was the owner of several businesses and later served as mayor of West Salem. From left to right are Willard, Ernest, Marjorie, Allen, John (father), Helen, Anna (mother), and Frances. John was also a choir director and singer, and the entire family was musically talented. (PCHS-FFF.)

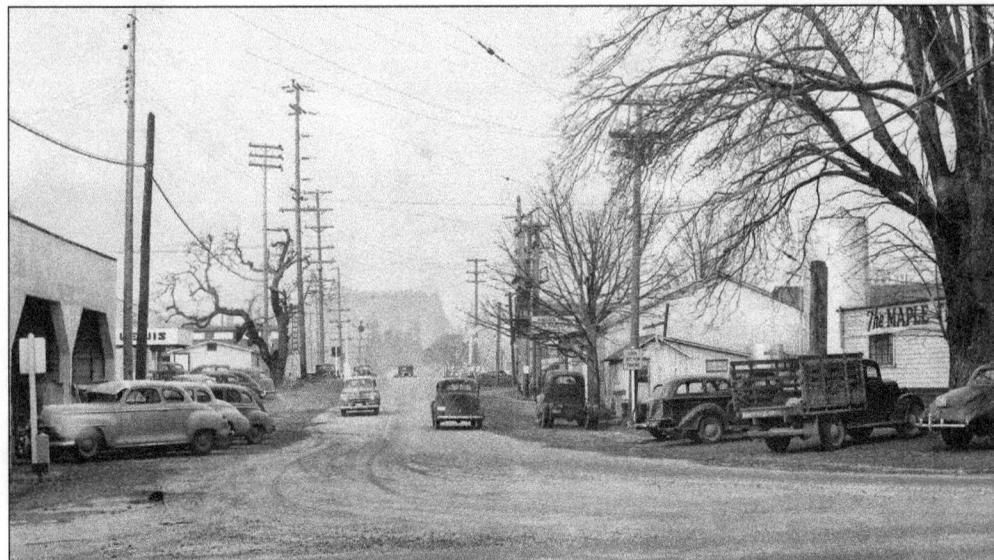

Pictured is a 1930s view of Wallace Road looking north from the intersection of Edgewater Street at the foot of the Center Street Bridge. Several businesses line the road, including The Maple Tree, which can be seen at right. (PCHS-Culp.)

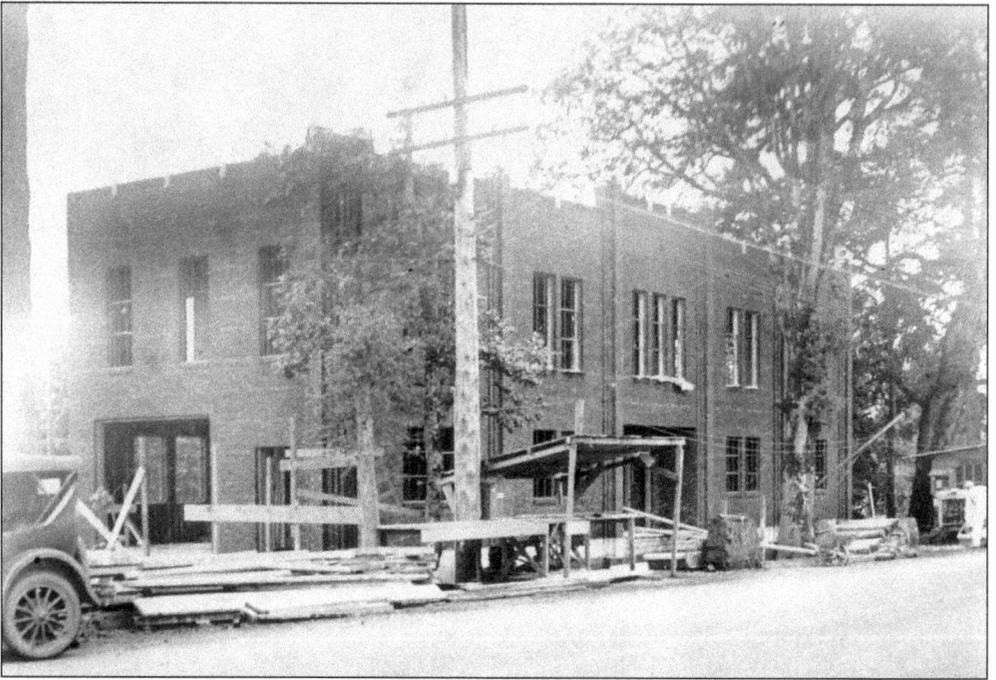

The West Salem City Hall building is pictured under construction in 1936. The cost of the Art Deco–style building was $30,000, and it was built by the Works Progress Administration at the height of the Great Depression. (MCHS 2007.001.1940a.)

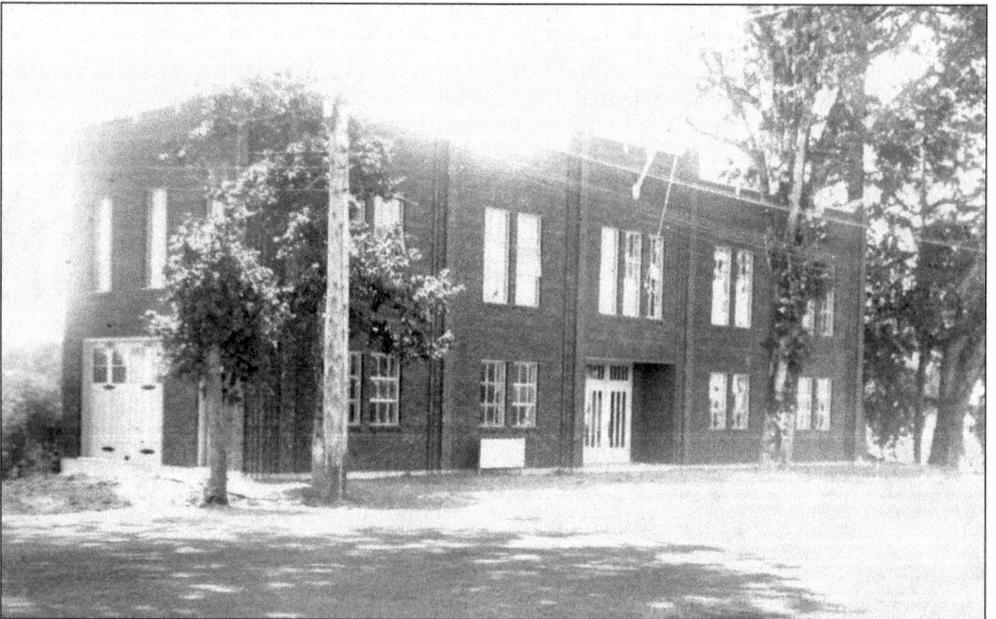

Here is the city hall building after completion in the summer of 1936. The main floor housed offices for the mayor and recorder, a spacious council chamber, the water office, a small library, and a fire truck bay. The upper floor was a community hall that could seat up to 400 people, complete with a stage and dressing rooms. The basement contained two high-capacity well pumps, heating equipment, and two jail cells. (MCHS 2007.001.1940b.)

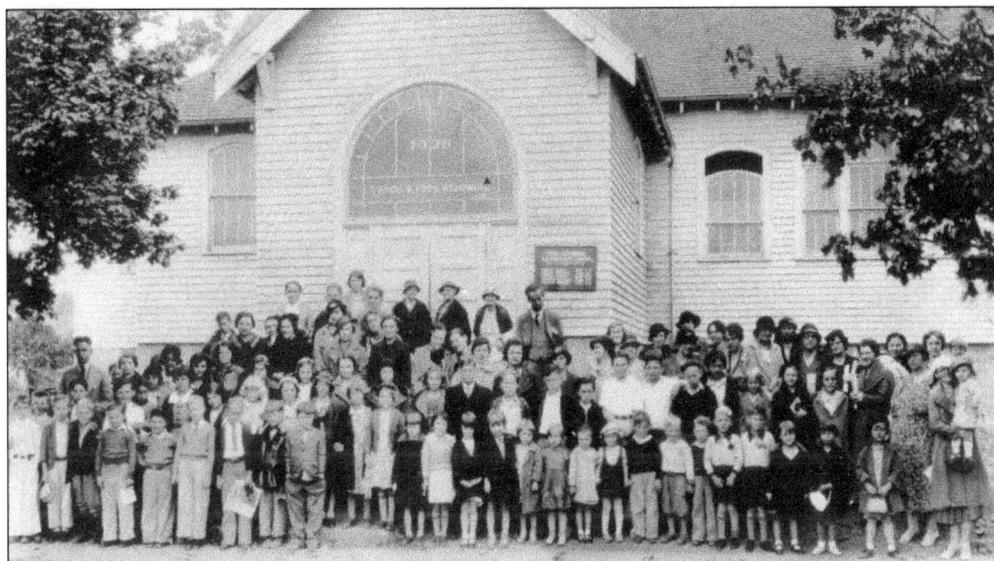

The Thomas B. Ford Memorial Methodist Church was built at the corner of Third Street and Gerth Avenue in 1926. Church members organized in 1878 and worshipped in an old school before this building was erected. The Sunday school classes of 1934 are shown in this photograph. Joe Rierson (wearing cap) is in the second row from the front, just to the right of the two boys wearing white shirts. (PCHS-Rierson.)

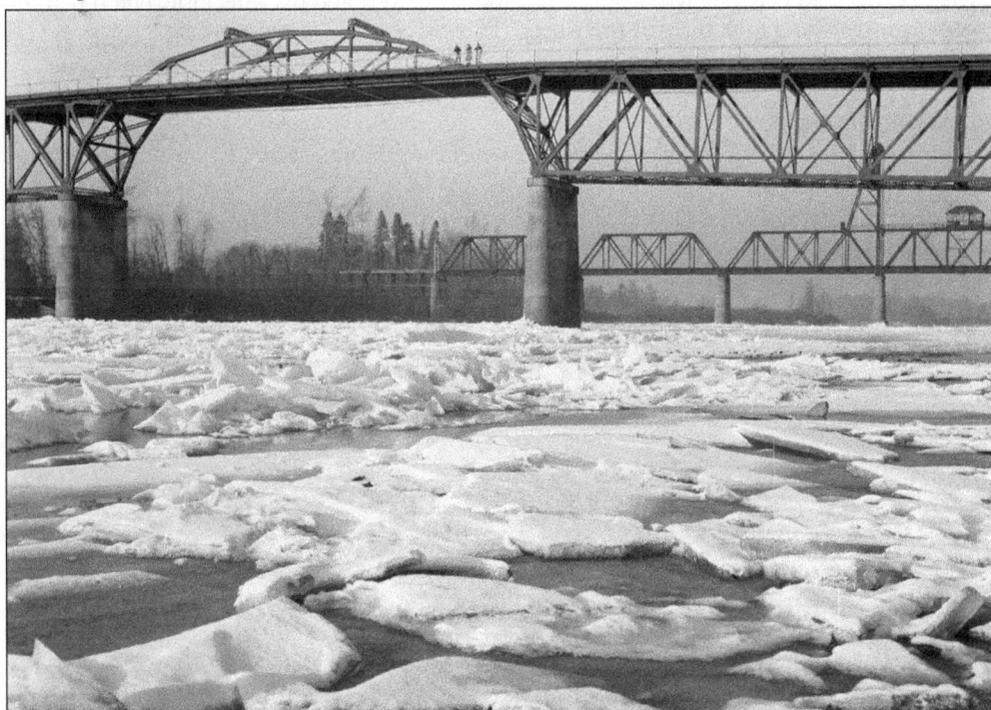

One of the heaviest known snowfalls ever to hit the Salem–West Salem area occurred in the winter of 1937. Twenty-four inches of snow fell in 24 hours, accompanied by severely freezing temperatures that caused ice floes on the Willamette River at Salem, as well as frozen pipes throughout the area. (SPL.)

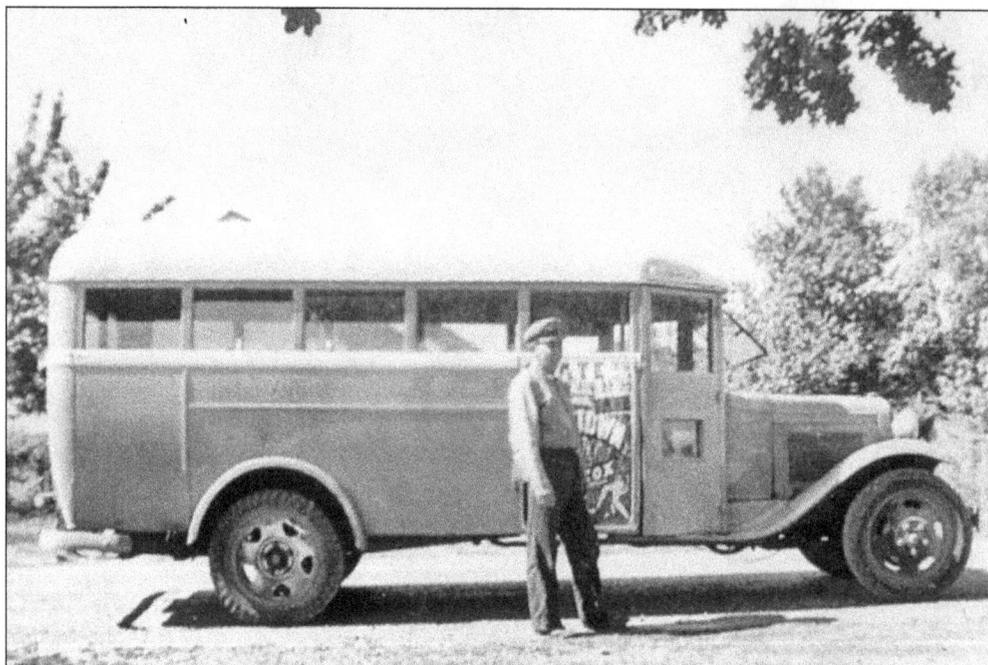

West Salem had its own bus service for several years. The West Salem Bus Company was first owned by Marshall Leek, shown here in 1938. Robert Covert and his wife, Elsie, purchased the company in 1945 and took turns at the wheel. (PCHS-Hay.)

NEW CABINS

TOURIST
CABINS

HOT AND COLD
SHOWERS

Riverside Auto Park

MRS. F. M. BURK & SON, PROPRIETORS

SHADY CAMP GROUND ON THE BANK OF THE WILLAMETTE RIVER

642 EDGEWATER STREET
WEST END MARION-POLK CO. BRIDGE

WEST SALEM, OREGON

This c. 1937 letterhead from West Salem's Riverside Auto Park advertises new cabins and hot and cold showers. The campground was owned by the Burk family and was located along the west bank of the Willamette River. Travelers, as well as migrants looking for seasonal work, often stayed in these cabins. (PCHS-FFF.)

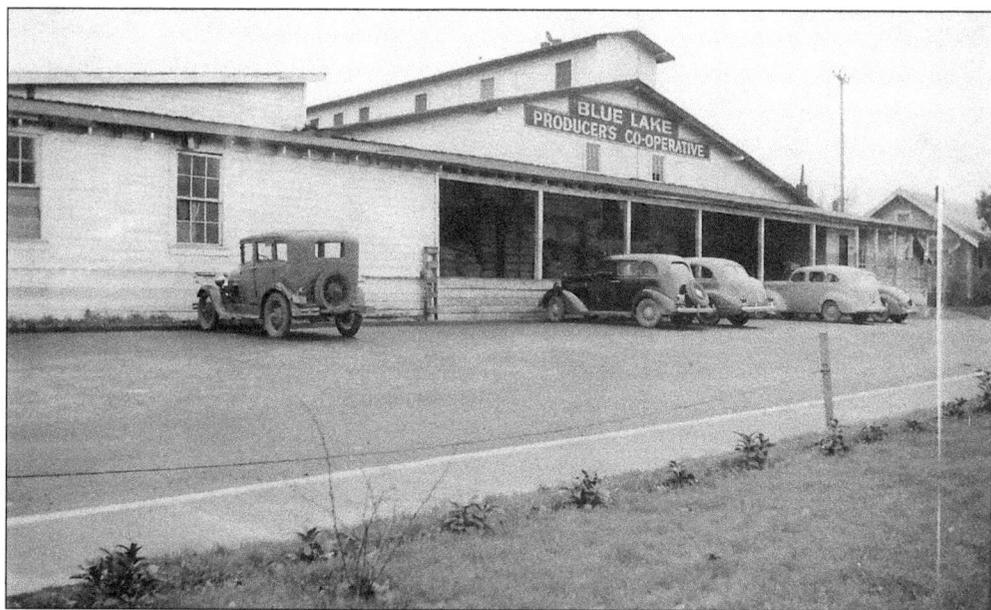

This photograph of the cannery in West Salem on Patterson Avenue was taken in 1938. The cannery changed ownership several times before becoming the Blue Lake Producers Co-Operative in 1937. The name was chosen because of the popularity of the Blue Lake variety of green beans it canned. (PCHS-Lucas.)

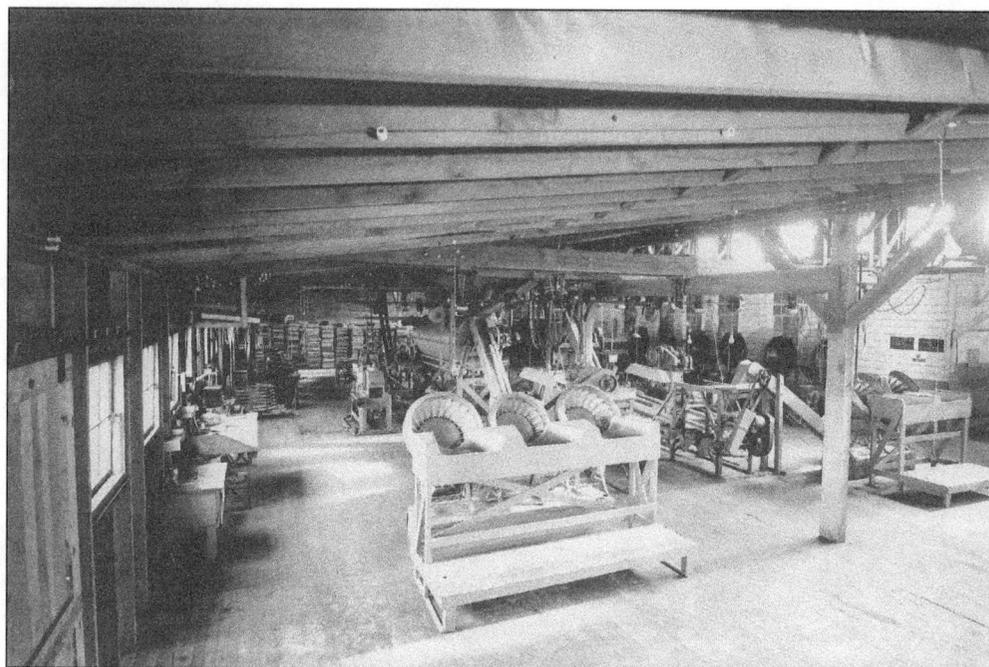

Here is an interior view of one section of the Blue Lake Producers Co-Operative in 1938. The machines with cylindrical tubs in the foreground are bean cutters. The majority of the massive building, including the floors, was made of wood. (PCHS-Lucas.)

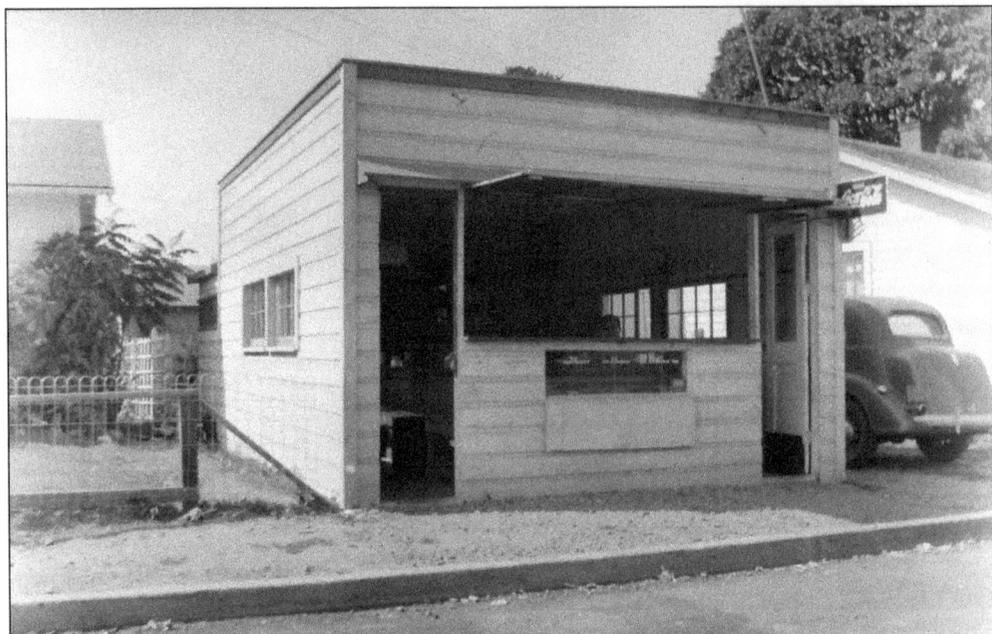

A small diner known as the Cannery Café opened just across Patterson Street from the Blue Lake Producers Co-Operative cannery, amid the residential houses. Cannery workers could purchase a meal or take a coffee break here. Patterson Street was named for Isaac Lee Patterson, an Eola farmer who had served as a state senator then governor in the 1920s. (PCHS-Lucas.)

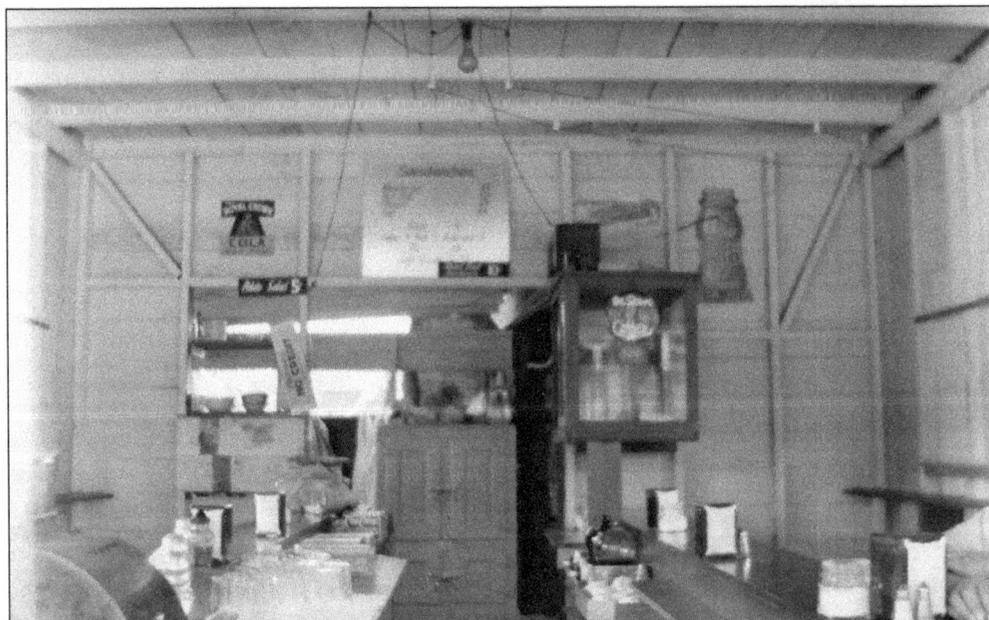

This photograph shows an interior view of the Cannery Café in the 1940s. The menu board shows that diners could purchase hamburgers, hot dogs, cheese or egg sandwiches, or a slice of pie for 10¢ each. Soup, potato salad, a cup of coffee, or a glass of Royal Crown cola were available for 5¢ each. Note the ice box in the center between the counters. (PCHS-Lucas.)

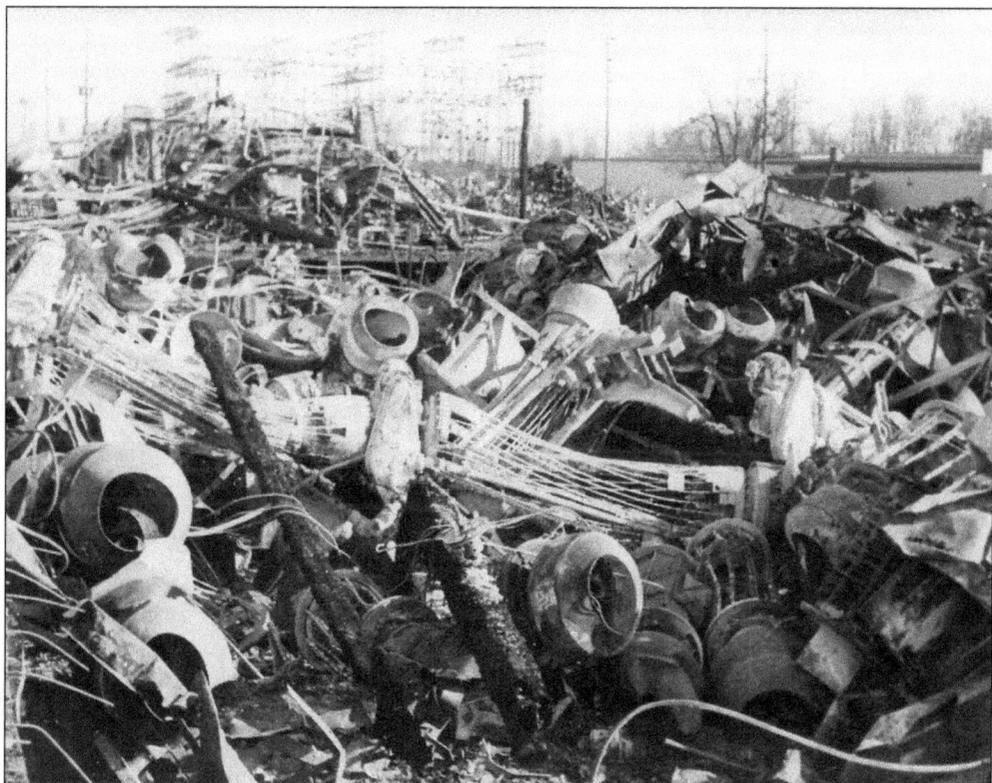

In the middle of the night on December 31, 1944, the Blue Lake Producers Co-Operative cannery caught fire. By the time the firemen arrived, the fire had spread throughout most of the 2.5-acre wooden structure. Thousands of filled and empty cans as well as the canning equipment inside were reduced to a tangle of metal, as seen in these two photographs. Nearby residents heard the loud popping of the filled cans exploding throughout the night and over the next few days. The cause of the fire was never determined, although some suggested it may have been arson, as this was the third fire in West Salem within a few weeks. (Both, PCHS-Lucas.)

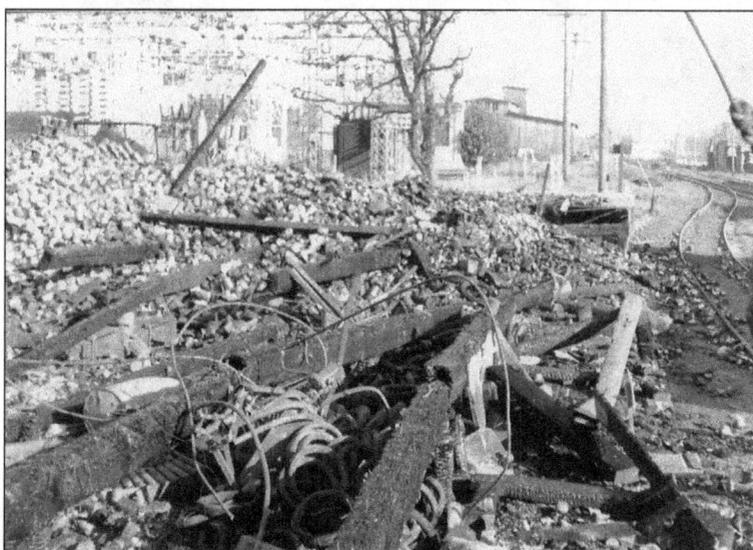

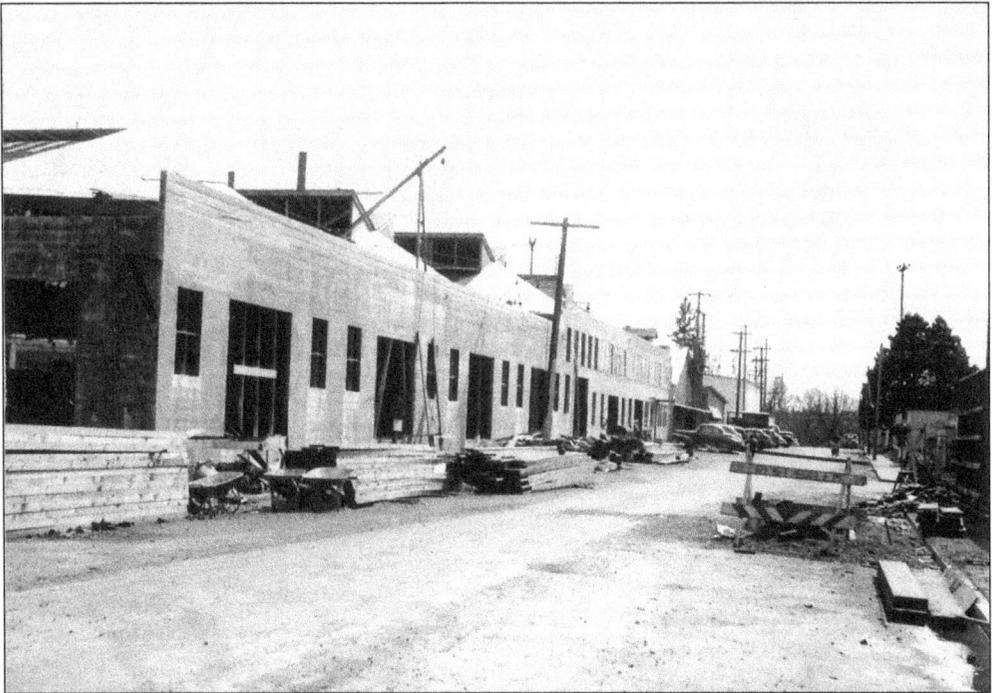

Following the devastating fire, the Blue Lake Producers Co-Operative cannery was promptly rebuilt. The photograph above shows the new main building under construction. It was 260 feet by 300 feet, built with concrete walls and floors to be less flammable. The cannery was able to complete a limited amount of packing in the late summer of 1945. Cannery workers are shown in the 1945 photograph below working on the corn husker and sorting lines. A year later, the name of the cannery was again changed, from Blue Lake Producers to Blue Lake Packers, Inc. (Both, PCHS-Lucas.)

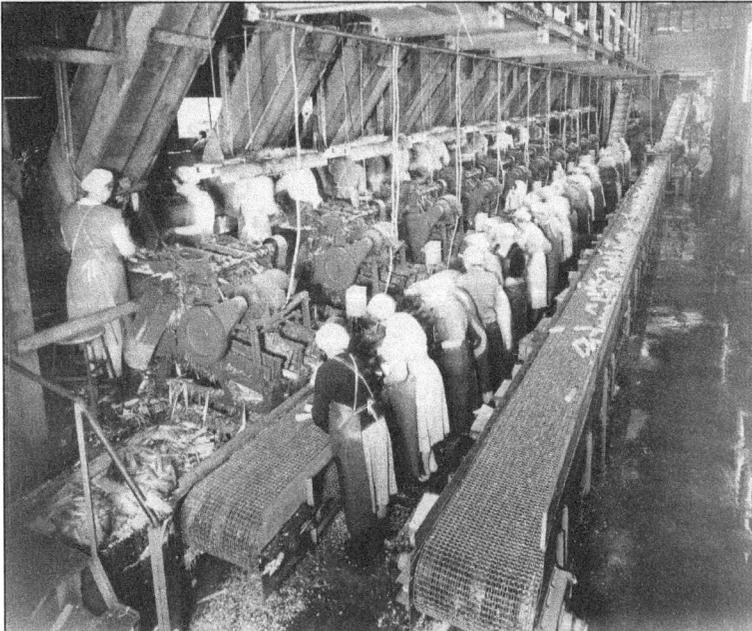

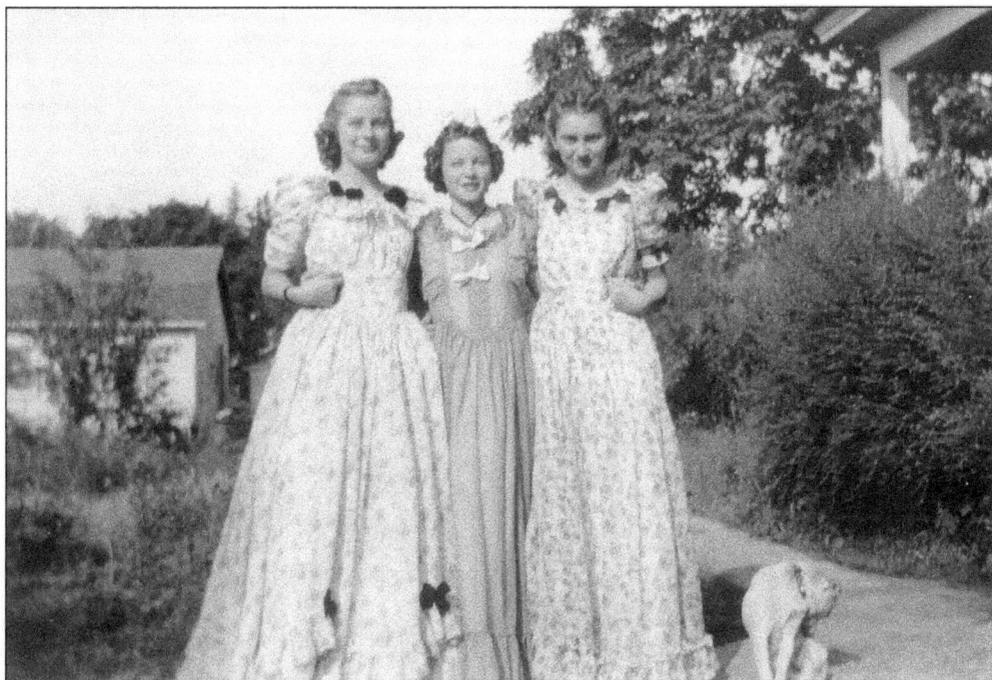

In 1940, the city of Salem celebrated its centennial. Residents of Salem and West Salem celebrated with many special events. These young ladies joined in the celebration by dressing in the style of pioneer days. From left to right are Edith Heise, Vivian Bell, and Frances Friesen. Frances's father, John Friesen, was mayor of West Salem at this time, and he participated in the opening ceremonies of the centennial. (PCHS-FFF.)

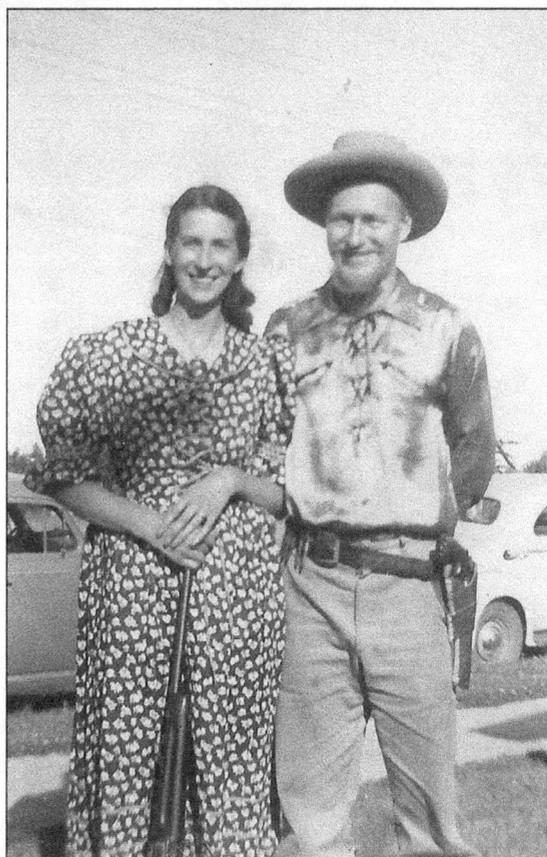

West Salem residents Juanita and Frank Sellers, the grandparents of author Lynn Sellers Mack, are shown dressed up for the 1940 Oregon Centennial celebration. Sellers, a baker who worked at a Salem bakery for many years, built the family's home on Ruge Street in the late 1930s. Juanita was among the first employees to work at the Meier & Frank store when it opened in Salem in 1955.

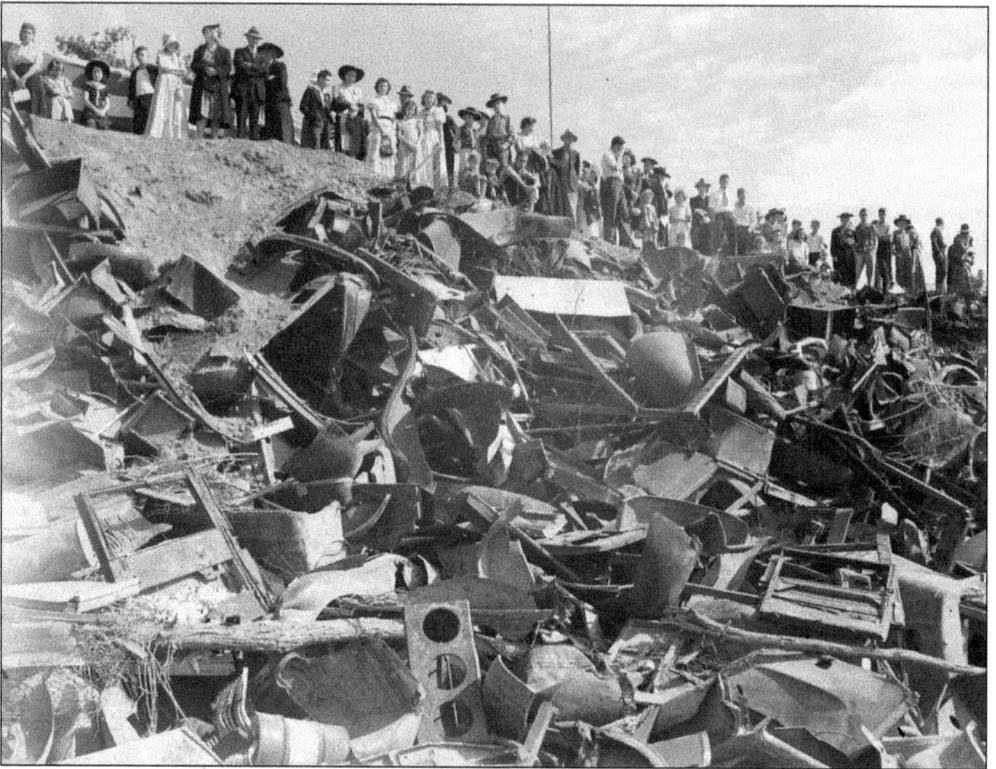

Folks dressed in old-fashioned costumes are lined up along the west bank of the Willamette River, waiting for the opening of a special riverside centennial ceremony in 1940. In the foreground, a section of riverbank is full of old car parts; the metal was later covered with sand and gravel in an attempt to prevent erosion. (SPL-BM.)

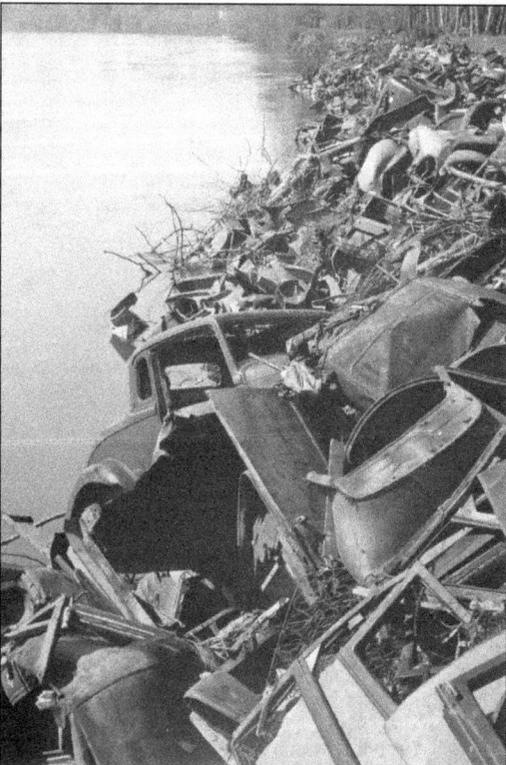

Capital Journal photographer Ben Maxwell took this 1940 photograph of old automobiles that had been dumped by the private property owner onto the West Salem side of the Willamette River bank to prevent erosion. (SPL-BM.)

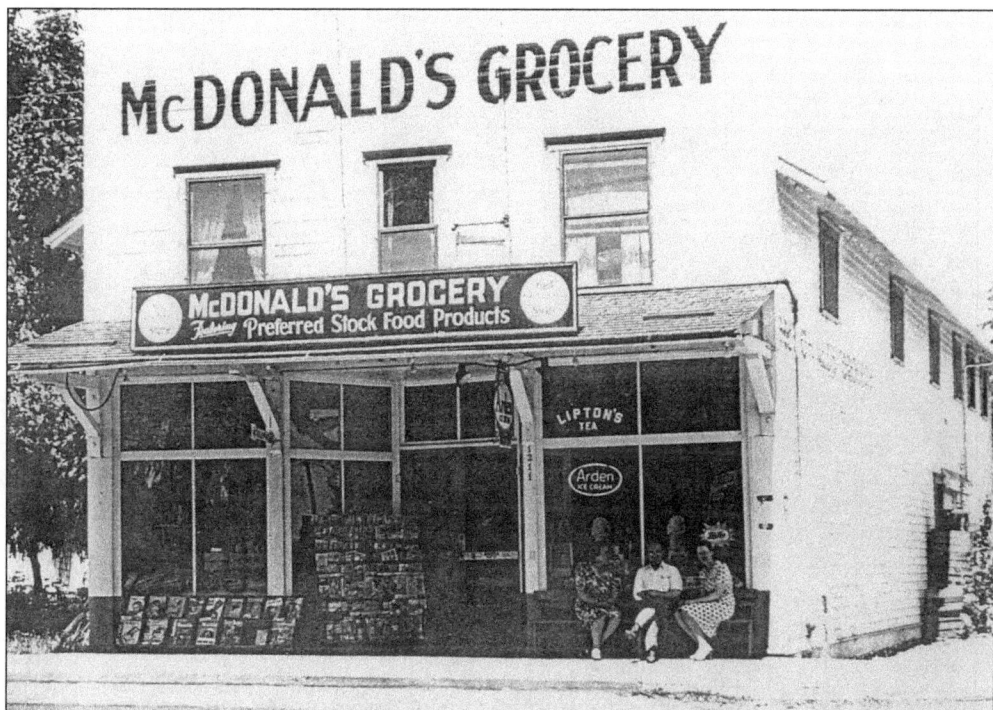

Three unidentified people in the late 1940s sit near the entrance to McDonald's Grocery, now home to Trudel's Deli. Reg McDonald purchased the business from Walter Gerth when Gerth retired. McDonald's Grocery featured meat, groceries, and a soda fountain offering Lipton's Tea and Arden Ice Cream. The store also carried a large selection of magazines, as can be seen displayed in front of the store. (PCHS–Robert Laurie.)

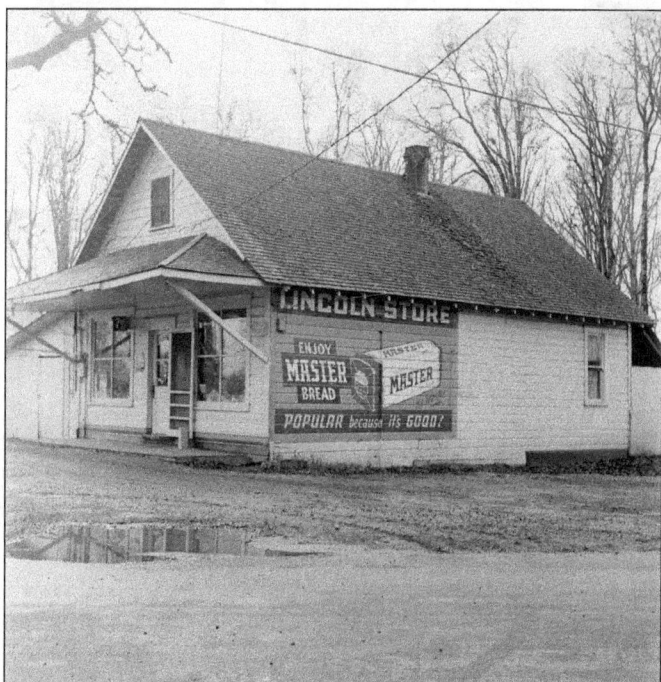

Another small roadside store familiar to many West Salem area residents was the Lincoln Store on Wallace Road. In earlier years, a store stood in the lower area of Lincoln, but by the 1930s, this store was opened in an old house, and it remained there for many years. It was torn down and replaced with a new building in the 1980s. (SPL.)

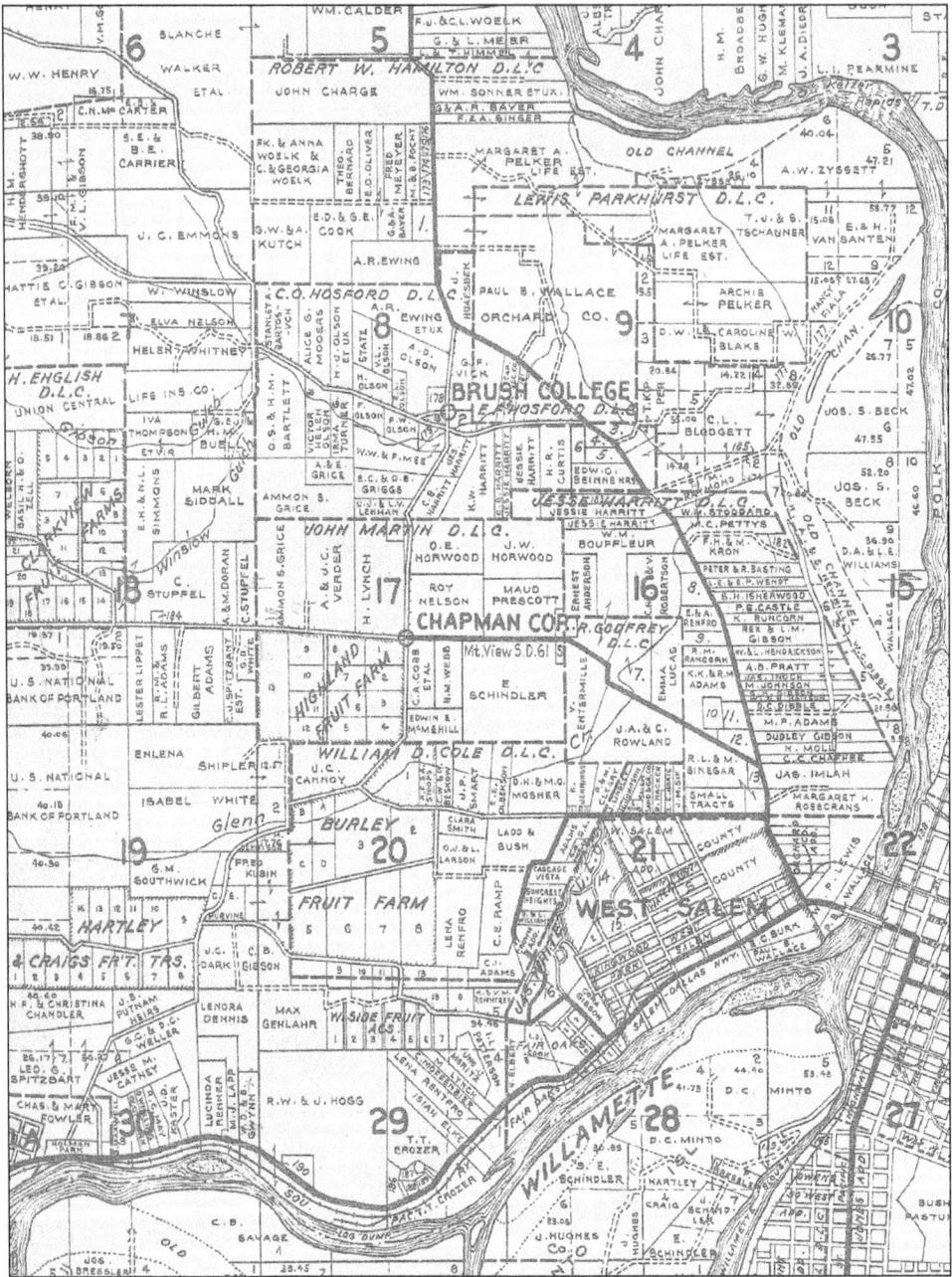

This 1942 Metsker map provides a great illustration of a portion of the West Salem area, showing property lines and listing rural property owners by name. The map also identifies many of the original donation land claim owners who first settled the area in the 1840s and early 1850s, including James White, William D. Cole, John Martin, R. Godfrey, Jesse Harritt, H. English, E.F. Hosford, C.O. Hosford, and Lewis Parkhurst. Several large fruit-farming tracts are shown in the West Salem hills: Clarkview, Highland, Burley, and Hartley & Craigs. Most of the single-family farms also had orchards, creating an amazingly beautiful landscape, especially in the early spring, when the trees were in bloom. The Paul B. Wallace Orchard Company is shown in section nine. (PCHS.)

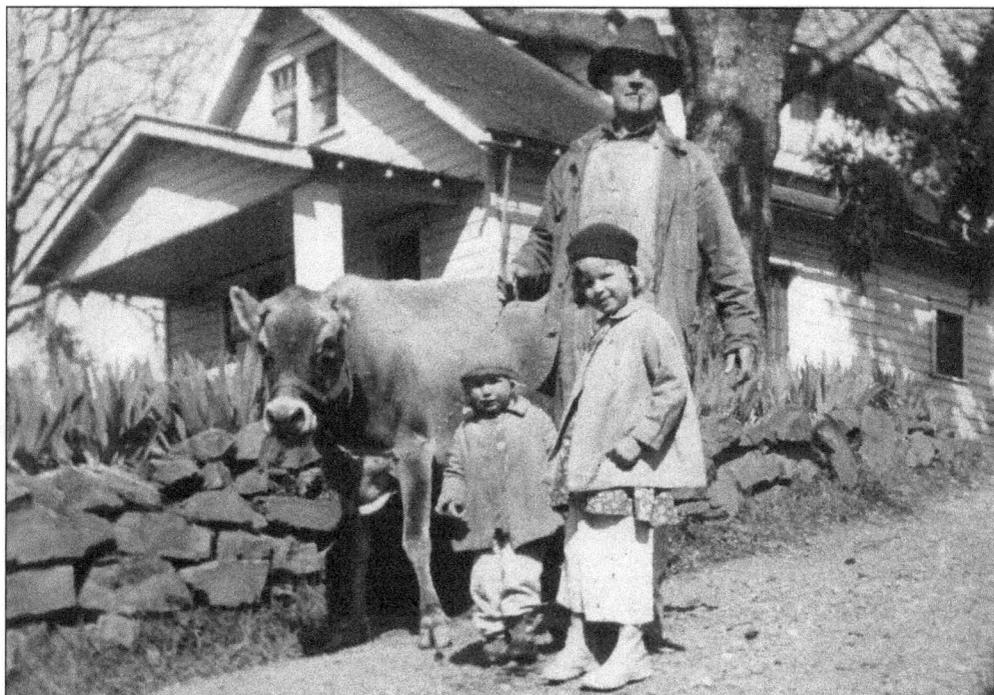

Elmer Emmett, son of John P. Emmett of Spring Valley, and two of his granddaughters, Janice (left) and Marion Coffel, along with their cow Old May, are at their home on Glen Creek Road, just up the hill from Wallace Road around 1939. Janice and Marion are seen below with their class at Mountain View School in 1945. Pictured from left to right are (first row) Kenny Askey, Rosemary Gilbert, Johnny Garner, Della Mae Schindler, Jerry Ruest, Joreen McDonald, unidentified, and Sandra Zahn; (second row) Gail Watson, Wyonna Askey, Janice Coffel, Mary Ruest, Dorothy Simmons, Milford Schroder, and Barbara Garner; (third row) Marvin McDonald, Buzz McDonald, Wayne Simmons, Beth Gilbert, Ann Gilbert, and Patti St. Clair; (fourth row) Ronald Hoxie, unidentified, Marion Coffel, Alcetta Gilbert, Molly Denison, and Estelle Schroder; (fifth row) Mrs. Dimmick, Winton Zimmerman, Gerald Dilleon, Barbara Dilleon, Ruth Ruest, Pat Olson, and Mrs. Burke. (Both, PCHS-JW.)

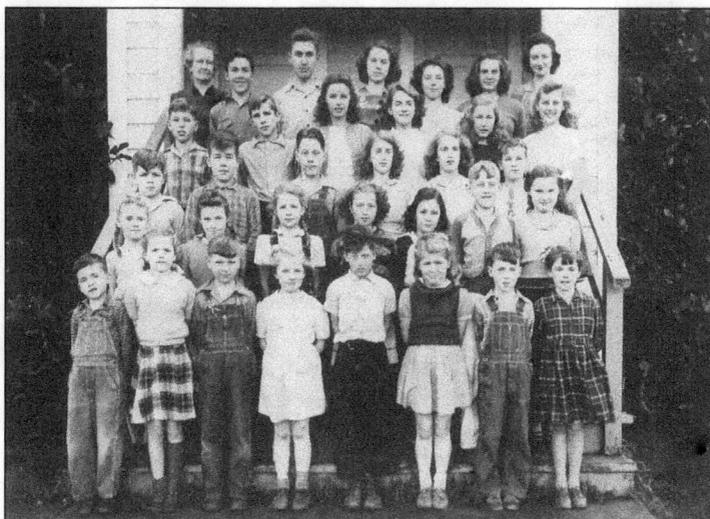

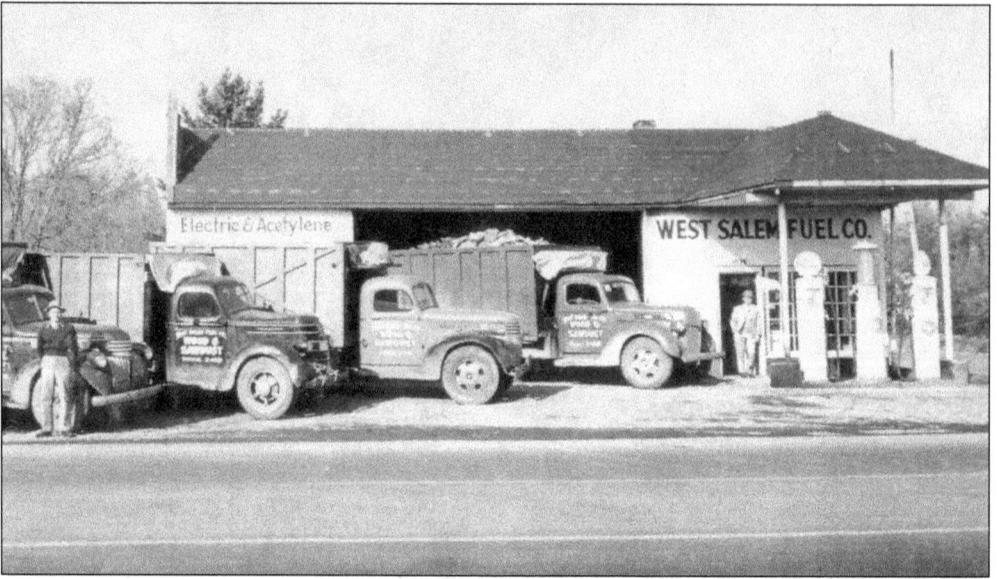

West Salem Fuel Company was located at 1525 Edgewater Street. The company sold and delivered wood, sawdust, gasoline, heating oil, and industrial oil products. At the far left is driver Charlie McCraven. Standing in the doorway is owner John Zumstein. Note the glass-domed gasoline pumps at the right. (Marvin Sannes collection.)

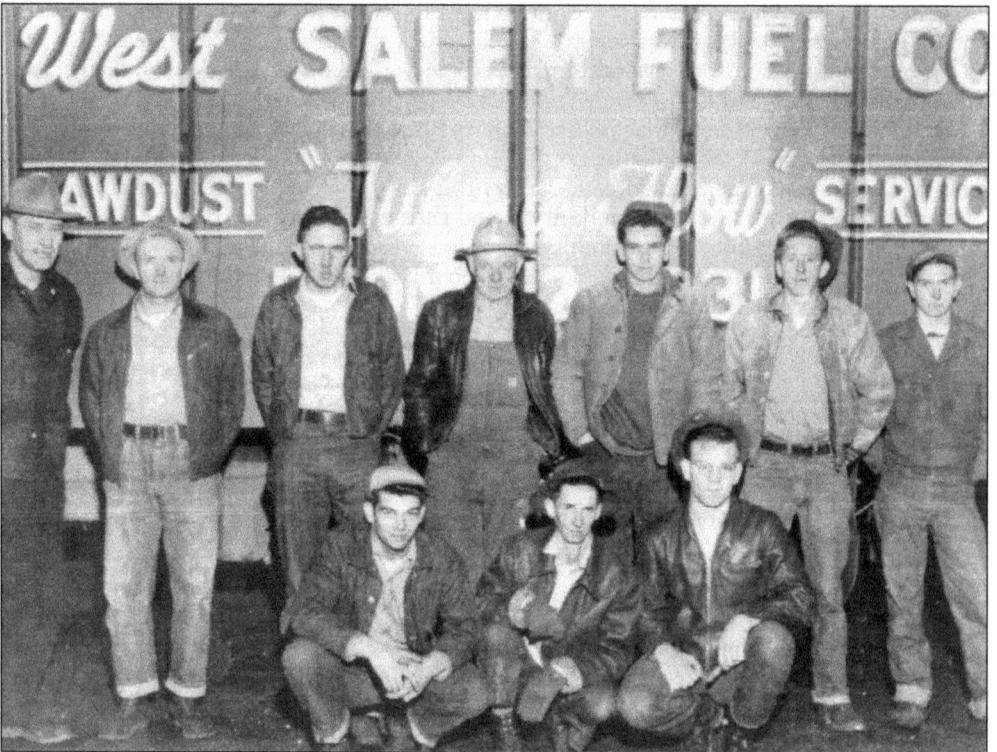

West Salem Fuel Company workers are, from left to right, (kneeling) Dick Prettyman, Eldon Johnson, and Jim Wells; (standing) Morris Shepard, Charlie McCraven, Al Warkenton, Ed May, Bill Nelke, Gene Timberlake, and Darrell Hoover. (Sannes Collection.)

Glenn O. Lewis and Merle E. Pruett opened The Maple Tree in the mid-1930s. The business was located at 495 Wallace Road, near the foot of the West Salem side of the Center Street Bridge ramp. Note the huge maple tree next to the building. (PCHS-Bales.)

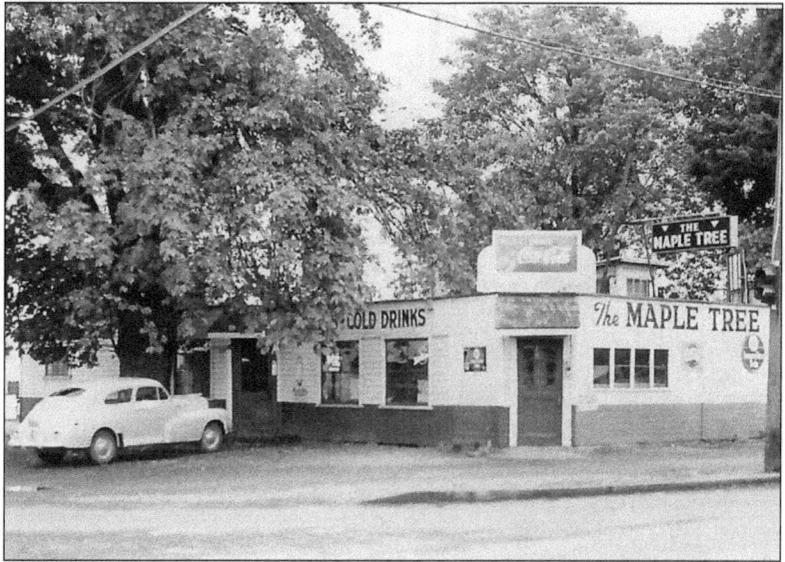

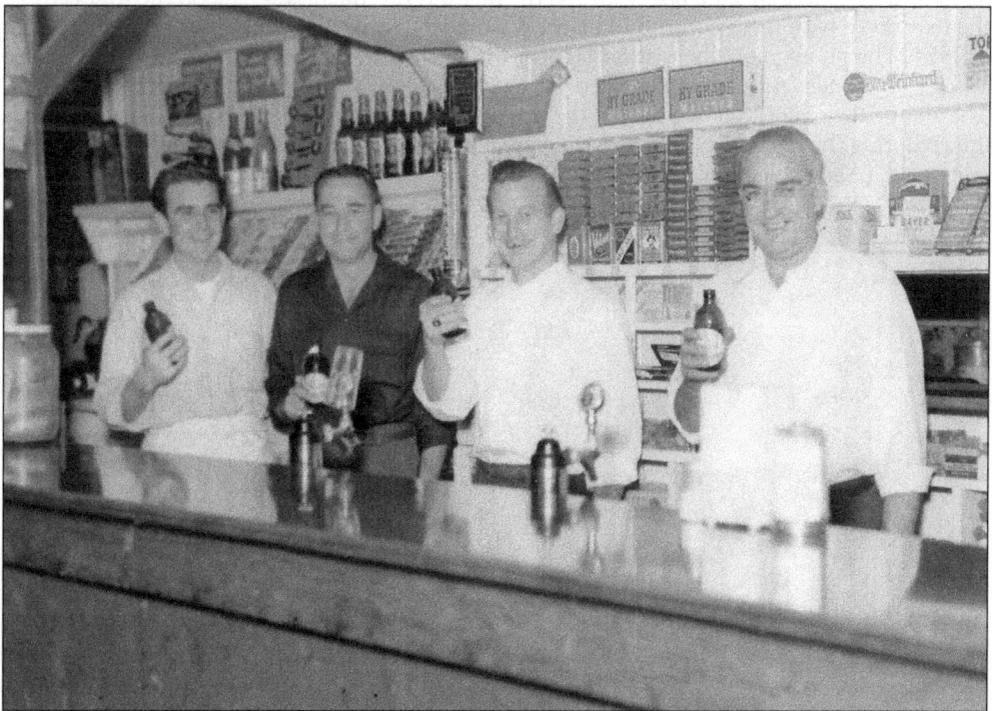

Celebrating behind the bar at The Maple Tree in 1949 is owner "Benny" Benson at the far right. Dick Dickinson (second from left) and his wife, Clara (not shown), purchased the business shortly after this picture was taken. Dick served as bartender while Clara prepared lunches for local workers. They owned the restaurant until it was torn down when the Marion Street Bridge was built in the early 1950s. (PCHS-Bales.)

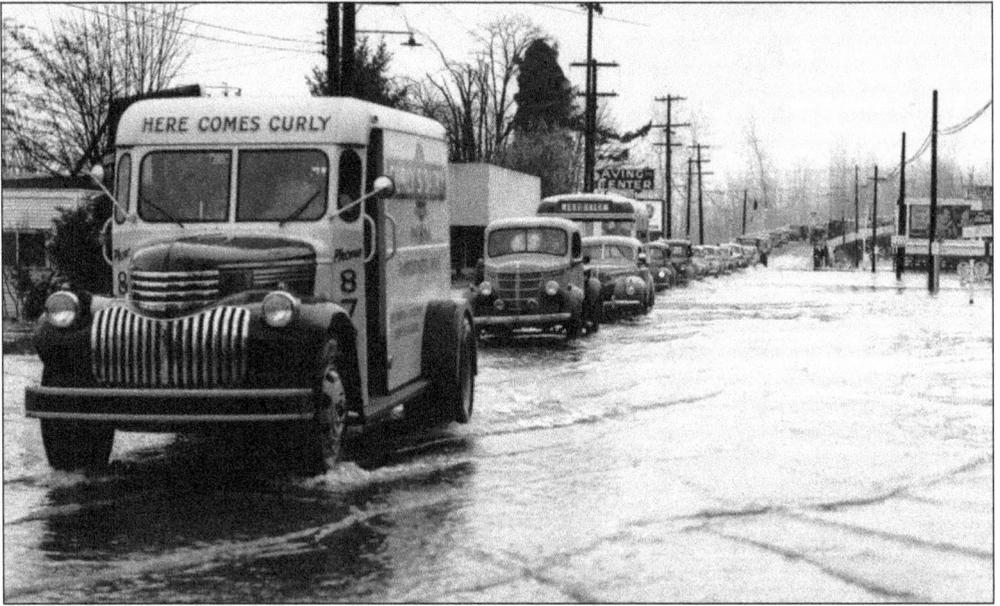

Due to its low-lying, riverside location, the lower area of West Salem was plagued with flooding in the earlier days. The flooding was particularly severe in 1861, 1890, 1943, and 1948, before flood control dams were built upstream and the highway revetment was built on the west bank of the river. Even with these controls in place, West Salem again experienced substantial flooding in 1964. The photograph above was taken in the 1940s and shows vehicular traffic, including a Curly's milk delivery truck and a West Salem School bus, sloshing west on Edgewater Street. The West Salem Super Service station (below) at the corner of Edgewater and Wallace Roads is shown during the flood of 1943. The Maple Tree, just across Wallace Road, appears to be nearly inundated. (Above, PCHS-Culp; below, SPL-BM.)

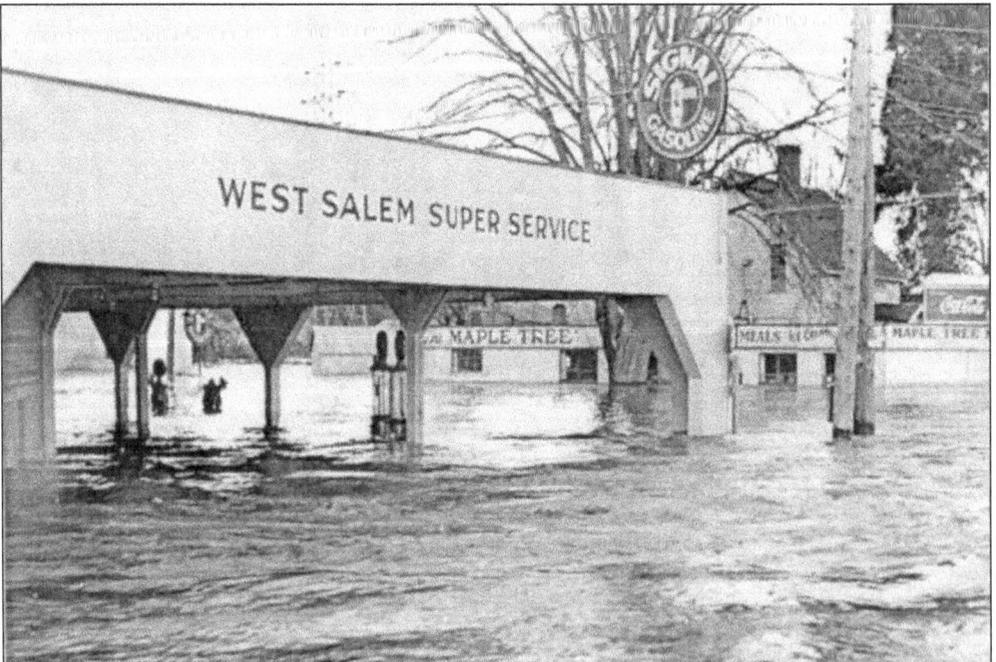

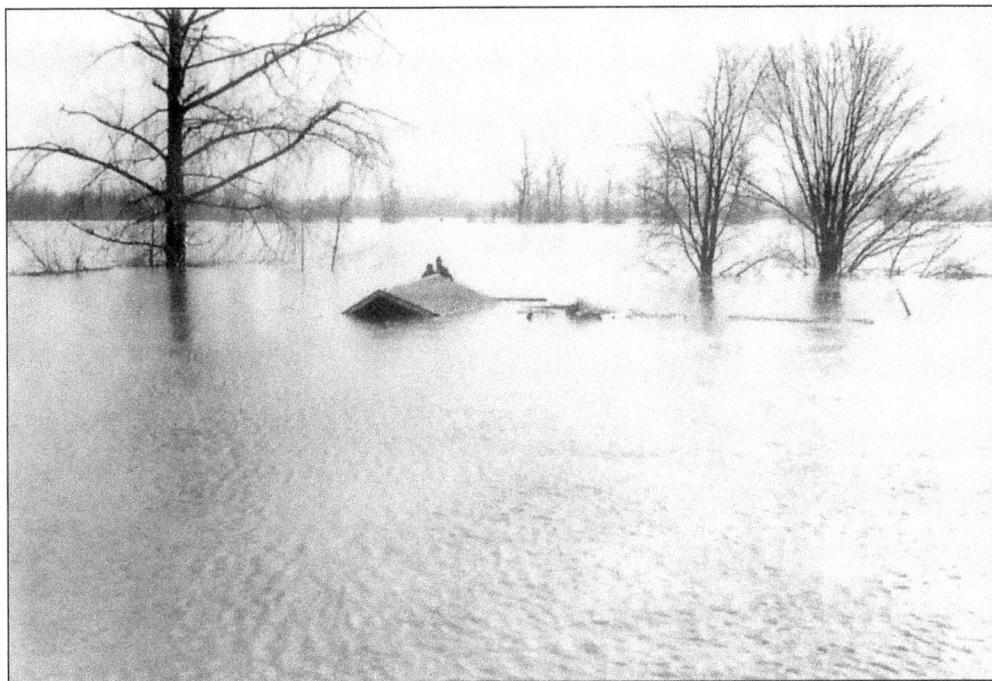

Two people are seen checking out a small building that is almost completely submerged along the river side of Edgewater Street between Gerth and Kingwood Avenues during the 1943 flood. (PCHS-DM.)

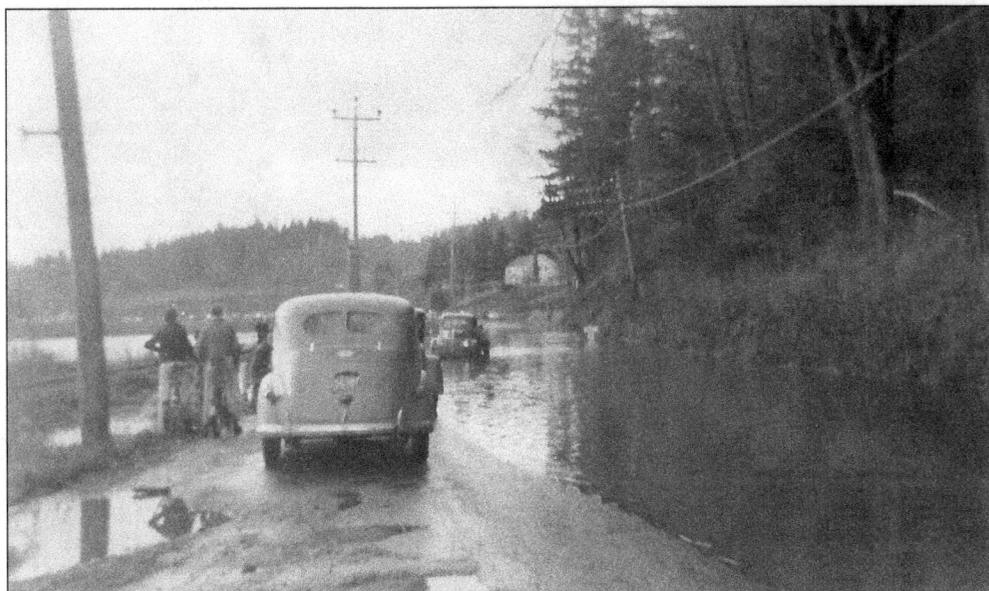

In this picture, cars are seen trying to navigate the floodwaters at the western end of Edgewater Street as it becomes Highway 22, just west of today's Eola Drive. The house in the middle of the picture is the Elbert House; it is still standing today. It is now located within Kingwood West, a senior residential housing complex run by Polk County.

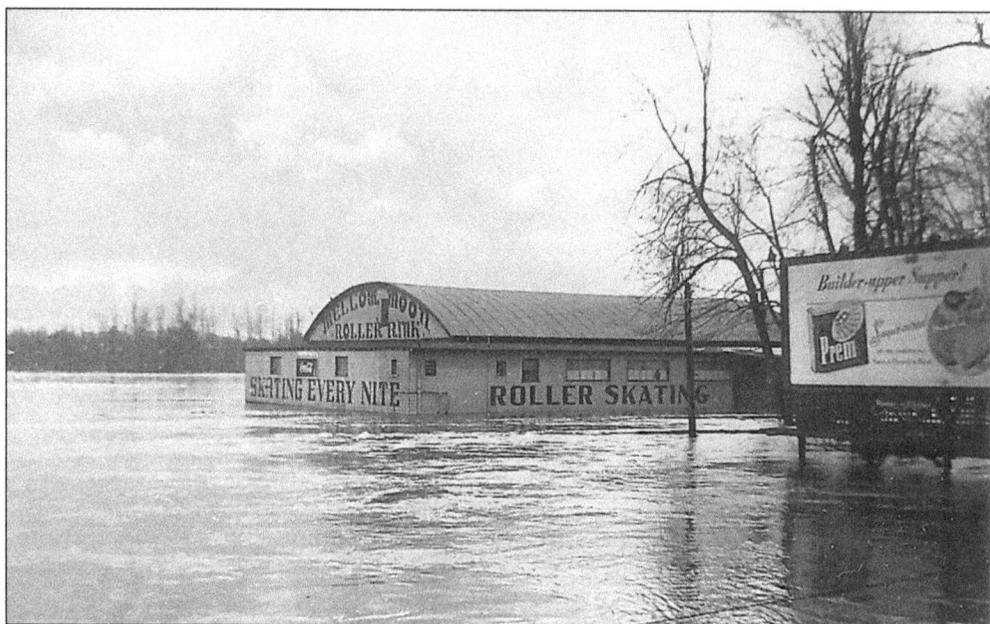

One of the most memorable flooding events in West Salem's history occurred during the winter of 1942–1943, when the Mellow Moon Roller Rink, built in 1925 along the river near the foot of Wallace Road, floated off its foundation and slammed into the approaches of the Center Street Bridge. The pavilion-style building was a dance hall until 1937, when it was converted into a roller rink. (PCHS-Ratzlaff.)

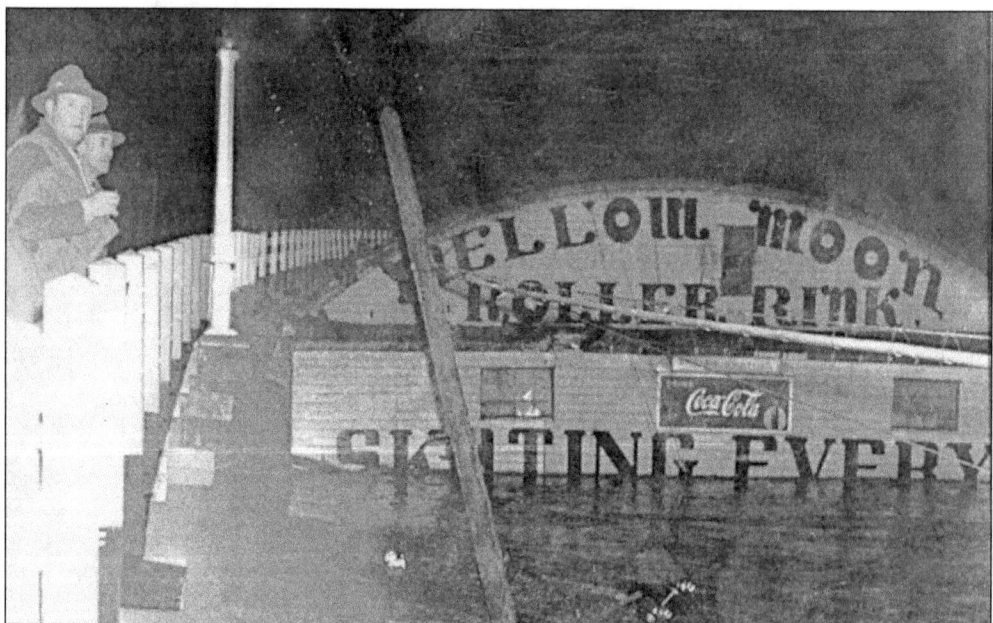

The Mellow Moon Roller Rink left its foundation and crashed into the bridge with such force that it damaged the bridge's wooden pilings and knocked down power lines, causing a power outage in West Salem. The building was wedged in tight, and dynamite had to be used to break it up so it could be dislodged from the bridge. Two men drowned while attempting to clear the debris. (SPL-BM.)

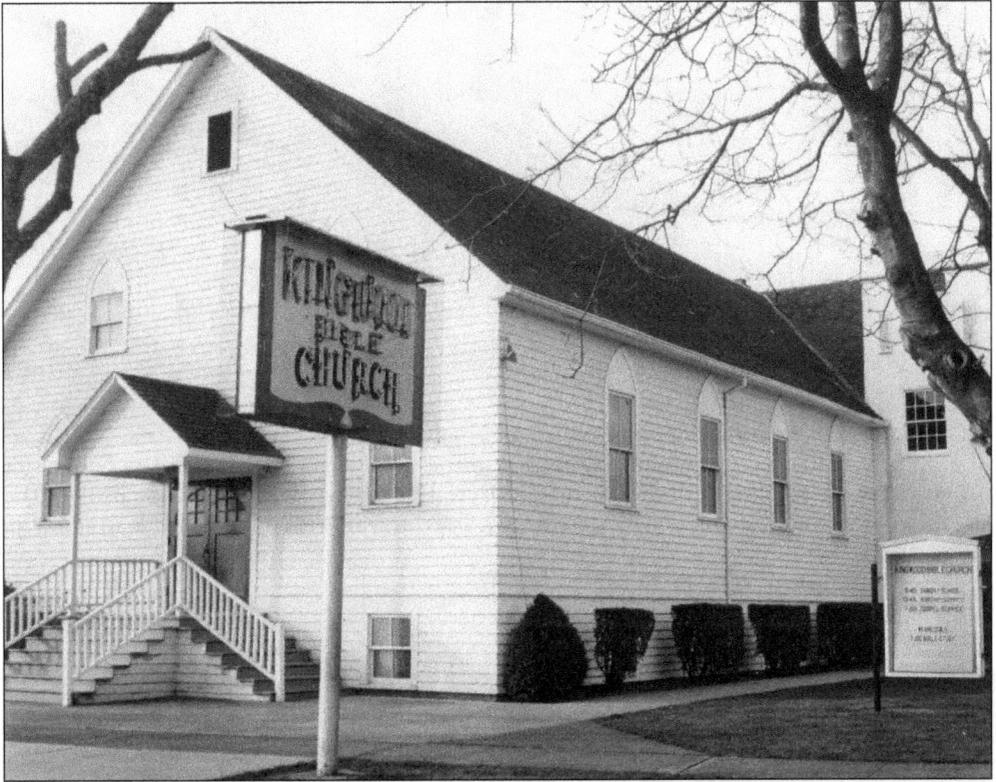

The Mennonite Brethren Church opened on Elm Street in West Salem on Easter Sunday in 1941 with Abe A. Loewen as pastor. The building had five classrooms, a dining hall, a kitchen, a pastor's study, and a sanctuary that could seat 350. The name of the church was later changed to Kingwood Bible Church (above). In 1944, the church established Salem Bible Institute, with classes meeting in the church classrooms. The Salem Bible Institute merged with another Christian school from Dallas, Oregon, to become Salem College and Academy. Constructed in the West Salem hills, the school (below) opened in September 1945 with a principal and eight teachers. Before the end of the first year, there were 90 students enrolled. The name was later shortened to Salem Academy. (Above, PCHS-Thiessen; below, PCHS.)

In 1938, an unattached gymnasium was added to the west side of the West Salem School (at the far left of the building with the peaked roof), creating three separate buildings. In 1947, the middle building with the chimney, erected in 1927, and the gym were connected with an addition, shown above.

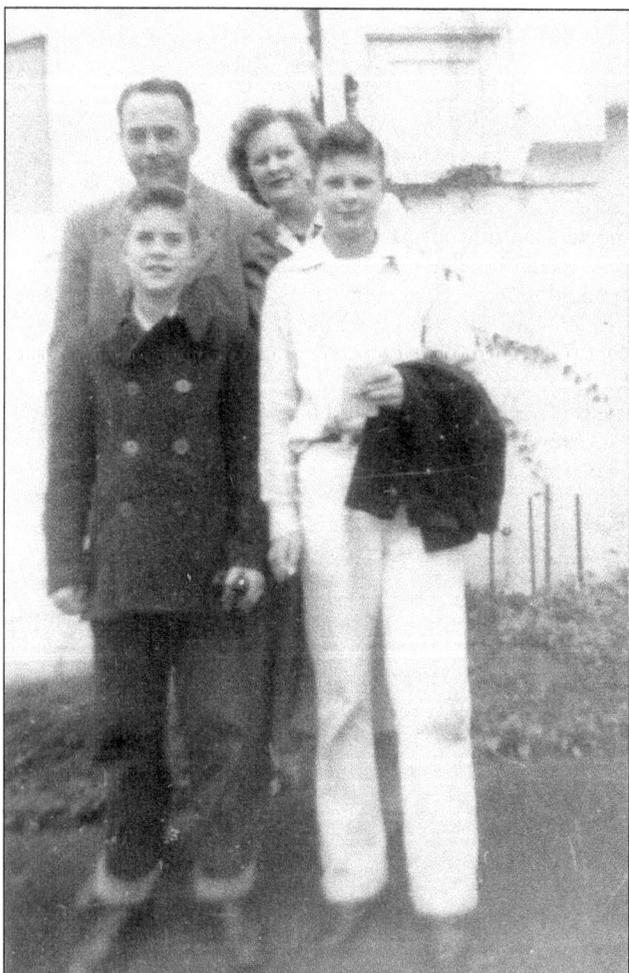

Larry and Richard "Chic" (holding jacket) Bales are shown in 1949 with their mother, Clara (Lyons) Dickinson, and her husband, Clarence "Dick" Dickinson, of West Salem. Dick and Clara owned The Maple Tree for several years. The boys attended West Salem School, where Chic lettered in baseball and basketball. (PCHS-Bales.)

Six

THE CITY REDEFINED

So much growth occurred in West Salem following its 1913 incorporation that by the mid-1940s, supplying adequate services—such as water, sewer, and fire protection—to the community became difficult. City leaders, including Mayor Walter Musgrave, began looking for a solution. The solution appeared to lie just across the Willamette River with the much larger city of Salem.

After serious discussion and stirring debates, the proposal to merge the two cities was brought to the West Salem voters in an election on July 26, 1949, with the citizens approving the merger by a vote of 357 in favor, 130 against. City of Salem citizens subsequently voted their approval in October. On November 14, 1949, some 36 years after its incorporation, the City of West Salem officially became part of the City of Salem.

During the 1950s and 1960s, the area continued to grow, supporting two large new shopping centers as well as the new Walter M. Walker Junior High School, which opened in the fall of 1961. The Wallace Marine Park was established, beginning with the 24 acres of prime riverfront land donated by West Salem resident Paul B. Wallace and increasing to today's 68 acres, which include a tournament-quality baseball and softball complex.

The West Salem area saw a surge of housing developments, as well as vineyards, in the surrounding hills during the late 1970s through the 1990s. Myers Elementary School was built in 1973 to accommodate the growing number of West Salem students. Undeniably, the most development has occurred more recently, with the building of new elementary schools, a state-of-the art high school, two new fire stations, and large tracts of beautiful homes nearly covering the West Salem hills.

What the future holds for West Salem is yet to be seen. Studies have predicted that the majority of the future growth for the city of Salem will occur in West Salem, perhaps doubling the area's population by 2020. While this unique community has certainly experienced significant changes over the years, its ability to embrace those changes has made West Salem the wonderful community it is today.

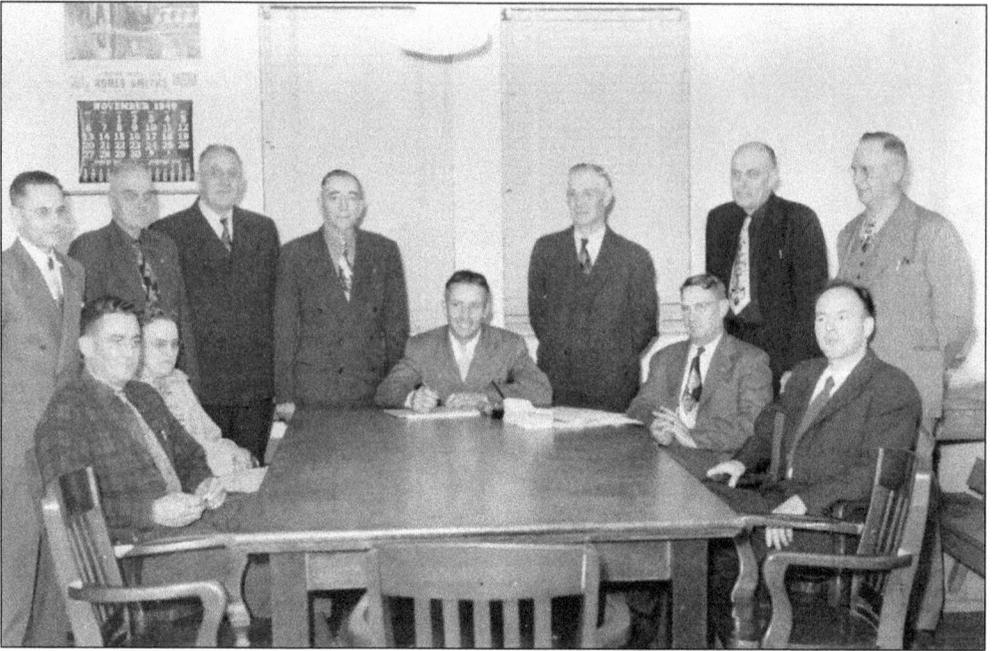

After much debate regarding the potential merger of West Salem and Salem and a vote of the residents of both cities, the West Salem City Council held its last session on November 7, 1949. Standing, from left to right, are Chester O. Douglas, councilman; W. L. Huckaby, building inspector; W.C. Heise, Earl C. Burk, and A.N. Copenhave, all councilmen; R.E. Pattison, city recorder; and William H. Porter, chief of police. Seated, from left to right, are Lawrence F. Sheridan, councilman; Thelma Brown, city treasurer; Walter Musgrave, mayor; C.A. Rust, councilman; and Steve Anderson, city attorney. On November 14, 1949, 36 years after it was incorporated, the City of West Salem became part of the City of Salem. Shown below, Salem mayor Robert Elfstrom (left) receives the West Salem city charter from West Salem mayor Walter Musgrave, who had been a strong advocate for merging the two cities. (Both, SPL-BM.)

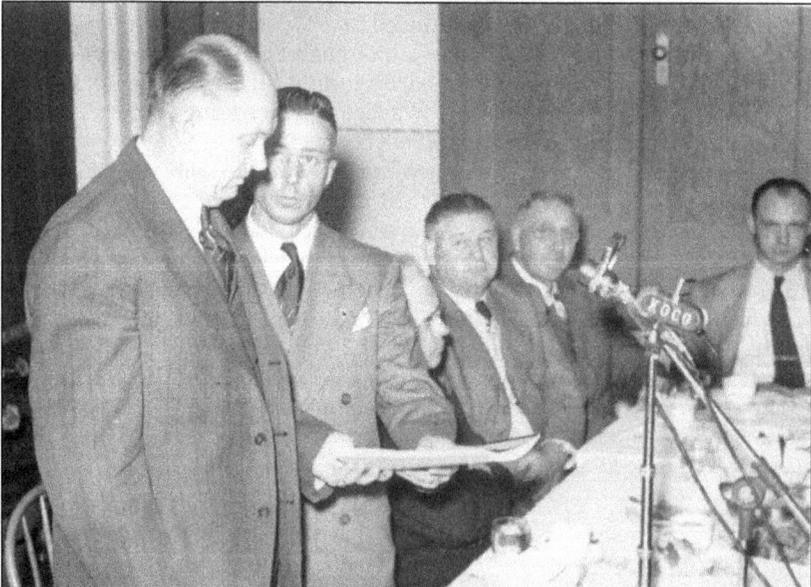

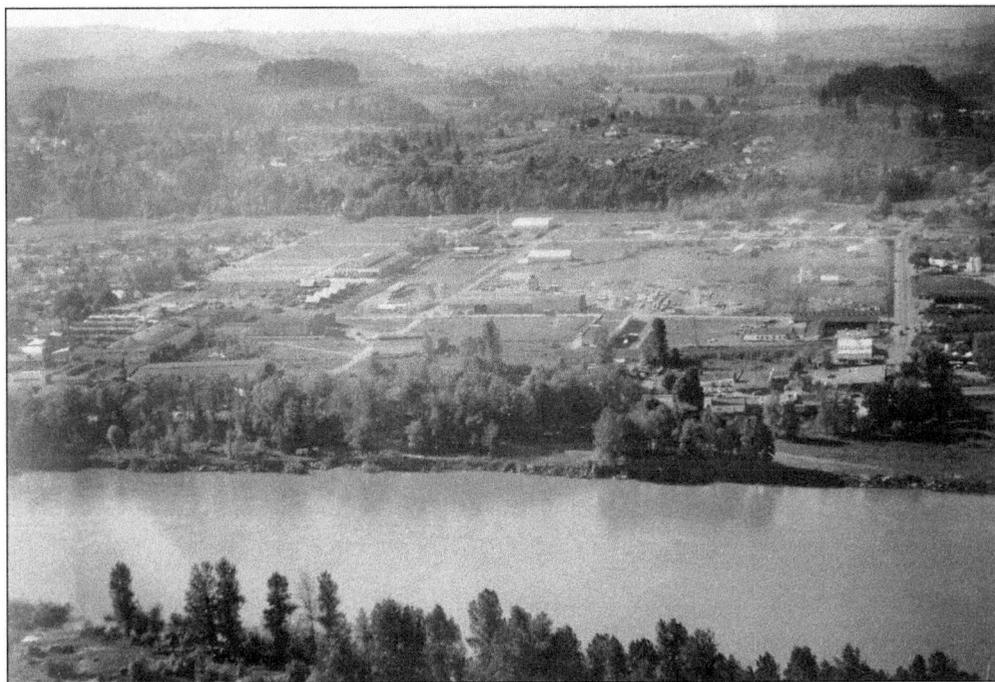

Here is an early-1950s aerial view of the West Salem riverbank, the growing industrial area, and the sparsely settled farm- and orchard-filled hills. The residential area of lower West Salem is mostly out of the picture to the left. Wallace Road, heading north, can be seen at the far right. (SPL-BM.)

Two unidentified men stand atop floating logs near West Salem. For many years, log rafts like these were a familiar sight along the Willamette River. Harvested in the coastal mountains to the west, logs were dumped into the river from railcars. A log dump was located just outside West Salem from which log rafts were towed by tugboat to the mill at Salem as late as the early 1970s. (SPL-BM.)

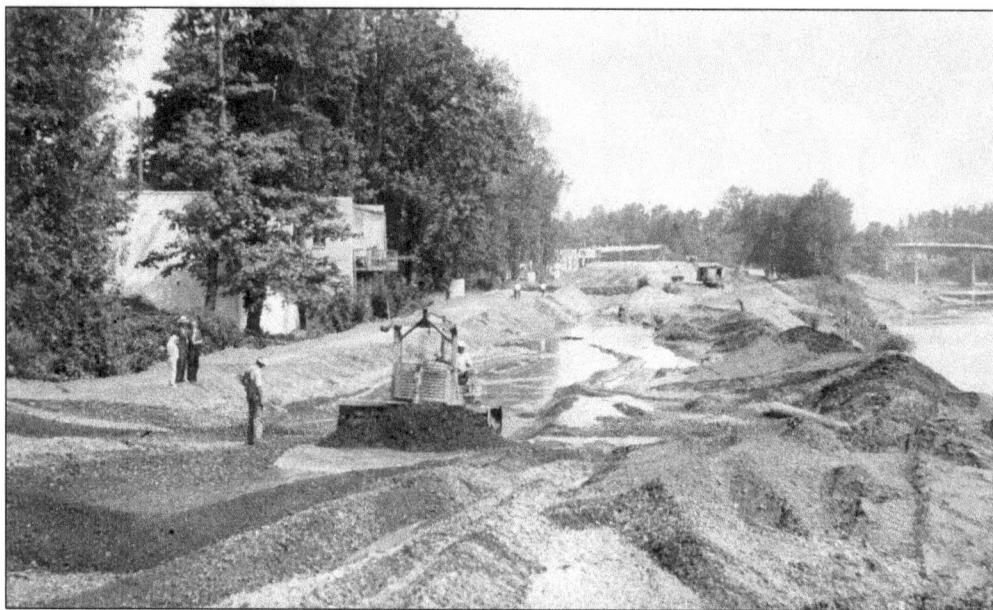

The West Salem riverbank was forever changed when the Highway 22 diversion was built, beginning as part of the construction of the approaches to the new Marion Street Bridge in the early 1950s but extending along the entire length of the community by the early 1960s. The suction dredge *Luckiamute* was used by the Army Corps of Engineers to remove sand and gravel from the river bottom, piling it onto the West Salem riverbank to create a roadbed for the highway bypass. In the photograph above, heavy equipment smooths out the gravel. The photograph below shows the Luckiamute dredge at work in the river. The project served two major purposes: it created a bypass for West Salem's increasing traffic load, and the embankment was built up to serve as a deterrent to flooding. (Both, PCHS.)

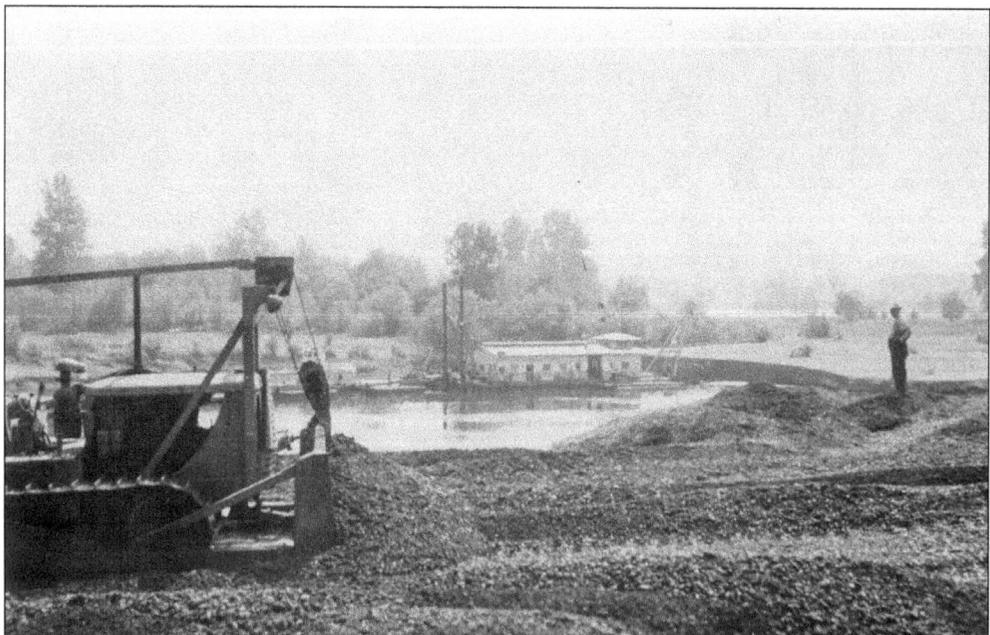

A woman and child walk through a West Salem orchard in full bloom. "Blossom Day" became a spring celebration in the early 1900s and continues today. Motorists drive along a planned route through the many orchards lining the West Salem hills, with stops at interesting local sites—such as the historic Brunk House, owned and operated by the Polk County Historical Society—that provide refreshment. (PCHS-Ben Gifford.)

In addition to fruit orchards, Christmas trees were grown in the West Salem hills. Here, Drew Michaels, owner of Kingwood Christmas Tree Farms, select a tree for his granddaughter in 1956. Several types of Christmas trees, including the prized grand and noble firs, were grown on the Kingwood farm and other tree farms in the area. (SPL-BM.)

111

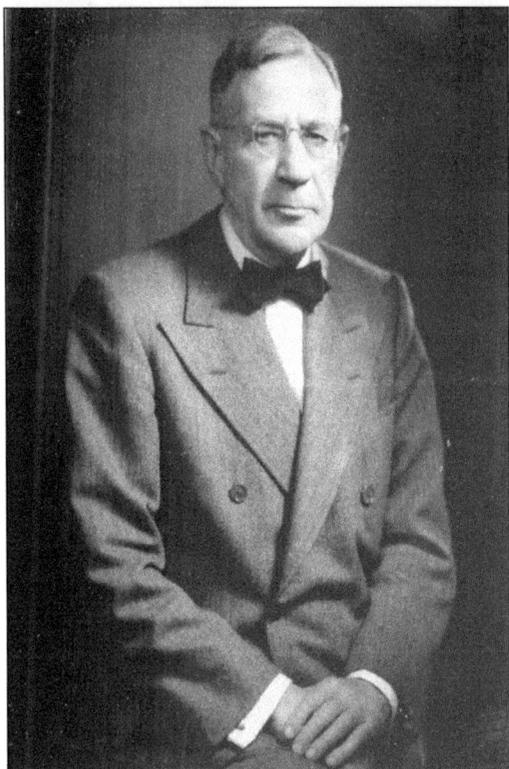

As well as managing Wallace Orchards, Paul B. Wallace was president of the Ford automobile agency in Salem. Like his father, Robert S. Wallace, Paul was very civic-minded. In the 1920s, he served on the building committee charged with construction of the new First Presbyterian Church, and he served as a church trustee for many years. Paul was appointed to the YMCA Board of Directors in 1902 and served as president from 1940 to 1952. He supervised Salem's successful campaign to purchase the vast Bush's pasture for a city park. He donated acres of prime riverside property on the west side of the Willamette River for use as a public park later known as Wallace Marine Park (shown below). He died in Chicago, Illinois, on June 9, 1952, while on a trip to a 50th-anniversary celebration of his graduation from Princeton University. (Left, PCHS-WC; below, author.)

On July 4, 1958, Salem celebrated Willamette River Days with several activities, including this boat race. Some of the nation's top boat racers participated in the 16-heat race. The day finished with a water skiing demonstration and a fireworks show. In the photograph at right, spectators and participants line the west bank of the river at Wallace Marine Park, one of Salem's urban treasures. Picnickers (below) enjoy the shade of trees at Wallace Marine Park on a hot Fourth of July during the Willamette River Days celebration, thanks to the vision and concern for community demonstrated by Paul B. Wallace. (Both, SPL-BM.)

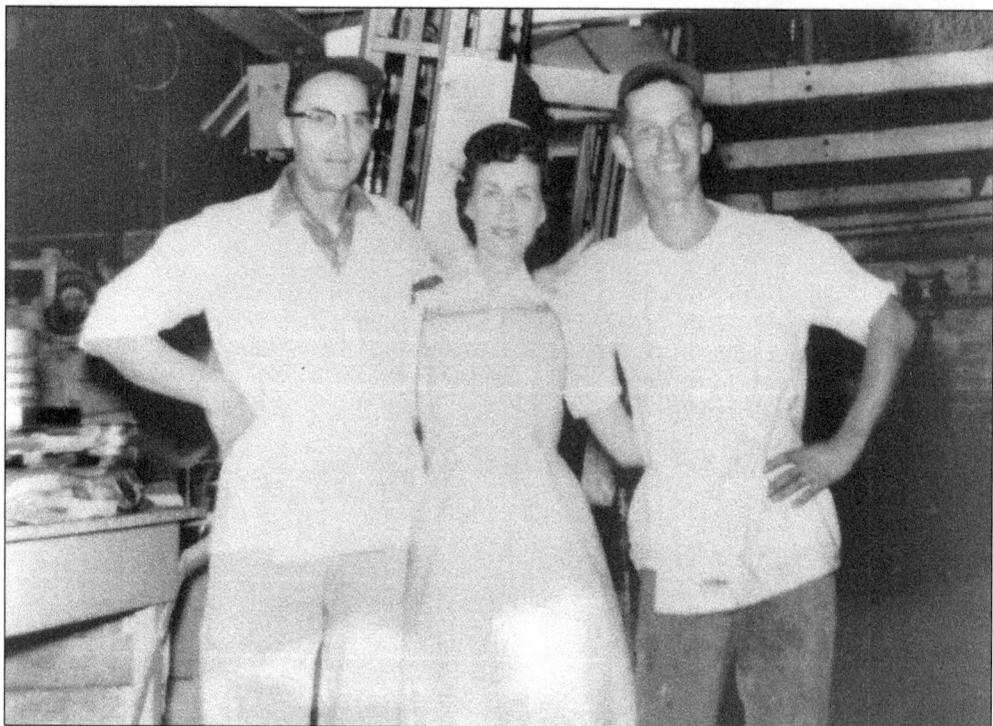

West Salem's Blue Lake Packers Cannery employees take time out for a photograph in 1956. Pictured from left to right are Ray Gunn, Myrtle Burright, and William Lucas. Lucas was a longtime cannery employee who meticulously documented the area canneries in a book he wrote and self-published in 1998 titled *Canning in the Valley, Canneries of the Salem District.* (PCHS-Lucas.)

Don and Joyce Sellers, author Lynn (Sellers) Mack's parents, are outside the Sellers home on Ruge Street in West Salem in 1958. The couple had recently arrived from Joyce's home country of England, where Don (a West Salem native) had been stationed with the US Air Force. Don passed away in 2004. Joyce was a longtime employee at the US Bank in West Salem before her retirement.

Oak Hills Shopping Center, built at the corner of Cascade Drive (now Eola Drive) and Edgewater Street, held its grand opening in November 1961. The new shopping center offered free parking for 165 cars and brought several new businesses to West Salem, including Safeway, Mootry's Pharmacy, Sprouse-Reitz variety store, and Western Union hardware store. The Safeway store was managed by Marvin Martin, with Dean Snodgrass as assistant manager. Mootry's Pharmacy (below) was owned by Earl Mootry and later his son Keith. An addition was built later to the east of the original shopping center to house the new, super-sized Safeway. The old Safeway building now houses the Oregon Building Codes Department, with Wallery's Pizza occupying the former location of Sprouse-Reitz. Also seen is the remnant of an old residence and its well house, which stood across Senate Street. (Both, SPL.)

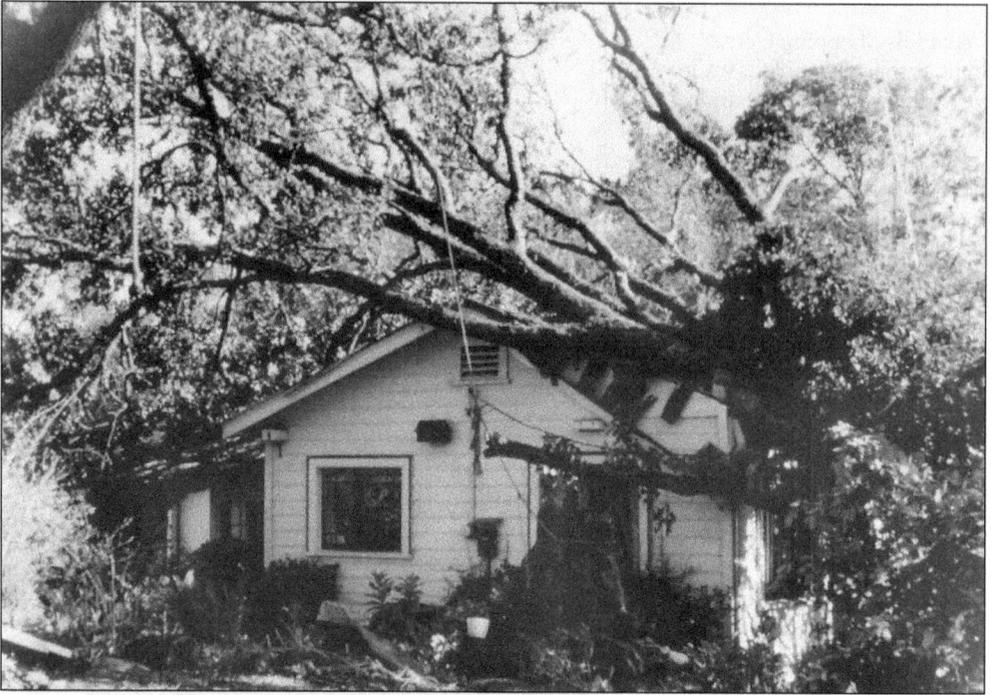

The Columbus Day storm in 1962 caused much damage in the Salem area. The Coffel family house on Glen Creek Road NW was damaged when a large tree fell on it. When the fast-moving storm hit on Friday, October 12, many homes were affected, either by damage or power outage. The storm brought sustained winds of more than 70 miles per hour, with gusts of 90 miles per hour. (PCHS-JW.)

Longtime West Salem Baptist Church kindergarten teacher Kay Wuerch watches as Lynn Sellers receives her kindergarten diploma during the class graduation ceremony in May 1968. Some of the other students graduating that day were Monte Voigt, JoAnn Wolfe, Laura Hoffman, Kathy Smith, Brenda Thiessen, Carin Gingerich, Randy Kautz, Wesley Canaga, and Karleen Frigaard. JoAnn Small can be seen at the organ.

In 1967, J.G. Watts, who had purchased the West Salem–area Wallace Orchards from Paul B. Wallace in 1952, developed the large property into an adult community that he named Salemtowne. The photograph at right shows an unidentified couple near the front entrance sign around 1967. Today, the community contains 460 privately owned homes with a golf course, swimming pool, activity rooms, and many more amenities. The aerial photograph below shows the early development of the community, including several homes built along the fairway. The original Wallace farmhouse (behind the large trees) was incorporated into the large community hall in the foreground. Author Debra Meaghers had an office in the clubhouse, as it was then called, when she worked there in the early 1970s. It is also where she met her future husband, Michael, a building products salesman. (Both, SPL-SJ.)

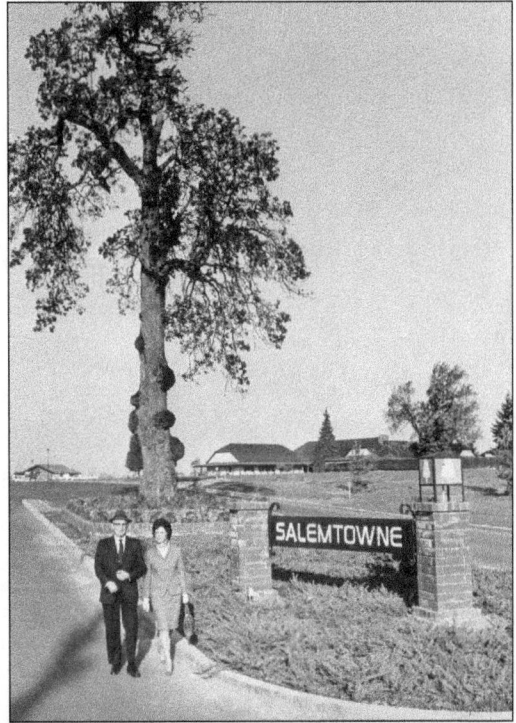

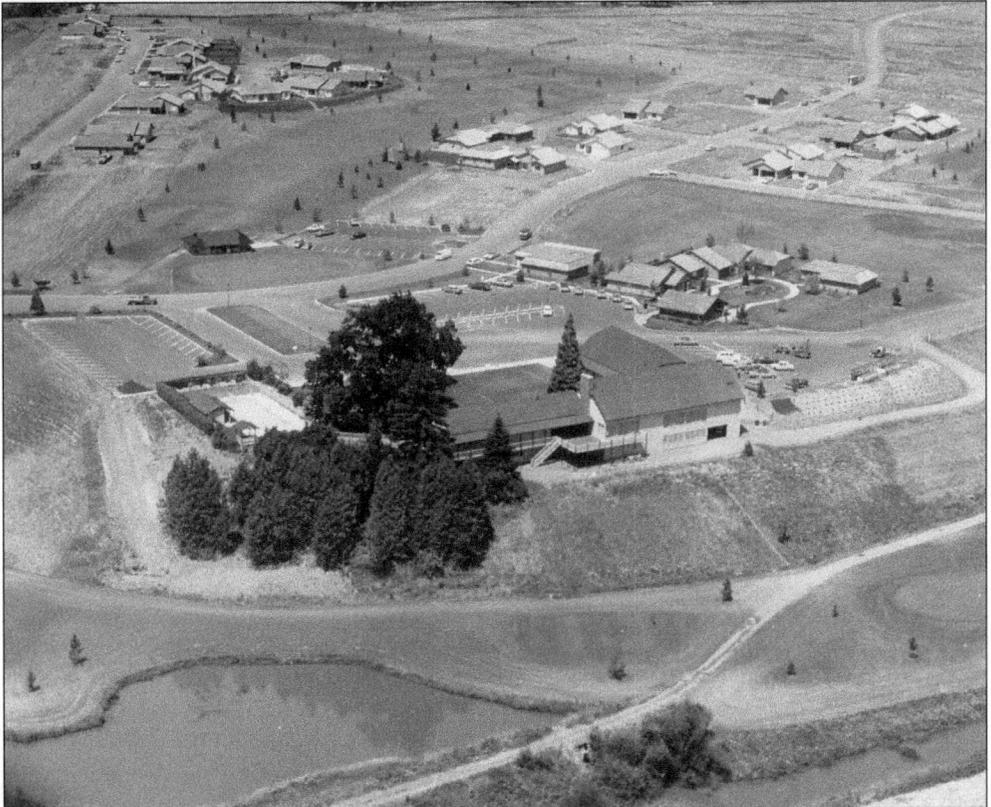

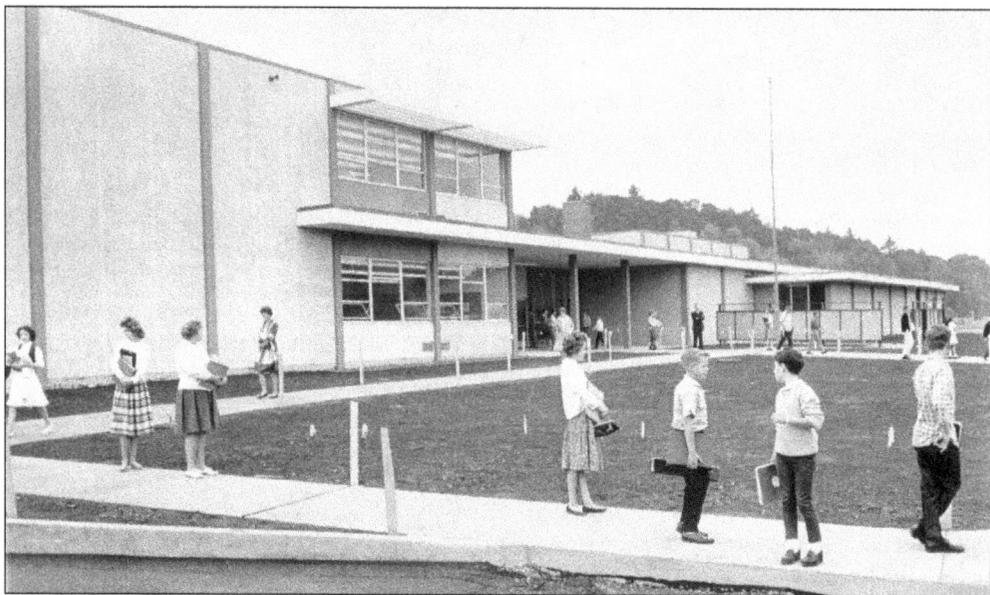

Students stand outside the new Walker Junior High School, named after Walter M. Walker, who settled in the Spring Valley area in 1848. It opened in the fall of 1961 with an enrollment of about 450. Nearly 300 students were from the West Salem area, and 150 were from Keizer, north of Salem. Students chose the school colors, green and white, and the school mascot, the Walker Wildcats. (SPL.)

Pictured is Walker Junior High School's junior varsity cheerleading squad for the 1975 basketball season. Standing, from left to right, are Lynn Sellers, Sara Patterson, and Denise Ward. Kneeling are Cathy Baker (left) and Patti Schmitz. The girls chose the pattern and the fabrics for their outfit, with most of the girls sewing their own uniforms. It was an especially exciting year, with both the varsity and junior varsity boys' basketball teams being undefeated.

The Walker Junior High varsity and junior varsity basketball teams were both undefeated during the 1975–1976 basketball season. This was the first time in Salem's history that one junior high school's varsity and junior varsity basketball teams both went undefeated. Varsity Salem city champions (above) include, from left to right, (first row) Keith Stoller, Brad Knox, Tim Bright, Jean Savard, Chris Clemens, Tony Cochran, Chris Acarregui, and Jerry Johnson; (second row) Paul Mather, Jeff Waltrip, Karl Hafferkamp, Tim King, Greg Newsom, Marc Nix, Brad Mathis, L. Gersbach, and coach Mike Alley. Shown below are members of the undefeated junior varsity team. Pictured from left to right are (first row) Randy Kautz, Bobby Amens, Rodney Jantzen, Jack Kennedy, Fred Mikesell, Doug Bock, David Weibe, and Robert Cary; (second row) coach John Turman, Dana Salisbury, Andy Warren, Jim Newell, Monte Voigt, Brent Culver, Steve Fetrow, Jim Heine, Tim Gates, Doug Miles, and manager Scott Baldwin.

No book about West Salem history would be complete without noting Walter Gerth and Ben Maxwell. Walter Gerth (left, around 1976) was born in 1883 in Marion County but grew up in Lincoln in Polk County. He established a grocery in West Salem in 1912 in a rented building, soon relocating to a structure he built at the corner of Edgewater Street and Gerth Avenue (now, Trudel's Deli). Gerth can be credited with many of West Salem's firsts: the first two-story building, first basement, first delivery service, first electric lights, first cement sidewalks, first gas pump, and first pay telephone. Gerth installed tiles from his new store to the river, creating West Salem's first sewer line. Longtime Eola resident Ben Maxwell (below) was a *Capital Journal* newspaper photographer and journalist who began chronicling Salem's events and history with his camera and pen in 1930. Beside his own photographs, he amassed a large collection of historic photographs that was donated to the Salem Public Library following his death in 1967. (Left, MCHS 2007.001.1014; below, SPL.)

The gymnasium (top left) was added to West Salem School in 1938, and it was connected to the school with an addition in 1947. Former student Richard "Chic" Bales wrote in his memoirs, "There were basketball games against squads from Parrish and Leslie. The backboard at the south end of the floor was very near the entrance and the door was often open . . . to let the heat out. One time Chuck Puhlman drove to the basket, but just as he went airborne, someone bumped him and he went out the door and tumbled down the stairs—fortunately not injured." A talent show performance on the gym stage is seen below, with students watching from the gym floor and balcony. Generations of students fought the temptation to swing from the balcony on the gym's thick climbing ropes, which were tied to balcony rails. (Both, PCHS.)

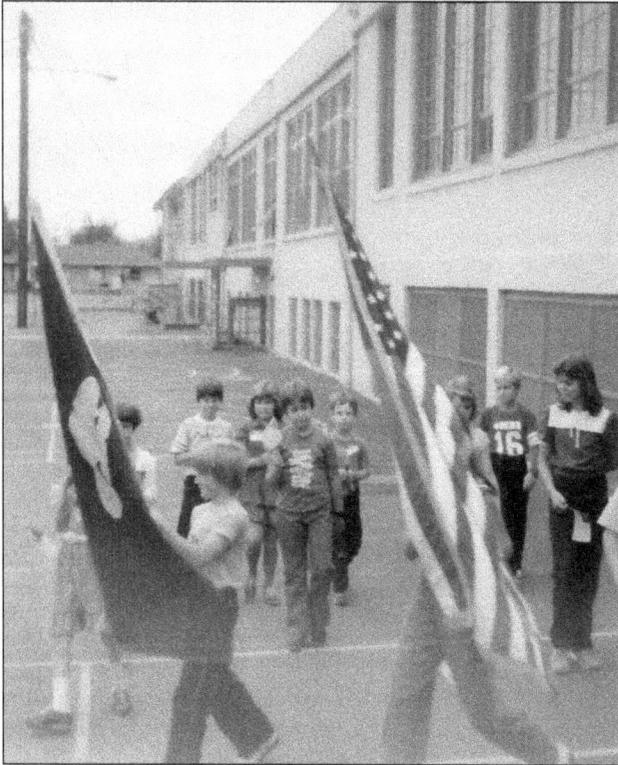

West Salem Elementary Students are photographed in the 1980s while performing a flag ceremony on the blacktop play area behind the school. The Pledge of Allegiance was recited every morning as school started, and on special occasions an outside ceremony was performed. (PCHS.)

In another 1980s photograph, students are seen playing a game during recess in the play area at the rear of the 1911 West Salem School building. In a move to lessen the use of the old school as well as to even out the student population, approximately one-third of West Salem's students were transferred to the new Myers Elementary School, constructed on the south side of Burley Hill in 1973. (PCHS.)

The oldest part of West Salem School, built in 1911 and shown at far right, was separated from the rest of the school by a breezeway. All the other sections of the school had been connected over the years with separate building additions. This photograph shows the West Salem School as it appeared in the 1970s with all of its additions completed.

This photograph of the West Salem School being torn down was taken on May 26, 2002. Because of deteriorating buildings, population changes, and other circumstances, the West Salem School closed it doors in 1986. Students were sent to other area schools, and the building sat empty for years, although it was used for other purposes briefly before it was torn down. A housing development replaced the school a few years later, but the site will always be known for being where the West Salem School once stood.

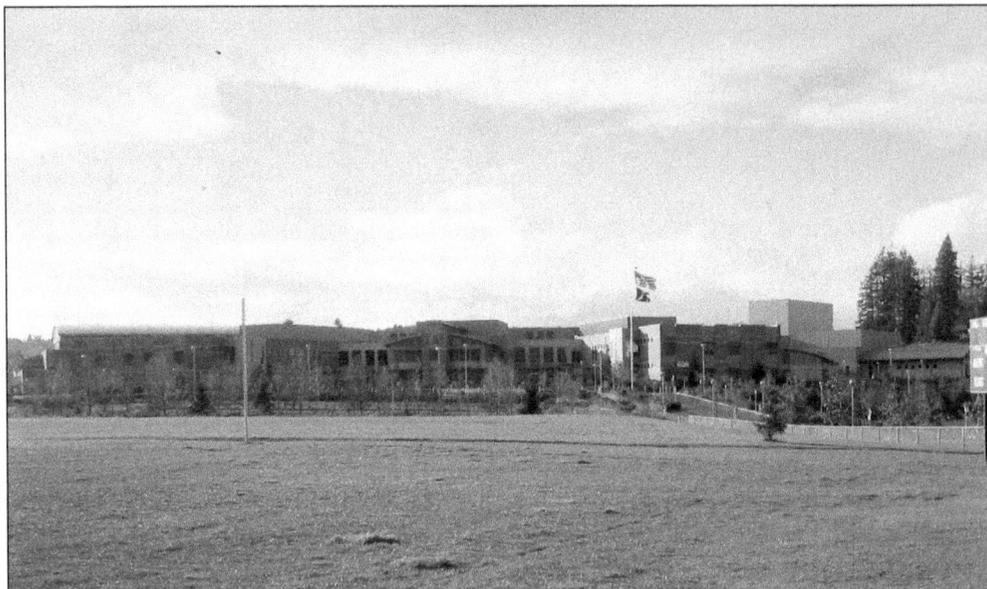

At approximately the same time that the old West Salem School was being torn down, a new state-of-the-art high school was being built. West Salem High School, the home of the Titans, opened in the fall of 2002. The beautiful campus was built near the intersection of Doaks Ferry and Orchard Heights Roads on the new Titan Drive. For years, West Salem area high school students attended high school over the river at one of the Salem high schools, while community members lobbied tirelessly for their own high school. The aerial photograph below, taken in May 2009, shows the sprawling campus. Demonstrated by the high level of parental and community support for its events, the West Salem High School has become the heart of the West Salem community and continues to provide a place to bring the community together.

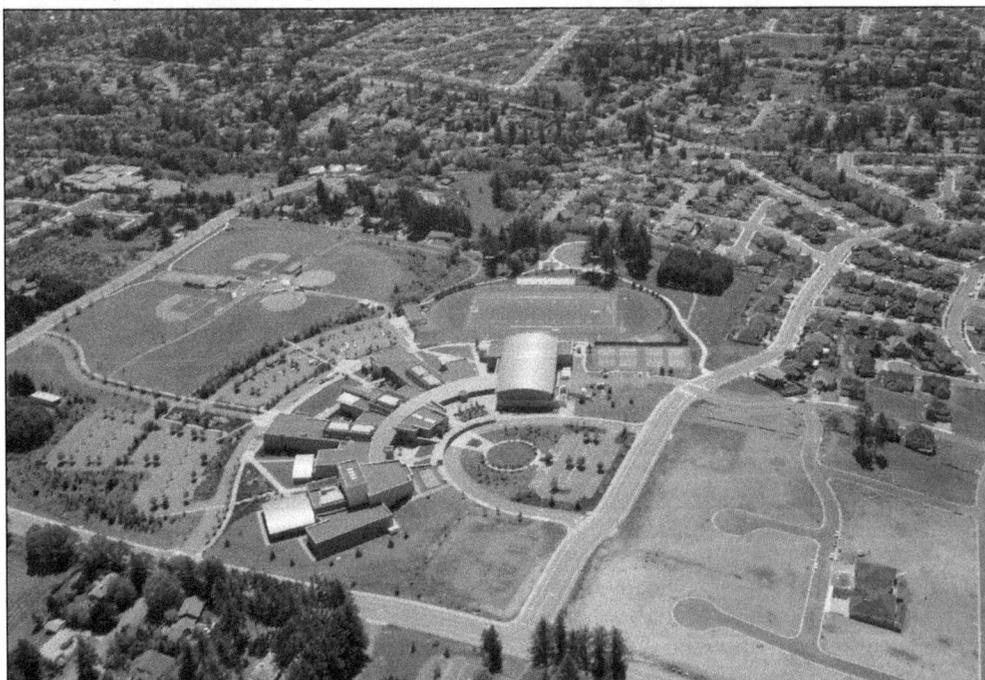

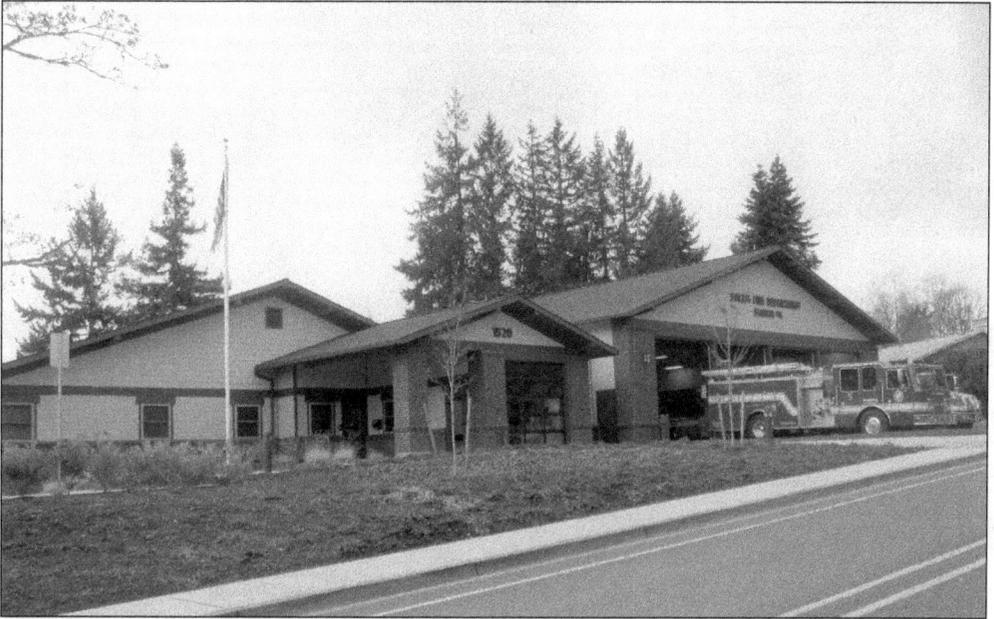

To meet growth needs, two fire stations were built in the West Salem hills in 2009. Station 5 (pictured) is located at 1520 Glen Creek Road. Another station, similar in design, was opened at 1970 Orchard Heights Road. Two new schools were built in West Salem and opened in the fall of 2011: Straub Middle School and Kalapuya Elementary School, both located off Orchard Heights Road.

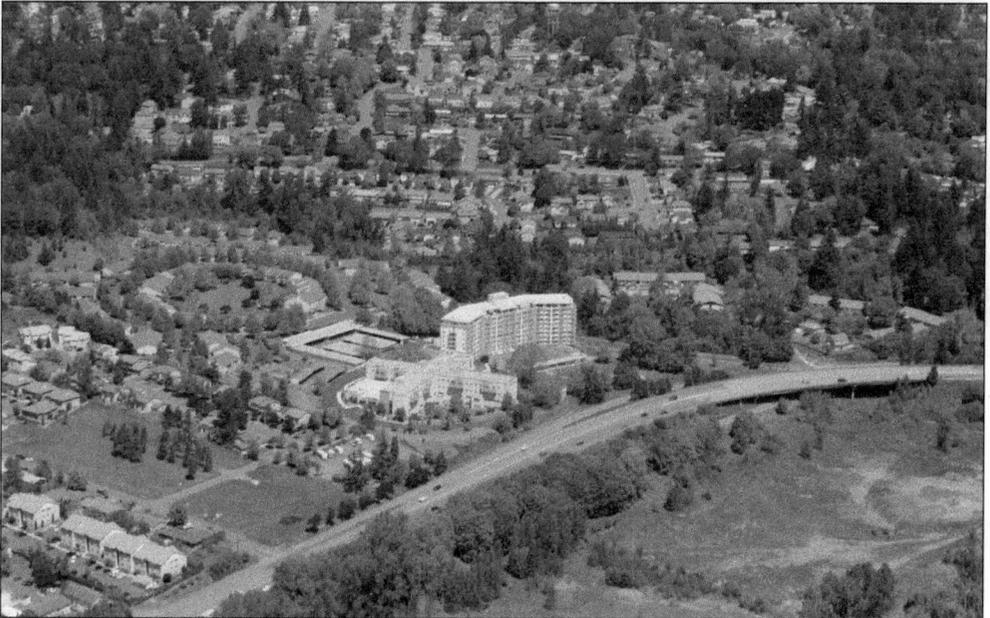

The easily recognizable retirement community of Capital Manor opened in 1963 with a 10-story tower and 258 living units—one of the first in the new building trend of housing complexes designed for senior living. Through the years, several additions have been made, providing villas, town homes, and apartments as well as continuing care. This May 2009 aerial view shows the "Manor" with its array of villas and gardens.

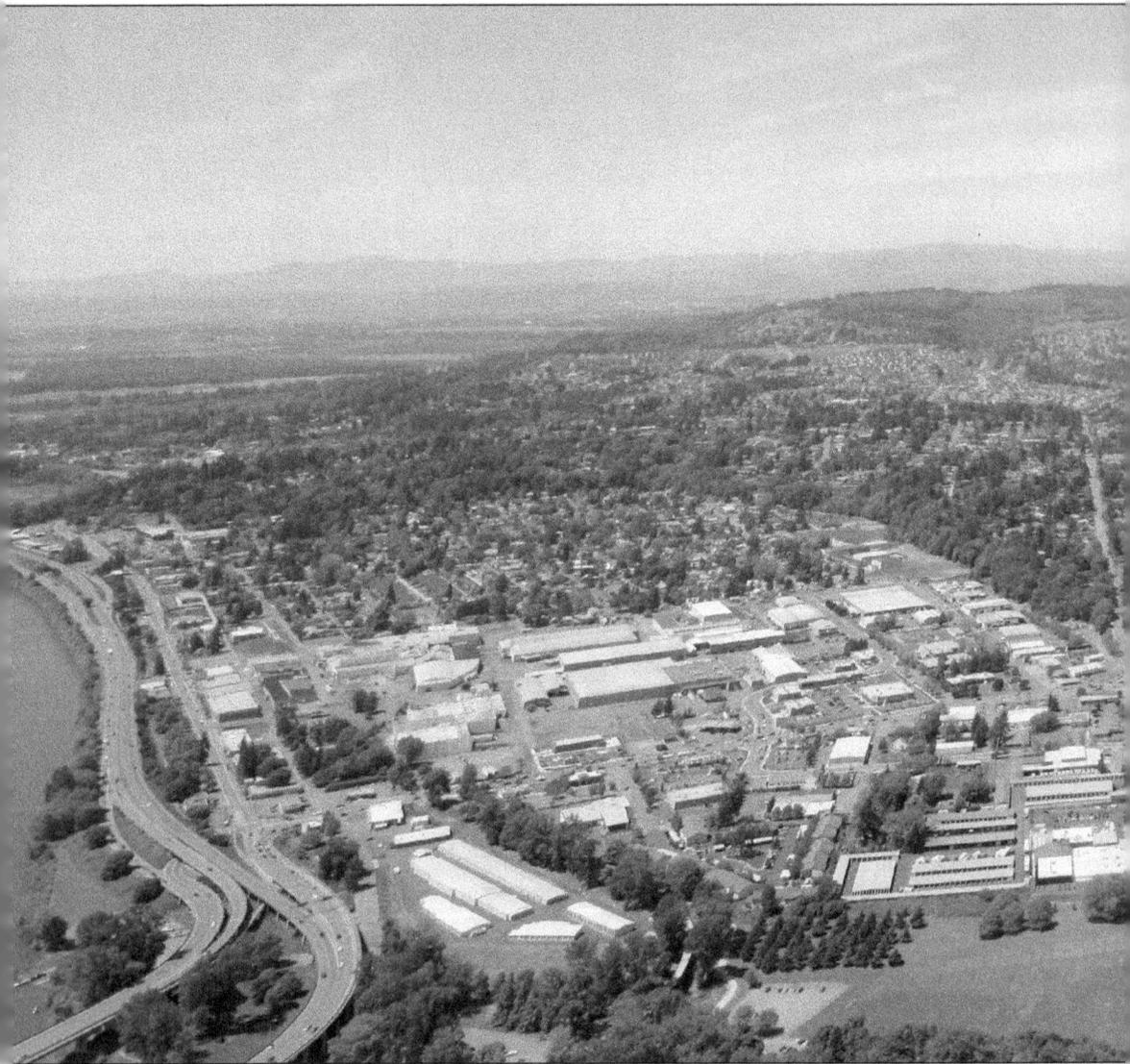

In this photograph taken by Lynn Mack in May 2009, the Willamette River and Highway 22 bypass are shown at the left, the crescent-shaped lower West Salem area is in the center, and the Wallace Marine Park is in the center-right foreground. Glen Creek and Orchard Heights Roads climb the hills from Wallace Road, which winds to the north. Over the course of the years since the first settlers arrived in West Salem, many residents have contributed to making

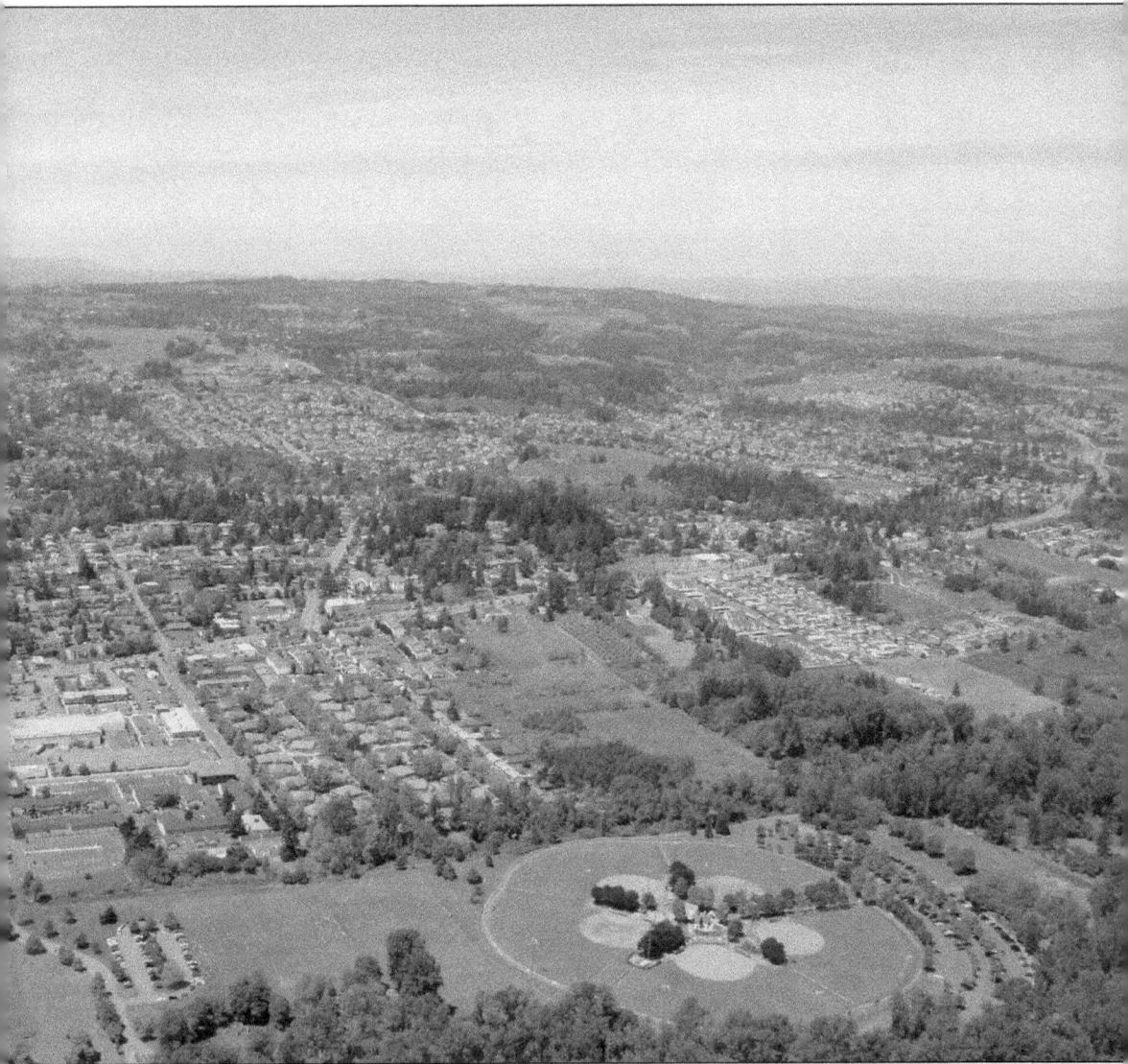

the community what it is today. This book provides but a glimpse of West Salem's history; had space allowed, the authors would have described many more families and events. History records familiar names such as Hosford, Gibson, and Gehlar, but many, many others played important roles in West Salem's history. Much of the community's history is yet to be written, for today's residents are creating tomorrow's history.

Visit us at
arcadiapublishing.com

9 781531 650094